NEW YORK DADA

NEW YORK DADA

Edited by

Rudolf E. Kuenzli

WILLIS LOCKER & OWENS • NEW YORK

Printed in the United States of America

Published by Willis Locker & Owens
71 Thompson Street, New York, NY 10012

Library of Congress Cataloging-in-Publication Data
Main entry under title:

New York Dada.

 "Bibliography on New York Dada": pp. 164–193
 Includes bibliographies.
 Contents: Introduction – Man Ray and the Ferrer
Center: art and anarchy in the pre-Dada period / Francis
Naumann – Robert J. Coady, man of The Soil / Judith
Zilczer – American Dada against surrealism, Matthew
Josephson / Dickran Tashjian – [etc.]
 1. Dadaism – New York (N.Y.) – Addresses, essays, lec-
tures. 2. Art, Modern – 20th century – New York (N.Y.) –
Addresses, essays, lectures. I. Kuenzli, Rudolf E.
N6546.N5N378 1986 700'.9747'1 85-23807
ISBN: 0-930279-10-7
 0-930279-09-3 (pbk.)

Book design: Judith Pendleton

Cover design: E. Willis

COVER: (*Front*) Morton L. Schamberg, *Machine*. 1916. Oil on canvas. 30⅛ x 22¼ in.
Yale University Art Gallery. Gift of Collection Société Anonyme. Black and white
photograph superimposed on yellow background. (*Back*) Francis Picabia, *Mouvement
Dada*. 1919. Ink on paper. 20⅛ x 14¼ in. New York, The Museum of Modern Art.

Contents

1 Introduction
 Rudolf E. Kuenzli

10 I. ESSAYS
 Man Ray and the Ferrer Center:
 Art and Anarchy in the Pre-Dada Period
 Francis Naumann

31 Robert J. Coady, Man of *The Soil*
 Judith Zilczer

44 American Dada against Surrealism: Matthew Josephson
 Dickran Tashjian

52 Marcel Duchamp's Approach to New York:
 "Find an Inscription for the Woolworth Building
 as a Ready-Made."
 Craig Adcock

66 Morton Livingston Schamberg:
 Notes on the Sources of the Machine Images
 William Agee

81 "My Baroness": Elsa von Freytag-Loringhoven
 Robert Reiss

102 Mina Loy's "Colossus": Arthur Cravan Undressed
 Roger Conover

120 Chasing Butterflies with Arthur Cravan
 Willard Bohn

124 Dada, Dead or Alive
 Kenneth Burke

 II. DOCUMENTS
127 Articles on New York Dada from New York Newspapers
146 Reprint of *TNT*

164 III. BIBLIOGRAPHY ON NEW YORK DADA
 Rudolf E. Kuenzli and Timothy Shipe

195 Notes on Contributors

Introduction
Rudolf E. Kuenzli

How can we speak of New York Dada, or New York proto- or pre-Dada? The New York group's gatherings in salons and galleries from 1915 to 1921, and the participants' preoccupations with the nature of visual art and chess, differ greatly from the public Dada demonstrations and manifestos in Zurich, Berlin, Cologne, and Paris. The group in New York did not distribute revolutionary pamphlets at factory gates, they did not provoke large audiences in concert halls or cabarets, they did not even write manifestos.[1] This group even existed prior to the invention of the label "Dada" by Tristan Tzara, Hugo Ball, and Hans Arp in Zurich in 1916. Although Marius de Zayas, Marcel Duchamp, and Francis Picabia learned of the birth of Dada in the same year, the New York group was not interested in adopting the label until 1921, and then only for a brief period, after which the key members joined the Dada group in Paris.

Yet the New York Dada group, despite its less militant stance, has had an incomparably greater impact on American artists and writers than, for example, Zurich Dada had on the Swiss. During World War I, both New York and Zurich became refuges for European pacifists and war resisters. But the Dada group in Zurich consisted almost exclusively of foreign refugees, who primarily collaborated with each other, whereas in New York, Picabia and Duchamp, who arrived there in 1915, immediately joined young American artists and writers every night at Walter Conrad Arensberg's apartment. This extraordinary salon was visited by Marcel Duchamp, Francis Picabia, Jean Crotti, Albert Gleizes, Edgar Varèse, Henri-Pierre Roché, Henri-Martin Barzun, Mina Loy, Baroness Elsa von Freytag-Loringhoven, Arthur Cravan, Man Ray, Charles Demuth, John Covert, Arthur Dove, Marsden Hartley, Katherine Dreier, Morton Schamberg, Charles Sheeler, Stuart Davis, Joseph Stella, Amy Lowell, William Carlos Williams, Allen Norton, Max Eastman, Elmer Ernest Southard, Alfred Kreymborg, Beatrice Wood, Isadora Duncan, Walter Pach, John Sloan, and George Bellows. Arensberg's salon became the meeting ground between Duchamp's and Picabia's radical anti-art and a-art position, and the young Americans' efforts to found a new art and a new poetry. These gatherings provided a first extensive opportunity for some young American painters and poets to interact with important European figures of the avant-garde. The studies of William Agee, Dickran Tashjian, and Abraham Davidson have convincingly shown that Duchamp and Picabia were catalysts for these young Americans, who received from them encouragement and confirmation in their new experiments with nonconventional material and new subject matter.[2] Charles Demuth's poem "For Richard Mutt," written in celebration of Duchamp's ready-made urinal, which Du-

champ signed "R. Mutt 1917," suggests the significance for young American artists of Duchamp's questioning and breaking the cultural norms of art:

For some there is no stopping.
Most stop or never get a style.
When they stop they make a convention.
That is their end.
For the going everything has an idea.
The going run right along.
The going just keep going.[3]

The gatherings at Arensberg's apartment, the contact with the Europeans, inspired the Americans to "go on" exploring new subject matters and new media.

Although Picabia was in New York for only extended visits, and Duchamp and Man Ray left for Europe in 1921, their new ideas were, according to Stuart Davis, alive in New York long after their departure: "Duchamp's suggestion worked slowly. Unesthetic material, absurd material, non-arty material – ten years later I could take a worthless eggbeater, and the change to a new association would inspire me."[4] Duchamp and Picabia challenged young American artists to move away from a sensual to a more conceptual notion of art. Picabia's machine drawings and his ironic, mechanomorphic portraits probably inspired Man Ray's *Danger-Dancer* (1920), Morton Schamberg's machine paintings and pastels (1916), Charles Sheeler's *Self-Portrait* (1923), Arthur Dove's composite collage portraits (1924–25), and Charles Demuth's *Poster Portraits* (1924–29). Duchamp's ready-mades, especially his *Fountain,* assisted in the making of another plumbing device, Elsa von Freytag-Loringhoven's and Morton Schamberg's *God* (1918). Man Ray's ironic, mechanical *Self-Portrait* (1916), an assembly of ready-made objects, or his photograph of an eggbeater, which he entitled *L'Homme* (1918), can easily be related to Duchamp's notion of the ready-made. Duchamp's *Large Glass* incited Joseph Stella to experiment with glass himself in his *Man in Elevated (Train)* (1918). Certainly John Covert's conceptional art, with its visual puns and use of "non-arti" material, is related to the work of Duchamp, who considered Covert "an outstanding figure from the beginning."[5] But with the exception of works by Man Ray, the young Americans' experimenting lacked the irony, playfulness, eroticism, and nonsense of Picabia's and Duchamp's work. Nevertheless, the Americans' tendency to interpret Dada anti-art and a-art as a rejection of European modernism exhibited at the Armory Show, and thus as a liberation, did encourage the Americans to explore their own ways of bringing art and American life closer together. Duchamp encouraged the Americans' rejection of European modernism very early, when he stated in an interview in 1915: "If only America would realize that the art of Europe is finished – dead – and that America is the country of the art of the future, instead of trying to base everything she does on European traditions!"[6]

While Picabia and Duchamp encouraged American artists to create a new art, they themselves were stimulated and inspired by America and American writers and artists. When Picabia arrived in New York for the Armory Show in 1913, he immediately made a series of watercolors, which "express

the spirit of New York as I feel it, and the crowded streets of your city as I feel them, their surging, their unrest, their commercialism, their atmospheric charm. . . ."[7] He exhibited these new works at Alfred Stieglitz's art gallery "291," where he met Paul Haviland, Marius de Zayas, and Benjamin de Casseres, whose ideas on art, which they had previously published in *Camera Work,* were very close to Picabia's own notions. De Zayas and his friends immediately responded to Picabia's exhibition of his watercolors and his Preface to the exhibition catalog with a special issue of *Camera Work,* which included Picabia's manifesto "L'Ecole amorphiste," Gabrielle Buffet's "Modern Art and the Public," and essays by de Zayas, Maurice Aisen, de Casseres, and Oscar Bluemner.[8] Discussions between de Zayas and Picabia, who came to "291" "virtually daily,"[9] must have led to joint experiments in expressing the subjective through abstract equivalents. The results of this collaboration were de Zayas' abstract portraits, in which he used algebraic formulas as equivalents. He exhibited these portraits at "291" immediately after Picabia's exhibition of his New York watercolors. Picabia's own *Mechanical Expression Seen Through Our Own Mechanical Expression* (1913) and his later mechanomorphic portraits of 1915 may have resulted from his meetings with de Zayas. Their collaboration resumed when Picabia returned to New York in June 1915. It was this second visit to America, which brought, in Picabia's words,

A complete revolution in my methods of work. . . . But prior to leaving Europe I was engrossed in presenting psychological studies through the mediumship of forms which I created. Almost immediately upon coming to America it flashed on me that the genius of the modern world is in machinery, and that through machinery art ought to find a most vivid expression. I have been profoundly impressed by the vast mechanical development in America. The machine has become more than a mere adjunct of human life. It is really a part of human life – perhaps the very soul. In seeking forms through which to interpret ideas or by which to express human characteristics I have come at length upon the form which appears most brilliantly plastic and fraught with symbolism. I have enlisted the machinery of the modern world, and introduced it into my studio. Naturally, form has come to take precedence over color with me, though when I began painting color predominated. Slowly my artistic evolution carried me from color to form, and while I still employ color, of course, it is the drawing which assumes the place of first importance in my pictures.

Of course I have only begun to work out this newest stage of evolution. I don't know what possibilities may be in store. I mean to simply work on and on until I attain the pinnacle of mechanical symbolism. Since coming to America I have painted a great deal. My brush has been very busy. And for two reasons. First and foremost, naturally, is the fact that I have a whole new scheme to evolve. But a very important item is the fact that in America work of an artistic nature is possible where it is utterly impossible in Europe today. The war has killed the art of the Continent utterly. . . .

Since machinery is the soul of the modern world, and since the genius of machinery attains its highest expression in America, why is it not reasonable to believe that in America the art of the future will flower most brilliantly?[10]

In this statement of October 1915, Picabia clearly attributes his discovery of machine drawings to his experience of America. He published his first symbolic machine portraits, which were portraits of his friends at "291," in de Zayas' recently founded journal *291.*[11] Whereas de Zayas used algebraic for-

mulas, geometry, and trajectories as symbolic equivalents in his earlier abstract portraits, Picabia chose machines and parts of mechanisms as his equivalents.

Duchamp, upon his arrival in 1915, was also inspired by New York, which he admired as "a complete work of art."[12] Shortly after coming to America, he suggested using "the Woolworth Building as a ready-made."[13] His personal life, his relationship with artists, and his position in the art world changed dramatically from what it was in Paris. In October 1915, he stated that in Paris he "was frightfully lonely. . . . But I love an active and interesting life. I have found such a life most abundantly in New York. I am very happy here. Perhaps rather too happy. For I have not painted a single picture since coming over."[14] Duchamp immediately became the center of the gatherings at Arensberg's apartment, and, according to Henri-Pierre Roché, "the toast of all the young *avant-garde* of New York. Projects built up around him. His smile inspired daring and a sense of confidence."[14] Duchamp's chief collaborator in New York was Man Ray, whom he visited in summer, 1915, shortly after his arrival, in the small artist's colony near Ridgefield, New Jersey. A few months before Duchamp's visit, Man Ray had published *The Ridgefield Gazook,* which he had written by himself, and in which he expressed his anarchic, anti-art position, his sense of humor, and his love for puns. In an interview with Arturo Schwarz, Man Ray insists that he was "Dada" before he met Duchamp, but that Duchamp strengthened and encouraged his attitudes and opinions.[16] Among all the young American artists of the Arensberg circle, Man Ray was the only one who did not care at all about forming an indigenous, modern American art. He broke his contacts with Stieglitz when the gallery "An American Place" was opened. Man Ray's insistence on absolute freedom, creativity, humor, independence, and anarchism made him, according to Arturo Schwarz, the only American Dadaist. In the manner of Rimbaud, Man Ray cultivated his personality; he accepted himself totally, including his unconscious impulses and his contradictions. Concerning his work in New York he stated: "I did not even understand my own things myself or why I did them. But I didn't care: the idea was to do it. It isn't a question of understanding, it's a matter of acceptance. [To] accept you[rself] with confidence."[17] His collaboration with Duchamp certainly encouraged his independence. He worked with Duchamp on *Rotary Glass Plates (Precision Optics);* photographed the dust-covered *Large Glass (Dust Breeding);* made a movie together with Duchamp about the Baroness Elsa von Freytag-Loringhoven; founded the first American museum for modern art, the *Société Anonyme* (1920) together with Duchamp and Katherine Dreier; and edited with Duchamp the first and only American magazine to officially embrace Dada, *New York Dada* (April 1921).

These encounters, interactions, and collaborations between Picabia, Duchamp, and young American artists and writers are the unique and most significant aspect of New York Dada. Duchamp's and Picabia's rejection of the European modernism of the Armory Show encouraged young Americans to free themselves from European tradition. This process of reception, transformation, and appropriation of anti-art or a-art by Americans for their own experiments in uniting art, life, experience, and technology makes New

York Dada a very important period for the development of American art and literature.

But why was the Dada label for the activities in New York only introduced in 1921, and then only for the magazine *New York Dada* and the symposium on "What Is Dadaism?" organized by the Société Anonyme? The reason can certainly not lie in the lack of contact between New York and the Dada centers in Zurich and Paris. Marius de Zayas had already received ten copies of Tzara's *First Celestial Adventure of Mr. Fire Extinguisher,* which contains Tzara's first Dada manifesto, in late 1916. In return, de Zayas sent issues of his magazine *291* to Zurich. In 1917, Tzara invited the artists of the Arensberg circle to exhibit at the Galerie Corray in Zurich.[18] In the following years, Tzara sent all Dada publications from Zurich and Paris to New York. In 1919, just prior to Tzara's arrival there from Zurich, Duchamp spent several months with the members of the *Littérature* group in Paris. As central figure of the Arensberg circle, Duchamp could have easily propagated the Dada label in New York. But any kind of -isms and proclamations, especially Tzara's propaganda style, were totally alien to Duchamp. The Americans of the Arensberg circle were not very interested in the label "Dada," since it suggested to them yet again something European. If "Dada" had any attraction for them, it was taken as a call for freeing themselves of any movement, and not as a label for yet another movement. In his essay "The Importance of Being 'Dada,' " Marsden Hartley stated: "Dada-ism offers the first joyous dogma I have encountered which has been invented for the release and true freedom of art."[19] In 1921, Man Ray also considered Dada as a liberation from previous artistic styles and movements: "Dada is a state of mind. It consists largely of negations. It is the tail of every other movement — Cubism, Futurism, Simultanism. . . ."[20] In his last interview, he recalled that in New York "Pleasure and liberty were the words I used, as my goals."[21] Although Tzara wanted to include a "New York Dada" section in his anthology "Dadaglobe," Man Ray wrote to him on February 24, 1921: "There were one or two others who promised some contributions for the American Da Da section, but they have not given it to me."[22]

Owing to Duchamp's well-known indifference, and to the fiercely individualistic Americans' resistance to yet another European label, the "official" Dada movement in New York declared by Man Ray lasted only a few months in the spring of 1921 — until Duchamp and Man Ray, who considered himself "the author of Dada in New York,"[23] left for Paris in the summer of 1921. But the collaboration between Duchamp, Picabia, Crotti, and the Americans extended over a period of several years during and after the First World War, and its impact, according to Stuart Davis, was felt throughout the twenties.

After the departure of Man Ray and Duchamp, a second short-lived attempt was made to introduce Dada to America and to form a New York Dada movement. Its organizers were Matthew Josephson, Malcolm Cowley, and their friends, all expatriate writers and critics, who had participated in some of the Paris Dada scandals, and who knew the Paris Dadaists quite well. Louis Aragon was Josephson's "tutor" in French literature in 1921–22, and Cowley spent two months with Aragon in Giverny, where he was in-

troduced to Tzara, Breton, and their friends. Upon their return to America in 1923, these expatriates wanted to re-create Paris Dada events in New York. They planned to hire a theater and

give a literary entertainment, with violent and profane attacks on the most famous contemporary writers, court-martials of the more prominent critics . . . all this interspersed with card tricks, solos on the jew's harp, meaningless dialogues and whatever else would show our contempt for the audience and the sanctity of American letters.[24]

But most of their plans were not realized, because of dissension among the members and lack of money. Josephson and Gorham Munson, however, did settle their differences over the two magazines *Broom* and *Secession,* and their attitudes towards Dada, with a fistfight of epic proportions, according to Cowley's "lofty" description of the event.[25] This group's attempt to introduce Dada to America unleashed a fierce debate in literary circles in 1924 concerning the "appropriateness" of Dada for America. It is curious that these literary proponents of Dada in America showed very little awareness of the earlier Arensberg circle and its attempt to introduce Dada to New York.

While the activities of the Arensberg circle had remained relatively hidden from the larger American art world at that time, post-World War II New York "Neo-Dada" lifted this obscurity and discovered the earlier experiments for a broader public through its creative responses to New York Dada, and especially to Marcel Duchamp.[26] From the late sixties to the early eighties, a number of important critical studies on New York Dada appeared: William Agee's essay "New York Dada, 1910–1930," which was the first to concentrate on the Arensberg circle; Arturo Schwarz's studies of Duchamp (1969) and Man Ray (1977), and especially his exhibition catalog on New York Dada (1974), which includes his very important interview with Man Ray and his indispensable "Chronology" of New York Dada; the May 1977 issue of *Arts Magazine,* which published a series of informative essays on the Arensberg circle; Dickran Tashjian's *Skyscraper Primitives: Dada and the American Avant-Garde, 1910–1925* (1975); Abraham Davidson's *Early American Modernist Painting 1910–1935* (1981); and Francis Naumann's essays, especially his "The New York Dada Movement: Better Late than Never."[27]

The essays in the present collection provide important new contributions to the already existing studies of New York Dada and its relations with early twentieth-century American art and literature. Since excellent surveys and chronologies of New York Dada are readily available, the focus of these essays is on works of individual participants that have not been previously explored. Many of the documents and photographs in these essays are published here for the first time. Francis Naumann's study of Man Ray's very early work – work antedating Man Ray's meeting Duchamp in 1915 – is a major contribution to our understanding of Man Ray's immediate grasp of Dada. Man Ray's strong anarchist leanings, which were encouraged by his teachers at the Ferrer Center and by his fellow student and friend Adolf Wolff, prepared him better than any other young American artist of his

generation to fully accept the radical, unconventional, and anarchic works of Duchamp and Picabia. Judith Zilczer's essay on Robert Coady, New York art dealer, editor of the magazine *The Soil,* and very controversial figure of the American avant-garde, convincingly demonstrates that Coady's vision of a new, all-embracing American art informed his exhibitions at his gallery, as well as his choice of contributions for *The Soil.* In promoting a close relationship between art and life, he agreed with the Dada anti-art, a-art position. But he feared that blind imitation of Dada works by American artists would prevent the emergence of an authentic American art, and would again lead to empty academicism. Dickran Tashjian focuses his essay on Matthew Josephson, who, upon his return from Paris, wanted to create an American Dada partly patterned on Paris Dada but in addition using American jazz, movie techniques, American advertising, and American technology. Craig Adcock applies the concept of *n*-dimensional geometry to Duchamp's readymades, especially the Woolworth Building, and traces the new opportunities America offered to Duchamp for his cultural transformations. William Agee's discovery of Morton Schamberg's machine pastels, in 1982, allows him to convincingly identify the sources for Schamberg's machine images, which demonstrate appropriation and independent development of Duchamp's and Picabia's machine drawings. The precise identity of the sources is highly important, since it allows us to understand Schamberg's attitude toward the machine. Schamberg's faithful rendering of actual parts of machines is a celebration of the machines' architecture and motion; his machine images do not contain erotic, symbolic, ironic, or antitechnology aspects of Dada machinery. Roger Conover's and Robert Reiss's contributions introduce previously unpublished materials that provide completely new insights into the two most colorful participants of New York Dada, the Baroness Elsa von Freytag-Loringhoven and Arthur Cravan. The Baroness, described by her contemporaries as "the mother of Dada," was quite literally the embodiment of everything we associate with Dada. Her role and her activities have so far only been known through series of anecdotes mentioned in chronicles of the period. Robert Reiss's contribution is the first essay on this highly influential figure of the Arensberg circle. In drawing information from the Baroness's unpublished autobiography, Reiss draws a very full picture of this important New York Dadaist. In his presentation of Mina Loy's previously unpublished "Colossus," Roger Conover introduces us to an Arthur Cravan quite different from the figure who has so far primarily been known through his magazine *Maintenant,* his boxing match with heavyweight champion Jack Johnson, and his stripping instead of giving a lecture at the Independents Exhibition in New York in 1917. Mina Loy's account of Cravan, whom she married in early 1918, reveals Cravan's offstage existence. Willard Bohn's short contribution further adds to our understanding of this mysterious figure. Kenneth Burke's essay "Dada, Dead or Alive," first published in *Aesthete 1925,* is reprinted here for the first time. It forms part of the intense debate in magazines like *Secession, Broom,* and *1924* over the appropriateness of Dada (primarily Paris Dada) for a new American art and literature.[28] Kenneth Burke, together with Josephson, Cowley, Slater Brown, Hart Crane, and Allen Tate, advocated an American embracing of

Dada, whereas Waldo Frank was convinced that America was already Dada—i.e., chaotic, nonsensical, disordered. What was needed in America, according to Frank, was the establishment of order, of a unified American tradition. Burke's response to Frank, in "Dada, Dead or Alive," presents his conviction that America needs "Dada aggrandized."

The "Documents" section of the present collection contains reprints of several important texts that are very rare and difficult to locate. The first part consists of crucial newspaper articles on New York Dada that were printed in New York newspapers. The second part presents the first reprint of the magazine *TNT*, which Man Ray and his anarchist friend Adolf Wolff edited in 1919. Only one complete copy is known to exist in the United States.

I would like to thank Francis Naumann for his generous help and advice, Daniel Campion for superb editorial assistance, Judith Pendleton for her artistic eye, and June Fischer for her excellent typing.

Notes

1. Even the manifesto "Dada est américain," attributed to Walter Arensberg, and published in *Littérature*, 13 (May 1920), 15–16, was not written by Arensberg. See Francis Naumann, "The New York Dada Movement: Better Late than Never," *Arts Magazine*, 54, No. 6 (February 1980), 145.

2. William Agee, "New York Dada, 1910–1930," *Art News Annual*, 34 (1968), 105–13; Dickran Tashjian, *Skyscraper Primitives: Dada and the American Avant-Garde, 1910–1925* (Middletown, Conn.: Wesleyan University Press, 1975); Abraham Davidson, *Early American Modernist Painting 1910–1935* (New York: Harper & Row, 1981).

3. *The Blind Man*, 2 (May 1917), 6.

4. See Rudi Blesh, *Stuart Davis* (New York, 1960), p. 16; quoted in Davidson, *Early American Modernist Painting 1910–1935*, p. 101.

5. *Collection of the Société Anonyme, Museum of Modern Art, 1920* (New Haven: Yale University Art Gallery, 1950), p. 192.

6. "The Iconoclastic Opinions of M. Marcel Duchamp Concerning Art and America," *Current Opinion*, 59 (November 1915), 346.

7. Francis Picabia, "How New York Looks to Me," *New York American*, March 30, 1913, magazine section, p. 11; quoted by William Camfield, *Francis Picabia: His Art, Life, and Time* (Princeton: Princeton University Press, 1979), p. 48.

8. *Camera Work*, special no. (June 1913).

9. Letter from Stieglitz to Carles, April 11, 1913; quoted in Camfield, *Francis Picabia: His Art, Life and Time*, p. 56.

10. "French Artists Spur on an American Art," *New York Tribune*, Sunday, October 24, 1915, section 4, p. 2.

11. *291*, Nos. 5–6 (July–August 1915).

12. "A Complete Reversal of Art Opinions by Marcel Duchamp, Iconoclast," *Arts and Decoration*, 5 (September 1915), 427.

13. See Marcel Duchamp, *Salt Seller: The Writings of Marcel Duchamp*, ed. Michel Sanouillet and Elmer Peterson (New York: Oxford University Press, 1973), p. 75.

14. "French Artists Spur on an American Art," *New York Tribune,* Sunday, October 24, 1915, section 4, p. 2.

15. Henri-Pierre Roché, "Souvenirs of Marcel Duchamp," in Robert Lebel, *Marcel Duchamp* (London: Trianon Press, 1959), p. 80.

16. Arturo Schwarz, *New York Dada: Duchamp, Man Ray, Picabia* (Munich: Prestel-Verlag, 1974), p. 88.

17. Ibid.

18. See Michel Sanouillet, *Dada à Paris* (Paris: Jean-Jacques Pauvert, 1965), pp. 569 and 572.

19. "The Importance of Being 'Dada,' " in his *Adventures in the Arts* (New York: Boni and Liveright, 1921), p. 254. Marsden Hartley gave this essay as a lecture entitled "What Is Dadaism?" at the Dada Symposium organized by the Société Anonyme in spring, 1921.

20. Margery Rex, " 'Dada' Will Get You if You Don't Watch Out; It Is on the Way Here," *The New York Evening Journal,* January 29, 1921.

21. Arturo Schwarz, *New York Dada: Duchamp, Man Ray, Picabia* (Munich: Prestel-Verlag, 1974), p. 92.

22. Quoted in Francis Naumann, "The New York Dada Movement: Better Late than Never," *Arts Magazine,* 54, No. 6 (February 1980), 145.

23. Man Ray, *Self-Portrait* (Boston: Little, Brown, 1963), p. 389.

24. Malcolm Cowley, *Exile's Return* (New York: Viking, 1956), pp. 179–80.

25. Ibid., pp. 184–85.

26. See John Tancock, "The Influence of Marcel Duchamp," in *Marcel Duchamp,* ed. d'Harnoncourt and McShine (New York: Museum of Modern Art, 1973), pp. 159–78.

27. For complete citation of these works, please consult "Bibliography on New York Dada."

28. See Dickran Tashjian's chapter *"Broom* and *Secession,"* in his *Skyscraper Primitives: Dada and the American Avant-Garde, 1910–1925,* pp. 116–42.

Man Ray and the Ferrer Center: Art and Anarchy in the Pre-Dada Period

Francis M. Naumann

In most historical evaluations of the Dada period in New York, it is assumed that relative to Dada in Europe and its reception there during the First World War, the New York Dada movement had less significance and held very little interest for most Americans, who did not directly experience the ravages of war on their own soil. If nothing else, these historians usually contend, the Dada movement in New York was motivated more by a desire to establish an aesthetic alliance with Europe's vanguard artists than to identify with their anarchistic leanings, intensified by the horrors of a war which literally surrounded them. Neither anarchism nor the outbreak of the war in Europe, however, can be dismissed as influential factors in determining the ideological framework upon which were built the most advanced manifestations of the arts in New York during the second decade of this century. Indeed, the early works of Man Ray—generally considered to be America's only full-fledged Dadaist—were profoundly shaped by these very factors. His brief though intimate association with an anarchist group in New York, and his deeply sympathetic regard for the suffering in Europe, placed Man Ray in a position which closely paralleled that of many European artists in the pre-Dada period.

One of the most important influences in the development of Man Ray's early work was his association with members of the Ferrer Center, a liberal school of child and adult education located on East 107th Street in New York's Spanish Harlem.[1] The Ferrer Center was organized and run by a number of free-spirited individuals who came from highly diverse cultural and professional backgrounds, men and women whose pedagogical talents were allied by a common commitment to the ideological tenets of anarchism. Just as the members of this organization sought to abolish the oppression of political authority, as teachers at the Ferrer Center they attempted to create an atmosphere of complete freedom for the students, providing an alternative to the structured and often inhibiting approach imposed by the more traditionally disciplined classroom.

Author's note: This study is dedicated to Arturo Schwarz, whose commitment to anarchism and to Dada parallels the subject of this article.

Shortly after it was established in 1911, the Ferrer Center, or Modern School as it was also called, became known as the gathering place for a number of New York's most celebrated cultural and political radicals—Leonard Abbott, Alexander Berkman, Will Durant, Emma Goldman, Margaret Sanger, Upton Sinclair, Lincoln Steffens, and a host of others—each of whom either lectured or offered courses at the school. The art classes were an especially important part of the curriculum, for here, rather than follow the slow and methodical approach stipulated through academic training, students were strongly encouraged to explore the impetus provided by their own fertile imaginations. This open and unrestricted atmosphere was promoted by Man Ray's teachers—Robert Henri and George Bellows—and enthusiastically shared by his fellow students—Ben Benn, Samuel Halpert, Abraham Walkowitz, Max Weber, Adolf Wolff, and William Zorach—all of whom would become better known for their artistic accomplishments in the years to come.

Upon his first visit to the life drawing class at the Ferrer Center, Man Ray was particularly impressed by the sketching technique taught to the students, for they were instructed to rapidly execute their drawings and color sketches from the model within the time period of a twenty-minute pose, an approach that differed sharply from the slower, more studied method he had been familiar with from the various academic institutions he had previously attended. Robert Henri, his most memorable teacher at the center, instructed Man Ray to freely assert his individuality, even at the risk of being misunderstood. Years later, Man Ray recalled that Henri's ideas were even more stimulating than his artistic criticism: "he [Henri] was against what most people were for, and for what most were against."[2]

While Henri's rebellious and pioneering position in the history of American painting has been well established, until recently his more radical, anarchist sympathies have been either overlooked or suppressed by historians and biographers.[3] His interest in social reform dates from his family's support for the Democratic Party, but his humanitarian concerns were more definitively aroused as a result of the government's poor treatment of the American Indian and by the injustices of the Homestead Steel strike in 1892.[4] As the leader of the Eight, he encouraged his fellow painters to seek inspiration in the dynamism of the city, whose ethnic groups and lower-class inhabitants succinctly embodied the vitality of life in its most dignified and uncorrupted state. But even more than his socialist inclinations, it was the dynamic preaching of Emma Goldman that drew Henri to the Ferrer Center in 1911 and converted him to the cause of anarchism, a philosophical doctrine that he embraced and supported until his death in 1929.

Henri taught without pay at the Ferrer Center for nearly seven years, and also managed to enlist the talents of his friend and former pupil George Bellows, whose anarchist leanings were quickly replaced by patriotic instincts when America entered the war in 1917 (at which time Bellows quit teaching and joined the military).[5] Together, Emma Goldman later noted, "they [Henri and Bellows] helped to create a spirit of freedom in the art class which probably did not exist anywhere else in New York at that time."[6]

This "spirit of freedom" is clearly reflected in the sketches Man Ray produced in the life drawing classes at the Ferrer Center. Independent of medium—whether charcoal, ink wash, or a densely applied watercolor pigment—his results were always consistent: the model is given visual definition by means of a rapid, though confident and fluid, application of line or color.[7] Because the drawings in this course had to be completed within a twenty-minute time limit, there was little opportunity for the students to render precise details in the fashion customarily demanded by more academic approaches. Consequently, with few exceptions, Man Ray's figure studies from this period are characterized by a lack of definition in the extremity of their appendages (fingers and toes), though—as in the example of a skillfully rendered, slightly foreshortened figure of a reclining nude (Fig. 1)—these details were sometimes worked out in the surrounding space on the drawing page.

Most of the sketches of nudes that survive from this period record the same buxom young female model—probably fourteen-year-old Ida Kaufman—who at age fifteen married the school's director, Will Durant, and later, as coauthor of many books with her husband, became well known under the name Ariel. "Her figure, quite stocky, with firm, fully developed breasts," Man Ray recalled some fifty years later, "resembled one of Renoir's nudes."[8] While his subjects may very well recall the works of this well-known Impressionist painter, the technique Man Ray adopted for the application of paint was far more dependent upon the bravura brushstroke and intense palette of Fauvism. The artist frequently accentuated these figure studies with open washes of bright, near luminous choices of pigment, where flesh tones can range from pale rose to fiery orange. In some cases it

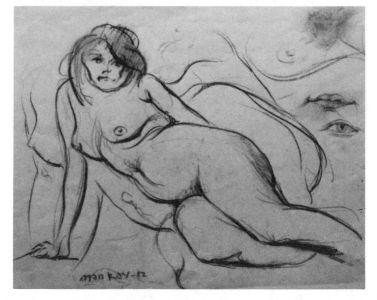

Figure 1. *Untitled.* Ca. 1912. Charcoal on paper. 43 x 35.5 cm. Estate of the Artist, Paris.

almost appears as if Man Ray has consciously reacted against the adverse criticism he had once received as a child for his arbitrary application of color, for most of these figure studies are highlighted with an assortment of bright, sometimes unmixed hues, seemingly selected from his palette in a random fashion and applied in quick, expressionistic gestures of pure color.

Occasionally, Man Ray would direct his attention away from the model to subjects in his immediate environment. The resulting works—usually rendered with brush and India ink and probably intended as illustrations for one of the school's publications—provide a sampling of the activities that took place in the life drawing classes at the Ferrer Center. One drawing documents the great variety of individuals who took advantage of classes at the Modern School (Fig. 2): a middle-aged woman, an elderly man, and a young boy are each shown diligently at work on their drawings. Another sketch shows two older men reviewing drawings as their students attentively look on (Fig. 3). The mustachioed gentleman in the foreground was probably meant to represent Robert Henri, while the bearded man to his right may have been based on the features of Adolf Wolff, a sculptor and friend of Man Ray's whose most distinguishing feature was a sharply trimmed beard.[9] The scene was probably meant to record one of Henri's

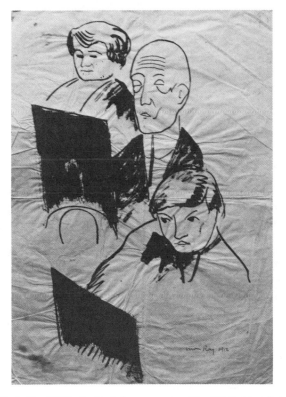

Figure 2. *Untitled.* Ca. 1912. India ink on paper. 40 x 28.5 cm. Estate of the Artist, Paris.

13

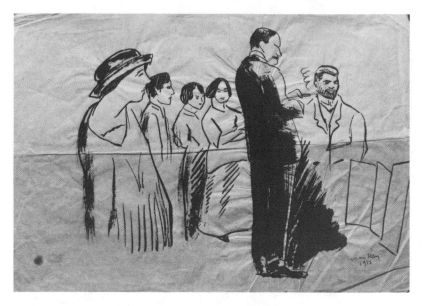

Figure 3. *Untitled.* Ca. 1912. India ink on paper. 40 x 28.5 cm. Estate of the Artist, Paris.

well-known "quiet" critiques. "Passing around from drawing to drawing," as Man Ray described these sessions years later, "he [Henri] made gentle, encouraging remarks, but never touched the drawings nor criticized adversely."[10]

The year 1912 marked a period of intense activity for Man Ray at the Ferrer Center: by the winter months this young, twenty-two-year-old student from Brooklyn was ready to participate in the first group exhibition organized by the artists associated with the Modern School, which was held at the Ferrer Center from December 28, 1912, through January 13, 1913.

It is difficult to establish with precision the works by Man Ray that were shown in this exhibition, although a painting entitled *A Study in Nudes* (Fig. 4), signed and dated 1912, was reproduced in a review of the show that appeared in *The Modern School,* the magazine published by the Ferrer Association.[11] Despite the poor quality of this black-and-white illustration, it can be seen that the harsh delineation usually associated with more academic modeling has been entirely replaced by a softer, more color-oriented approach to the definition of form. Moreover, the seven female nudes – in addition to a small baby clutching the thigh of a kneeling figure on the right – are somewhat reminiscent of the postures and compositional arrangement given to several paintings in the bather series of Cézanne, the Postimpressionist painter whose works were just then becoming associated with the most advanced developments of modern painting on both sides of the Atlantic.[12] That the works Man Ray showed in this exhibition did not conform to a unified stylistic approach, however, is confirmed by the comments published by his friend and fellow exhibitor Adolf Wolff: "Man Ray is

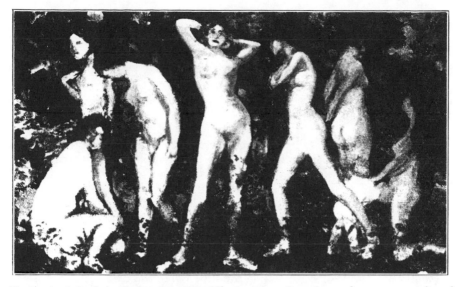

Figure 4. *A Study in Nudes.* Ca. 1912. Oil on canvas. Location unknown; reproduced in *The Modern School,* Spring 1913.

a youthful alchemist forever in quest of the painter's philosopher's stone. May he never find it, as that would bring an end to his experimentations which are the very condition of living art expression."[13]

Man Ray's stylistic oscillations in this period were aptly matched by the diversity of subjects incorporated in his work, evidenced in part by the range and variety of titles given to the paintings and drawings he showed in the next group exhibition at the Ferrer Center—held only four months after the first—from April 23 to May 7, 1913. This second showing appears to have been a more ambitious undertaking, for over sixty-five works were exhibited and virtually every art student associated with the school participated, including the children, whose works were exhibited alongside those of the adults. The show was even accompanied by a small catalog, containing a brief introduction by Max Weber and a simple handlist of the titles provided for each work.[14]

It is difficult to securely identify with known works any of the paintings, drawings, or watercolors shown by Man Ray in this exhibition. Their titles, however, indicate that the subjects were not always derived from tangible elements in the artist's immediate environment nor faithfully recorded in a traditional, representational method. Indeed, certain titles suggest that at this time Man Ray was becoming more and more aware of the potential inherent in a less figuratively dependent approach for the generation of images. Along with works simply entitled *Nude, Portrait, Bridge, New York,* and *The Copper Pot,* for example, he showed works with such diverse titles as *Amour, Fantasy, Decoration,* and *Tchaikowsky* (the latter of which was most likely an abstract or "abstracted" composition, meant, I suspect, to represent the music of the composer, rather than a portrait likeness of the composer himself).[15]

15

Even before his introduction to the Ferrer Center, Man Ray recalled, he engaged in many long conversations with an unnamed, aspiring young musician-friend, who argued that music was superior to painting because it was "more mathematical, more logical and abstract." Man Ray remembered assenting to this notion, but he claimed that at the time he did not know quite how this principle could be applied to his work, though he acknowledged that it was the germinating factor that later led to his involvement with abstraction. "I agreed," he remarked, "but intended later to paint abstractedly [sic]."[16]

At the Ferrer Center, Man Ray could hardly have avoided continuing conversations along these lines, for the interrelationship of music and art was a favored topic of his friend Manuel Komroff, who was both an artist and musician. Komroff not only participated in most of the exhibitions held at the center, but on Monday evenings he also held piano recitals at the school, playing "selections from the great masters."[17] Komroff was the only artist to be represented by more works than Man Ray in the 1913 exhibition at the Ferrer Center, and most of the titles he gave to his paintings and watercolors invoked an analogy to music: *Etude in F Minor, Study in C Sharp Minor, Study in the Key of C,* and so on. In fact, at the time when the exhibition was being held at the center, Komroff published an article in the school's magazine entitled "Art Transfusion," by which he meant that sculpture, painting, and literature were becoming more and more like music, while at the same time, modern music was increasingly sharing qualities with the visual arts. "As each art is striving to include all the others," he observed, "they are all becoming one." He further postulated that "Nature and art have very little in common," concluding that "true art . . . is as far removed from earth as space itself."[18]

The potential inherent in abstraction was further expounded upon in the introductory essay to the catalog, which, it has been noted, was written by Max Weber, one of the older, more established artists who began frequenting the center in 1912, and an artist who was to have a pronounced influence on Man Ray's earliest experiments with Modern Art. Although a more thorough discussion of Weber's stylistic influence on Man Ray will be reserved for a future study, it should be noted that by the time of this exhibition at the Ferrer Center, Weber's familiarity and understanding of the Cubist and Futurist movements in Europe was considerably in advance of his contemporaries, and he had already begun to experiment with the principles of abstraction in his own work. In his introduction to the catalog, Weber indicates that he and his fellow painters were on the threshold of a new artistic reality. "Surely there will be new numbers, new weights, new colors, new forms, new odors, new sounds, new echoes, new rhythm of energy, new and bigger range of our sense capacities," he wrote; "we shall paint with the mind eye, the thought eye . . . we shall not be bound to visible objects. . . . We shall put together that which in a material sense is quite impossible."[19] Weber later recalled that he also urged his fellow students "to take time off from the life-class," and, like Henri, he suggested that if they wished to capture the energy and heroism of modern times, they should "go out among the people who toil in the mills and shops, go to scenes of bridge construction, foundries, excavation."[20]

16

On at least one occasion, Man Ray appears to have taken Weber's advice literally. In a lost painting from 1912 entitled *Bridgebuilders* (Fig. 5), the artist has faithfully recorded a group of workmen in the process of hoisting a large cylindrical drum during the construction of a bridge. If we can judge solely by the titles of works shown in this exhibition, Man Ray may have relied on themes drawn from city life in a number of other paintings and drawings from this period. Although the work that was entitled *New York*, for example, cannot be securely identified with an extant painting by the artist, a semblance of its spirit and perhaps even its style might be garnered from two works whose subjects were meant to encompass the overcrowded vitality of the city and its complex transportation network: *Skyline* (Fig. 6), a small pen and ink sketch of 1912, and *Metropolis* (Fig. 7), a more highly finished watercolor dating from early 1913.[21]

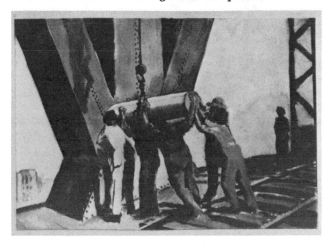

Figure 5.
Bridgebuilders. 1912.
Oil on canvas(?).
24 x 28 in. Location unknown.

In *Skyline* the city's many bridges are shown as if uprooted from their moorings and impacted into the cityscape itself, serving to join the low-lying houses near the piers in the foreground of the image with the towering skyscrapers defining the city's skyline at the upper summit of the drawing. In a similar fashion, *Metropolis* records a somewhat detached, distant view of the overcrowded city — perhaps the logical viewpoint of the Brooklynite who commuted to Manhattan every day. Indeed, the basic theme of this drawing appears to emphasize the city's various methods of transportation; nestled against the skyline in the lower left portion of the composition is an oval-shaped ferryboat, which appears to be making its way upriver in the presence of two large steamships docked between piers in the harbor. Issuing forth from a large, low-lying brick building in the right corner — probably meant to represent the central train station — are a series of commuter lines disappearing into the center of the composition, while a sole trolly car makes its way over a viaduct in the center ground on the right side of the drawing. The most prominent element of this composition takes the form of a large woman's head looming above the entire ensemble in the upper left-hand corner of the work. The sharply juxtaposed scale and detached positioning of

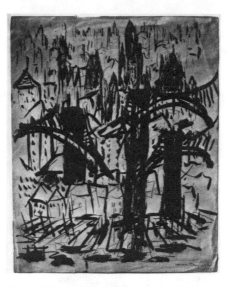

Figure 6. *Skyline*. 1912. Pen and ink on paper. 10 x 8 in. Location unknown; photograph courtesy Naomi Savage.

this head – along with its cold, expressionless features – suggest the possibility of a symbolic interpretation for this element; Man Ray may have intended this head to represent some kind of mythic goddess of metropolitan life. Finally, the most prophetic element of this intriguing watercolor comes in the form of seven abstract planes of color, rendered as two-dimensional strips winding their way through the center of the composition. The first plane begins as a single blue rectangle issuing forth from the depths of the river in the central foreground, while the last two planes are rendered as olive-green shapes merging with cloudlike formations in the sky above.

Man Ray's assimilation of modernism in this period was so pervasive and inspiring that it did not prevent him from occasionally incorporating two distinct styles in a single work of art. An untitled ink drawing (or woodcut?) reproduced in *The Modern School* magazine in the fall of 1913 (Fig. 8) appears to have drawn its inspiration from a number of sources. A crouching, distorted, and anonymous figure is shown bending into the confines of an overcrowded rectangular space, much in the manner of Weber's large-scale nudes or in certain examples of French Cubist painting. But the background landscape is here replaced by sharply rendered architectonic forms, which, together with the work's basic graphic qualities, recall Man Ray's earlier ink drawing *Skyline* (Fig. 6). Certain passages in this work, however, reveal a more direct reliance on specific details in *Metropolis* (Fig. 7), the watercolor based on the theme of New York's bewildering transportation network. The ferry boat and commuter lines, for example, have become more abstracted and are placed in reversed positions in the illustration, while the triple-stacked steamers, which were earlier shown docked at the piers, are now represented by a series of sharp, otherwise unintelligible lines. Finally, the entire image is unified by the presence of a heavy black crescent-shaped

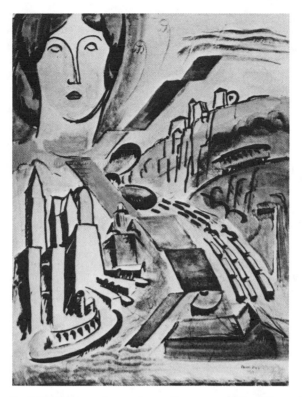

Figure 7. *Metropolis.* 1913. Watercolor and pencil on paper. 51 x 46 cm. Galerie Alphonse Chave, Vance.

line, zigzagging in the shape of an S-curve through the center of the composition, assuming a position parallel to that of the rectangular planes interwoven through the center of *Metropolis.*

The possible significance of these abstract shapes is made clearer in the enlargement and elongation of this image in a work entitled *Tapestry Painting* (not illustrated), a large nine-foot-high, oil-on-canvas picture, which, if we can judge by the title, was meant to be displayed in the fashion of a wall hanging.[22] In this second version of the image, it becomes clear that the large figure in the center of both compositions was meant to be shown playing a guitar, the upper neck of which is represented by one of many dark crescent shapes. The repetition of these shapes throughout the image may have been intended to symbolize the sound emanating from this musical instrument, a detail that unites the theme of this picture with other musical analogies, which, as we have seen earlier, preoccupied Man Ray and his friends during these years at the Ferrer Center—one among many concerns that would eventually lead Man Ray to explore the potential inherent in more abstract imagery.

On May 3, 1913, Man Ray addressed a letter to the editor of the *New York Globe,* reproaching the newspaper's art critic, Arthur Hoeber, for publishing

Figure 8. *Untitled.* Ca. 1913. Pen and ink (woodcut?). Location unknown; reproduced in *The Modern School,* Autumn 1913.

an insufficiently prepared review of this exhibition. Among his objections, Man Ray accuses Hoeber of never having actually seen the exhibition, further asserting that the critic's entire review was based only on his reading of the catalog introduction, which was written by Max Weber and which Man Ray felt was not intended to express the full variety and diversity of ideas that were represented in the exhibition. "Mr. Hoeber's notice proves," he amusingly concluded, "that even a critic can become creative if only he neglect natural representation."[23]

In the stimulating environment of the Ferrer Center, Man Ray was exposed to the most progressive and revolutionary ideologies of his day; even

more than the artistic instruction of his teachers, these ideas would serve to nurture the revolutionary attitude already assumed by this rebellious young painter. But the artist who would have the most profound effect on the formation of Man Ray's political ideologies, as well as decided impact on his personal life, was the Belgian-born anarchist Adolf Wolff (1883–1944), self-proclaimed "poet, sculptor and revolutionist," and, as he himself emphasized, ". . . mostly revolutionist."[24]

Man Ray met Wolff (or "Lupov," as he is barely disguised in Man Ray's autobiography) at the Ferrer Center. Like Man Ray, after only a few months of exposure to the workings of the school, Wolff became one of its most active participants. In the evenings he gave a course in French for adults, while on Thursday afternoons he taught art to the children. Learning that Man Ray was unhappy living at home, Wolff offered his young friend a place in which to work, in a small studio he rented on Thirty-fifth Street. Man Ray, however, did not find the space very comfortable, as Wolff left the floor wet and dirty from his work, and the studio was filled with his sculptures, drawings, and oil paintings. One morning, moreover, Man Ray entered the small studio only to discover the older artist and a young woman lying together on the studio couch. Wolff laughingly explained that the woman was a model, and they were only trying out a new pose for a sculpture. Man Ray later learned that Wolff had been recently divorced from a young Belgian named Adon Lacroix, with whom he shared a child and still maintained a close friendship. Unbeknownst to Man Ray at this time, Wolff's ex-wife was to have a decisive effect on his immediate future. Shortly after this incident occurred, Wolff introduced Man Ray to Lacroix, an encounter that was to be of some consequence for the young couple, for they immediately fell in love and married within a year.

During the mid to late teens Wolff participated in a number of anarchist demonstrations, several of which resulted in his arrest and imprisonment. This dedication to anarchism was succinctly incorporated in his poems and sculpture of this period. Like his personality, Wolff's poetry was characterized by a crude, unrefined power that reflected his militant temperament, while his sculpture clearly paralleled the most advanced sculptural expressions of the day. The more figuratively dependent works of ca. 1913–14 are characterized by a basic reduction and simplification of form,[25] doubtlessly inspired by Cubist painting and sculpture, examples of which Wolff would have known from the Armory Show or from exhibitions of progressive European and American art in the New York galleries. We know he frequented these exhibitions during the 1913–14 gallery season, for at that time he served for a brief period as an art reviewer for the socialist magazine *The International*. To this monthly publication he contributed a series of articles entitled "Insurgent Art Notes," presenting his somewhat unorthodox and prosaic reviews of current exhibitions, from a small show at the Ferrer Center (quoted earlier) to important larger exhibitions of modern art at the well-known galleries.

In the same period when Wolff was writing for *The International*, Man Ray provided the cover illustration for at least three numbers of this socialist review, with a design that is repeated (with a different-colored background) on

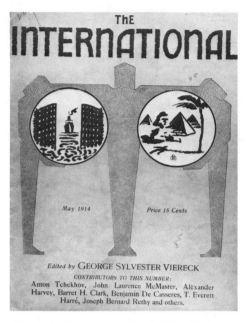

Figure 9. *The International,* May 1914.

the March, April, and May, 1914, issues of the magazine (Fig. 9).[26] Within the circular frames defined by the outstretched and supporting arms of three anonymous, symmetrical, and architecturally suggestive figures (somewhat reminiscent of Wolff's Cubist-inspired sculpture), Man Ray has supplied two ink drawings, one of an ocean steamer about to pass through the opening doors of a lift lock, and the second of pyramids and a sphinx in the shadow of a sun-drenched palm. These two seemingly unrelated views may in fact have been a subject of some political importance in 1914, for it was in that year that the Panama Canal was informally opened, the most important man-made waterway in the Western Hemisphere to open since the Suez Canal in 1869; together, these two canals created a single round-the-world sea passage, regarded strategically as an especially important transportational route during the war.[27]

While these covers for *The International* may provide some indication of Man Ray's support for socialist issues, his only other known contribution to leftist politics came in the form of two political cartoons he designed for the covers of *Mother Earth,* the radical periodical edited by Emma Goldman and Alexander Berkman, whose offices were just a few blocks away from the Ferrer School.[28] The first of these covers (Fig. 10) shows a giant two-headed dragon tugging at opposite ends of a figure labeled "HUMANITY," while the separate heads of the monstrous beast are identified by the labels "CAPITAL-ISM" and "GOVERNMENT." The illustration makes it clear that Man Ray considered the individual powerless against the larger ideological forces that ultimately control humanity's destiny. It should be noted that this drawing appeared on the cover of the August 1914 issue of the magazine, precisely the month when it became clear that the European war would reach world-wide

22

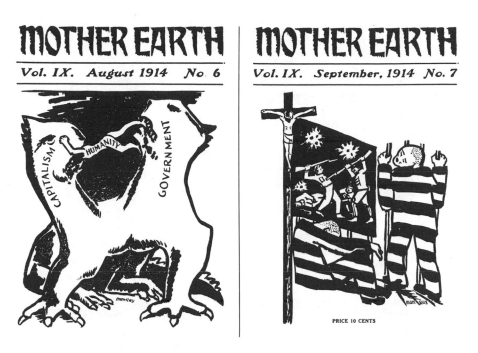

MOTHER EARTH | MOTHER EARTH

Vol. IX. August 1914 No. 6 | Vol. IX. September, 1914 No. 7

PRICE 10 CENTS

Figure 10. *Mother Earth*, August 1914. Figure 11. *Mother Earth*, September 1914.

proportions. This issue also carried on its title page a poem by Adolf Wolff entitled simply "War," where, in a strongly anarchist tone, law and order are denounced as the very causes of death and destruction.[29] The next issue of *Mother Earth* carried Man Ray's drawing of two prisoners in striped garb (Fig. 11), positioned in such a fashion that their uniforms complete the stripes of an American flag, the staff of which is a crucifix and whose stars are composed of mortar blasts in a violent battle scene. More than the obvious reference to the plight of political prisoners evoked by this image, it is the visual pun incorporated in its design that lends the drawing such strength.

Man Ray's heightened political awareness in this period coincided with a thoughtful reexamination of painting's more formalistic qualities – both from an historical and modern perspective – resulting in a radical departure from his earlier work. Having already experimented successfully with the fragmented, intersecting planes of Analytic Cubism (such as in his *Portrait of Alfred Stieglitz*, 1913 [Yale University Art Gallery]), Man Ray decided that "for the sake of a new reality," in both approach and technique, the modern artist should make every effort to acknowledge the inherent two-dimensional quality of the canvas surface.[30] To this end, he was led to investigate the various solutions offered to this problem by the art of the past, looking for inspiration to Byzantine and Early Renaissance sources. These historical precedents, combined with his pacifist reaction toward the outbreak of war in Europe, were doubtlessly the most significant factors to influence the selection of technique and subject in Man Ray's most important politically

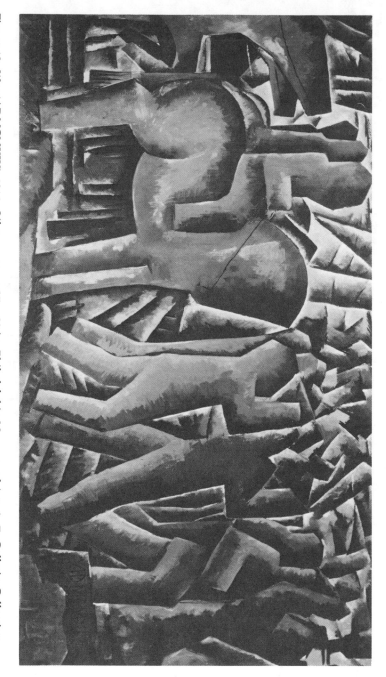

Figure 12. *War (ADMCMXIV)*, 1914. Oil on canvas. 37 x 69 in. Philadelphia Museum of Art; A. E. Gallatin Collection.

inspired pictures of this period: *War (ADMCMXIV)* (Fig. 12) and *Madonna* (Fig. 13).

Measuring just under six feet in width, *War (ADMCMXIV)* remains Man Ray's most monumental Cubist composition. According to his recollections, the unusual size of this canvas was determined by a space he had to fill in his living room, and its inordinate scale and positioning reminded him of the kind of problems that must have confronted the wall painters of the Renaissance. In emulation of these earlier masters, he prepared the canvas with a base of fish glue and plaster dissolved in water, to provide a matte and chalky surface reminiscent of the intonaco used in fresco.[31] The subject, he then claims, was inspired by a reproduction of Uccello's famous battle scenes. But rather than allow the recessional effect created by a strict application of the rules governing Renaissance perspective systems – of which Uccello was a well-known master – Man Ray rendered the figures and background shapes in his composition as if they were reflections of one another. The blunt, angular, and unarticulated forms of horses and soldiers are echoed into their surrounding environment, creating a uniform surface tension that serves to reassert the painting's inherent physicality. Modeled almost entirely with a palette knife, the figures are rendered as overbearing, cylindrical forms – their severe geometry and lack of articulation recalling the sculptures of Adolf Wolff – while their positions and frozen postures seem to imply the frustration and inevitability of their struggle. Locked into never-ending combat with their oppressors, these soldiers are rendered as mere automatons, mindlessly engaged in their struggle, obeying without question the futile orders of their commanders.

According to Man Ray, the title given to this painting – *War* – was suggested by his wife, Adon Lacroix, who was especially affected by the European conflict, for her parents were still living in the country of her birth – Belgium – which, despite its position of neutrality, was ruthlessly invaded by German troops in August of 1914. To the lower right corner of his painting, Man Ray then dated the picture by adding the Roman numerals "ADMCMXIV," employing stencil-styled letters that were later overpainted and replaced by a more calligraphic inscription. While Lacroix may have suggested the title *War*, the prominent dating of this picture may have been inspired by Frank Stephens' "A.D. 1914," a poignant antiwar poem that was published in the October 1914 issue of *Mother Earth*.[32]

Arranged symbolically in a cruciform format, an even more prominent display of Roman numerals declares the year of Man Ray's quiet though powerful *Madonna* (Fig. 13), a painting whose subject and flat, unarticulated forms evoke the religious icons of the Byzantine period. The artist later subtitled this picture "In Mourning – War I,"[33] but the relationship of this image to the war in Europe can only be understood when we examine a preparatory study for the picture (Fig. 14). Here, it is revealed that the tapering black shape used to desribe the Madonna's arm in the finished painting was actually derived from the neck of a large black cannon, while the halos given to the figures are taken from billowing, cloudlike formations issuing from the cannon's smoldering mouth. "Perhaps the idea was to express my desire for peace as against war," the artist later remarked; "there were no religious intentions."[34]

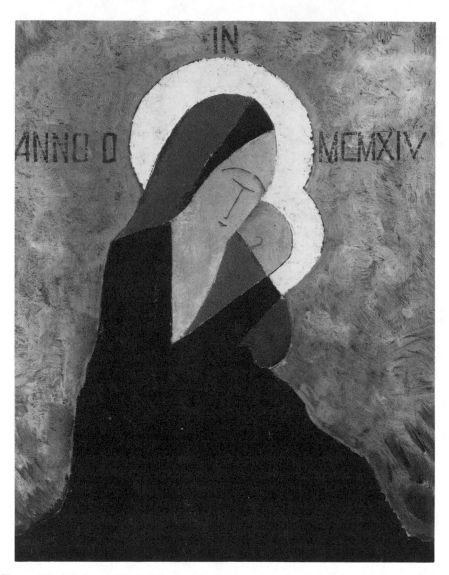

Figure 13. *Madonna*. 1914. Oil on canvas. 20⅛ x 16⅛ in. Columbus Museum of Fine Arts; gift of Ferdinand Howald.

In the ensuing years, Man Ray's inclination toward anarchist politics would find more casual expression in two ephemeral publications, both of which he edited and privately printed, *The Ridgefield Gazook* in 1915, and *TNT* in 1919. The first of these publications consisted of a single hand-printed sheet folded to form four pages. Reproduced on the cover of the first and only issue of this magazine to appear was a drawing by Man Ray of two insects engaged in the act of mating, captioned "The Cosmic Urge – with ape-

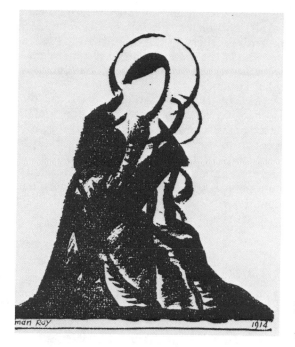

Figure 14. *Study for Madonna.*
1914. Charcoal (?). Location
unknown.

ologies to PIcASSo." The remaining contents were devoted primarily to parodies of his friends Adolf Wolff ["Adolf Lupo"], Adon Lacroix ["Adon La⁺"], Hippolyte Havel ["Hipp O'Havel"] and Manuel Komroff ["Kumoff"]. But, other than for a passing reference to the Czech anarchist Joseph Kucera ["MacKucera"], the only portion of this publication referring specifically to anarchist activities is found in a poem entitled "THREE BOMBS," illustrated by Man Ray and allegedly written by Wolff. The poem consists of nothing more than a series of blank lines, two exclamation marks, and a sequence of seemingly arbitrarily distributed letters, all of which is enveloped by the smoke of three sizzling explosives placed in a dish, flanked by accompanying knife and fork, located below the poem. While the literary contribution of this poem is problematic, the three bombs are undoubtedly a reference to the three young anarchists from the Ferrer School who were killed in July of 1914 when a bomb they were preparing accidentally blew up.[35] Wolff knew the three young men, and immediately after their deaths he dedicated a poem to their memory; but he was best known in anarchist circles for his design of a bronze urn that was used to contain their ashes.

Man Ray and Wolff remained friends throughout the teens and saw one another nearly every week, beginning from the time when Man Ray and Adon Lacroix (Wolff's ex-wife) began sharing quarters in 1913. Every Saturday afternoon Wolff would bring over his daughter Esther to visit her mother, and on these occasions the two artists would frequently discuss ideas and exchange casual comments about their work. The last evidence of their collaboration dates from 1919, when in March of that year an untitled abstract bronze sculpture by Wolff appeared as the cover illustration for

Man Ray's *TNT*, the single-issue publication Man Ray later described as "a political paper with a very radical slant," which he also claimed was "a tirade against industrialists, the exploiters of workers."[36] But other than the magazine's explosive title—which ran across the cover in large black letters—there was little in the publication that could be even remotely construed as a reference to anything politically subversive.

Although exceptionally few works by Man Ray—outside of those discussed in the present context—can be said to have been specifically motivated by anarchist leanings or pacifist sentiments, there can be little doubt that the artist's early exposure to these libertarian ideals served to prepare him for the acceptance of Dada's more radical, nihilistic, and unconventional qualities. In his interviews and various published statements, throughout his life Man Ray would frequently acknowledge the importance of his training at the Ferrer Center, an experience that would form the background and framework for his most successful Dada productions.

Notes

1. On the Ferrer School, see Paul Avrich, *The Modern School Movement: Anarchism and Education in the United States* (Princeton: Princeton University Press, 1980) and Ann Uhry Abrams, "The Ferrer Center: New York's Unique Meeting of Anarchism and the Arts," *New York History*, 59, No. 3 (July 1978), 306–25.

2. Man Ray, *Self Portrait* (New York and London: Andre Deutsch, 1963), p. 23.

3. Noteworthy exceptions are William Innes Homer, *Robert Henri and His Circle* (Ithaca: Cornell University Press, 1969), pp. 179–82, and Avrich, *Modern School*, pp. 145–53.

4. The Homestead Steel strike was one of the most bitterly fought labor disputes in U.S. history. In June of 1892, workers belonging to the Amalgamated Association of Iron and Steel Workers struck the Carnegie Steel Company at Homestead, Pennsylvania, to protest a proposed wage cut. Later renowned in the art community for his extensive collection of old master paintings, as general manager of the steel company, Henry C. Frick ordered three hundred Pinkerton detectives to protect the plant and the strike breakers, a policy that resulted in an armed battle between the workers and the detectives. Deeply disturbed by such a crushing victory over labor, on July 23, 1892, the Russian-born anarchist Alexander Berkman made an unsuccessful attempt to assassinate Frick. After serving fourteen years of a twenty-two-year sentence, Berkman was released and returned to New York, where he resumed his association with Emma Goldman and became involved in the activities of the Modern School. Fifteen years after the Homestead incident occurred, Henri would serve on a committee to prevent Berkman's extradition on charges of complicity in a bombing case (see Avrich, *Modern School*, p. 147).

5. On Bellows' association with anarchists and anarchism, see Charles H. Morgan, *George Bellows, Painter of America* (New York: Reynal & Company, 1965), pp. 153–54, and Avrich, *Modern School*, p. 149. In 1917, Bellows so sympathized with the American war effort that he volunteered for service in the Tank Corps and devoted his artistic efforts to illustrating the atrocities of the European conflict (see the exhibit catalog *George Bellows and the War Series of 1918* [New York: Hirschl & Adler Galleries, March 19–April 16, 1983]).

6. Emma Goldman, *Living My Life* (New York: Alfred A. Knopf, 1931), pp. 528–29 (quoted in Avrich, *Modern School*, p. 149).

7. Seven figure studies from this period are illustrated in *Man Ray: 60 Years of Liberties*, ed. Arturo Schwarz (Paris: Eric Losfeld, 1971), pp. 9, 12, and 63. Many figure studies of this type have appeared in auction (see, for example, the catalog for Sotheby's, London, December 5, 1983, lot no. 518, illus.), and others are preserved in the artist's estate (collection Juliet Man Ray), Paris.

8. *Self Portrait*, p. 23. Man Ray thought of illustrating his autobiography with one of these drawings, but told Ariel Durant that he had decided against it for fear that it might offend her or her husband (see Will and Ariel Durant, *A Dual Autobiography* [New York: Simon & Schuster, 1977], pp. 83 and 390).

9. The basis for establishing the identities of these figures is primarily circumstantial, although their indistinctly rendered features bear a vague resemblance to photographs of these artists from this period; see the photograph of Henri instructing art students in a night class at the New York School of Art, 1907 (reproduced in Homer, *Robert Henri*, fig. 19), where, coincidentally, Henri strikes a pose remarkably similar to the position given in the Man Ray drawing; a photographic portrait of Wolff appears in an article by André Tridon, "Adolf Wolff: A Sculptor of To-Morrow," *The International*, 8, No. 3 (March 1914), 86. Wolff's politics and art had a profound effect on the ideas and work of Man Ray in this period, a topic that will be discussed at greater length below.

10. *Self Portrait*, pp. 22–23.

11. See Adolf Wolff, "The Art Exhibit," *The Modern School*, No. 4 (Spring 1913), p. 11; this work was brought to my attention by Paul Avrich.

12. A book tracing the history of the literature, exhibitions, and acquisition of paintings by Cézanne in America is currently being prepared for publication by John Rewald.

13. Adolf Wolff, "Art Notes," *The International*, 8, No. 1 (January 1914), 21.

14. *Exhibition of Paintings and Water Colors at the Modern School*, 63 East 107th Street, New York, April 23–May 7, 1913, unpaginated (a copy of this rare catalog is preserved in the Papers of Forbes Watson, Archives of American Art, microfilm roll no. D57, frames 474–76).

15. *The Copper Pot* may refer to the large brass bowl filled with dried foliage, a motif that became a trademark of Alfred Stieglitz's gallery, "291," which Man Ray had begun to frequent at this time (see William Innes Homer, *Alfred Stieglitz and the American Avant-Garde* (Boston: New York Graphic Society, 1977), p. 46; for an illustration of this vessel, see p. 198, fig. 93).

16. *Self Portrait*, p. 14.

17. Noted in Avrich, *Modern School*, p. 90.

18. Manuel Komroff, "Art Transfusion," *The Modern School*, No. 4 (Spring 1913), pp. 12–15.

19. Max Weber, Introduction to the Modern School catalog (see n. 14 above).

20. Quoted in Lloyd Goodrich, *Max Weber* (New York: Whitney Museum of American Art, 1949), p. 46 (also cited in Avrich, *Modern School*, p. 155).

21. *Metropolis* is signed and dated 1913, but I would be inclined to place it early in the year because it reveals little or no dependency upon the angularization or fragmented space of Cubism – the stylistic direction to which Man Ray's work would momentarily evolve after his exposure (or at least reaction) to the vast display of modern art at the Armory Show in February of 1913. Moreover, the general theme of metropolitan life is one that is prominent in drawings that can be securely dated to 1912, and it is a subject that must have persisted in his work at least until early in 1913, if we

can judge by the titles given to the paintings and watercolors he exhibited in the second Modern School exhibition.

22. A photograph of this painting is preserved in a cardfile kept by the artist of works dating from the New York and Ridgefield years (Estate of the Artist, Paris). A complete inventory of the paintings and sculptures recorded in this cardfile will form an appendix to the author's dissertation, "The Early Works of Man Ray, 1908–1921," currently in preparation at the Graduate Center of the City University of New York.

23. Arthur Hoeber's review appeared in his column, "Art and Artists," *The New York Globe*, May 2, 1913, p. 10; Man Ray's letter was printed in the May 9, 1913, issue of the newspaper (p. 10).

24. See Francis M. Naumann and Paul Avrich, "Adolf Wolff, 'Poet, Sculptor and Revolutionist, but Mostly Revolutionist,'" *The Art Bulletin*, 66, No. 3 (September 1985). Many of the biographical details that follow pertaining to this artist are excerpted from this study.

25. For illustrations of these sculptures see "Adolf Wolff: Sculptor of the New World," *Vanity Fair*, 3, No. 2 (October 1914), p. 54.

26. *The International*, March (vol. 7, No. 3), April (vol. 7, No. 4), and May (vol. 8, No. 5), 1914.

27. Although it was not until August of 1914 that the Panama Canal was informally opened, the United States had been engaged in its excavation since 1906.

28. *Mother Earth*, August (vol. 9, No. 6) and September (vol. 9, No. 7), 1914; while Man Ray designed only these two covers for the magazine, the logo he designed for its title was retained throughout the duration of its publication.

29. Adolf Wolff, "War," *Mother Earth*, 9, No. 6 (August 1914).

30. This subject is more extensively explored in Francis M. Naumann, "Man Ray: Early Paintings 1913–1916; Theory and Practice in the Art of Two Dimensions," *Artforum*, 20, No. 9 (May 1982), 37–46.

31. From an interview with the artist conducted by Arturo Schwarz; quoted in Schwarz, *Man Ray: The Rigour of Imagination* (New York: Rizzoli, 1977), p. 32.

32. Frank Stephens, "A.D. 1914," *Mother Earth*, 9, No. 8 (October 1914), 254.

33. Information provided in the artist's cardfile (see n. 22 above).

34. Statement by the artist published in *Mother and Child*, ed. Mary Lawrence (New York: Thomas Y. Crowell, 1975), p. 64; my interpretation of the painting and preparatory drawing is based on the artist's description of *Madonna* provided in this statement.

35. For a detailed account of this incident, see Avrich, "Lexington Avenue," ch. 6 in *Modern School*, pp. 183–216.

36. From an interview with Arturo Schwarz, "This is Not For America," *Arts magazine*, 51, No. 9 (May 1977), p. 120.

Robert J. Coady, Man of *The Soil*

Judith Zilczer

The historical legacy of Robert J. Coady (1876–1921; Fig. 1), one of the most controversial figures in the rise of the American avant-garde, abounds in contradictions. As proprietor of two New York galleries from 1914 to 1919, Coady introduced significant examples of European modern painting to this country. As art editor of *The Soil* (1916–17), he championed his vision of an

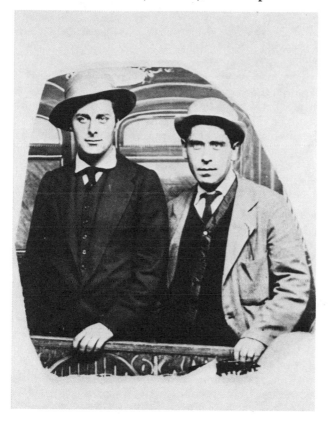

Figure 1. Robert J. Coady (*right*) and unidentified friend in New York, 1913. Photograph. Collection of the author.

31

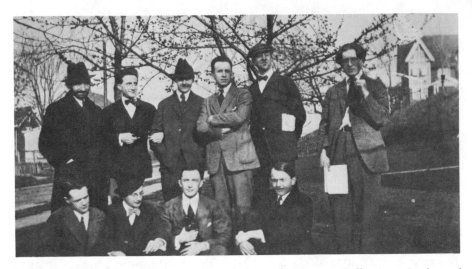

Figure 2. The Others Group, 1916. Photograph. Poetry Collection, Lockwood Memorial Library, State University of New York, Buffalo. *Left to right, front:* Alanson Hartpence, Alfred Kreymborg, William Carlos Williams, Skip Cannell; *rear:* Jean Crotti, Marcel Duchamp, Walter Arensberg, Man Ray, Robert Alden Sanborn, Maxwell Bodenheim.

indigenous American art rooted in popular culture. He was both an iconoclast and an idealist. His aesthetic vision encompassed primitive art and modern technology. Thoroughly familiar with the New York and Parisian vanguards, he maintained an independent distance from all groups and movements.

After Coady's death in 1921, his friend the sports writer Robert Sanborn (Fig. 2) confided to the critic Henry McBride:

I am formulating an idea of some memorial to him and should appreciate suggestions from you. It seems to me that it would be appropriate to assemble the five numbers of *The Soil* and publish them with introductory essays by a few of his artist friends and critics. I am well aware that due to his uncompromising consistency this number of friends was a diminishing one but I believe there were a few of sufficient breadth of mind to love and admire him no matter how much he disagreed with their pet theories.[1]

Sanborn's plan for a memorial publication never materialized, and Coady's collection of art and unpublished writings have since disappeared.[2] Although Coady's life and career have been documented from the fragmentary records that do survive, his contribution to American culture merits further analysis in light of new historical evidence.[3]

Coady's contribution as editor of *The Soil* cannot be considered apart from his activities as a dealer. In December 1914, Coady founded The Washington Square Gallery with the sculptor Michael Brenner. A rare installation photograph of the gallery (Fig. 3) reveals that from the first Coady exhibited ancient, primitive, and modern European art together in their Greenwich Village gallery.[4] The writer Alfred Kreymborg (Fig. 2), who was a frequent

Second and Last Installment, in Which the Art Gallery, the Greenwich Village Gazette and Other Matters of Interest Are Discussed.

By ALFRED KREYMBORG

The Washington Square gallery.

Figure 3. Interior, Washington Square Gallery. Photograph from *The Morning Telegraph* [New York], December 6, 1914.

visitor to the gallery, provided the most complete surviving description of Coady's enterprise:

It is a plain oblong room, in a warm tan tone, on the ground floor of 46 Washington Square South. Three large blister globes provide the enlightenment you require so badly. Four wooden benches, more comfortable than park benches, leaning back to back, are your sole invitation to sit down. But you cannot sit down. The paintings that challenge your imagination, if you have one, and your eye, failing that, bring you to your feet. Here you find the very latest men of art from Paris side by side with the very oldest art of the past.[5]

Works by Juan Gris and Henri Rousseau were installed in the very same room with examples of African and ancient sculpture. Paintings by one unknown Chinese-American artist, Chin Yin, were prominently featured in Coady's exhibition design. This ahistorical mixture of contemporary work with art from a variety of past cultures foreshadowed the eclectic range of topics covered in *The Soil*.

Coady, whom Kreymborg described as "a quiet, almost sullen, sorrel-topped light-weight with a smile that is more grim than ingratiating,"[6] had a deep commitment to both modern and primitive art. Kreymborg recognized that, by establishing the unusual exhibition program at the Washington

33

Square Gallery, Coady pursued both an educational and an iconoclastic mission: "he is attempting and actually doing as dangerous a bit of propaganda as any man, in his particular field, in this sleepy town of ours, or for that matter, this sleepy country."[7] The publication program of the Washington Square Gallery was indicative of Coady's "propagandistic" aims. He marketed Kahnweiler photographs of the work of Pablo Picasso, Juan Gris, Georges Braque, and Fernand Léger, as well as Druet reproductions of ancient and modern art.[8] These inexpensive photographic prints were suited to the needs of students. According to Kreymborg, Coady expected that students would be the primary audience for the Washington Square Gallery.[9]

Coady also promoted modern literature. Both he and Michael Brenner had become acquainted with the Parisian literary vanguard through Gertrude Stein (Fig. 4).[10] Limited editions of modern prose and poetry could be purchased at the Washington Square Gallery. Coady's inventory included three works by Max Jacob: *Les Oeuvres* with woodcut illustrations by André Derain, *Saint Matorel* with original etchings by Pablo Picasso, and *Le Siège de Jerusalem* illustrated by Picasso. Apollinaire's *L'Enchanteur Pourrissant* with

Figure 4. Michael Brenner. *Portrait Sketch of Gertrude Stein.* 1923–24. Cast plaster. 15½ x 8⅝ x 11⅛ in. Hirshhorn Museum and Sculpture Garden, Smithsonian Institution. Gift of Mrs. Michael Brenner, New York, 1977.

woodcuts by Derain was also available at the gallery. In a rare pamphlet published by the gallery, Coady featured Gertrude Stein's *Three Lives* – "This much talked of, hated and admired book is on sale for one dollar a copy. . . ."[11]

Coady was equally committed to fostering serious art criticism. In the same pamphlet, he announced the forthcoming publication of Ambroise Vollard's monograph on Paul Cézanne: "The art world has been waiting for this work by Cézanne's most intimate friend and admirer, Mr. Ambroise Vollard, the one man best qualified to give a true estimate of the great painter."[12] It was not until 1915 that Coady succeeded in publishing an American edition of Vollard's *Cézanne's Studio.* In his introduction to this slender publication, Coady stressed Cézanne's importance for the subsequent evolution of modern art and linked his painterly innovations to primitivism:

Paul Cézanne was the greatest painter that ever lived. He did more with the medium of paint than did any other artist.

. . . it was Cézanne who finally turned the tide from academic stagnation into freer and fuller channels. He was incessantly searching for newer and newer ends and means and, as the unfinished quality of many of his canvases would indicate, his task was endless. He opened many avenues to the future. He started the trail to the aborigine. The various "movements" of to-day are either efforts or pretentions to continue the work his death arrested. After him Matisse developed his joyous color and spirited decoration. Picasso, the leader of to-day, and his co-contributors, Gris, Braque, and Léger are carrying the art into purer realms of culture and taste.[13]

Coady believed that European modern art would inspire comparable vanguard painting and sculpture in the United States.

In December 1916 Coady expanded his efforts both to promote modernism and to foster the growth of contemporary American culture. He published the first of five issues of *The Soil* (Fig. 5). The magazine included everything from an excerpt of The Book of Job to Gertrude Stein's word portrait "Mrs. Th_____y" and an essay by one Adam Hull Shirk on "The Dime Novel as Literature."[14] Coady's improbable and jarring juxtaposition of written material and imagery enlarged the ahistorical scope of his aesthetic program at the Washington Square Gallery.

Henry McBride devoted a portion of his Sunday column in the New York *Sun* to an enthusiastic review of the first issue of *The Soil:* "I love the new publication from start to finish. I wouldn't have a thing in it altered. I consider it the most perfect art journal I have ever seen. It beats *Blast* all hollow."[15] McBride's enthusiasm stemmed in part from the fact that he and Coady shared a keen admiration for Gerturde Stein.[16] He welcomed Coady's publication of Stein's work. McBride immediately understood that Coady's search for "American art" was not an expression of isolationist nationalism:

Mr. Coady holds, like Walt Whitman, that American art should be all embracing. Therefore he begins the review with a superb drawing from a Greek vase and a superb chapter from the Book of Job. . . .

The pictures are by Rousseau le Douanier, Cézanne, Picasso, Walkowitz, Poussin, Chin Yin, Macdonald Wright and various photographers. . . . I shall await the January issue with impatience.[17]

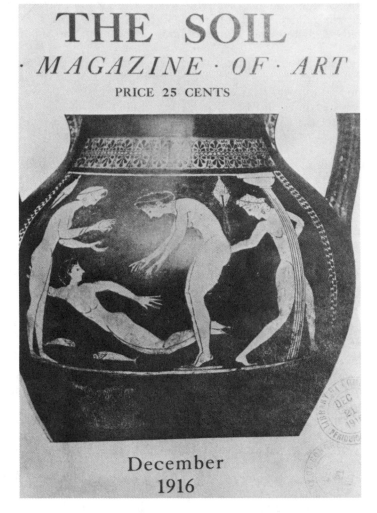

THE SOIL

MAGAZINE · OF · ART

PRICE 25 CENTS

December
1916

Figure 5. Cover, inaugural issue of *The Soil*, December 1916.

McBride appreciated the comparison of European modernism, primitive art, and American popular culture in Coady's journal.

Earlier that year McBride had opened the *Sun*'s art page to an exchange of letters between Coady and Willard Huntington Wright over the purpose of The Forum Exhibition.[18] Coady was so grateful for McBride's continued support that in July he wrote the art critic:

Thanks a thousand times for the notices, and so much space. The Soil is very grateful to The Sun's art page.

I am sending you another copy of *The Soil* in which I have corrected some of the errors which seem to change the sense of things. I see you have noticed some of them.

The printers are driving me mad. We had to sue them and they sued us and held up our copy. . . . Damn them.

I have not as yet gotten the Stein book ready, but will get at it very soon. Let me hear from you when yours is ready.[19]

Although Coady was unable to realize his plans to publish a book by Gertrude Stein,[20] he had found an effective forum for disseminating his own ideas in his short-lived journal.

In successive issues of *The Soil,* Coady presented his "all embracing" vision of American art, which Henry McBride found so refreshing. Coady valued both the traditions of Western culture and the innovations of European modernism. In his essay on American art, Coady explained the relationship of Western culture to the American scene: "The Old World can teach us a lot. Her masters can develop our taste and help us realize ourselves. . . . Lorrain and Van Gogh can show us that color is light. Cézanne can show us form."[21] However, he was opposed to slavish imitations of European models, whether ancient or modern. Coady believed that easy and fashionable acceptance of modernism resulted in a new academicism. He dismissed such superficial responses to modern art as "a dizzy hysteria [of] ismism."[22]

Coady's position was entirely consistent with his earliest efforts at the Washington Square Gallery. Alfred Kreymborg reported that Coady wanted to educate the public by exhibiting the best examples of European modern art:

> Because you are painting in what you think or what some may call the Cubist manner does not make you the less an academician than the man whose ambition it is to have his latest fruit still life hang in the National Academy exhibition. . . . Then there is another and more subtle form of an academician – the man who has invented a new art form, and who having done so and become popular, proceeds to copy himself to make an academy of himself. How many artists escape this dread denouement? Only a sacred few. It is against these as well as the others, that the peaceful looking gallery on the Square is trying to keep its doors shut. The fact that a canvas is signed "Picasso" does not avail. It must be Picasso at his best.[23]

These questions of quality and authentic expression were central to Coady's critique of modern art in the pages of *The Soil:* "Coady claims that each individual belongs to one of two classes, the faker or the outcast. . . . It is to these outcasts that the Washington Square Gallery, itself an outcast, bids special welcome –"[24] Coady continued this policy when, late in 1916, he relocated the enterprise on Fifth Avenue under the new name of the Coady Gallery.[25]

It is in this context that Coady's celebration of American popular culture and the machine aesthetic must be understood. He believed that the most authentic expressions of American culture were to be found outside the conventional art institutions. Just as he recognized the authenticity and power of African and primitive art and the work of children, so he discovered the seeds of an American folk culture in the products of American industry and in popular sports and entertainment (Fig. 6). Coady was among the first to propose an analogy between folk culture and American popular culture. The publication of photographs of machines, railroads, boxers, and storefront windows in *The Soil* represented more than an absurd Dada gesture. While

he was not averse to using such improbable aesthetic icons for iconoclastic purposes, Coady earnestly believed that the American urban industrial environment would provide the raw material for a truly indigenous art.[26]

In Coady's hands, popular culture became a weapon against all that seemed false to him in contemporary art. He presented a photograph of the commercial lighting for the Monroe Clothes Shop on Broadway and Forty-second Street as a challenge to Joseph Stella's painting of *The Battle of Lights: Coney Island,* and proclaimed the Hippodrome clown "Toto" to be "the most creative artist that has visited our shores in many a day." Coady suggested that the direct audience appeal of Toto's performances surpassed the achievements of European and American modernists such as Francis Picabia, Constantin Brancusi, Jules Pascin, and Elie Nadelman.[27] In a published letter to Jean Crotti, he questioned the value of Crotti's wire assemblage *Portrait of Marcel Duchamp (Sculpture Made to Measure)* and disputed both the quality of Crotti's work and his aesthetic premises:

the American public would like to know what is its value as a work of Art. What it possesses or contains which makes it a work of Art and how it justifies you as an artist—a big artist—one of "The Big Four". . . .

Is your "absolute expression" the absolute expression of a big artist, how does it differ from the absolute expression of a little artist, how does it differ from the absolute expression of a—plumber?[28]

Coady's irreverence toward the avant-garde was his most original contribution to New York Dada.

Photo by Paul Thompson

Figure 6. Jack Johnson. Photograph from *the Soil,* January 1917.

Coady's collage pastiche of modern painting, *Cosmopsychographical Organization,* (1916; Fig. 7) was imbued with that spirit of irreverence. The composition, now lost, was comprised of photographic reproductions of works by Picasso, Matisse, and other modern artists. Although not all component reproductions can be identified with certainty, two of the central figures from Henri Matisse's *Joie de Vivre* (1905–06, oil on canvas, The Barnes Foundation) appear in the lower right and lower center portions of Coady's collage composition.[29] It is probable that Coady incorporated many of the Kahnweiler and Druet reproductions sold at his galleries in the collage. His caption for the work was a deliberate parody of the artists' statements published in the elaborate catalog for the Forum Exhibition.[30] Within this text Coady inserted allusions to the American avant-garde. The title of Coady's collage recalls the titles for Synchromist paintings by Stanton Macdonald-Wright, Morgan Russell, and Thomas Hart Benton.[31] "[T]he absence of M . . . D . . ." is an overt reference to Andrew Dasberg's lost painting *The Absence of Mabel Dodge,* a featured work in the 1914 National Arts Club Exhibition of Contemporary Art.[32] Finally, Coady poked fun at the very citadel of American modernism – Alfred Stieglitz's gallery "291." Mocking the special issue of *Camera Work* devoted to the question "What Does 291 Mean to You?" Coady wrote "in five months' time those pictures will be worth twice what is being asked for them to-day?"[33]

However, Coady's critique of modernism was neither anti-art nor antimodern in spirit. His own activities at his two galleries attest to his longstanding support of European modern art. In mocking examples of abstract art, Coady intended to raise aesthetic and cultural issues rather than to undermine modernism. His was not a reactionary call for a return to representational art. In his essay on American art, Coady explicitly ruled out imitation of past styles and reproduction of nature as viable aesthetic solutions: "We need our art. But we're getting very little from our art world. . . . It can't come from imitating 'Representation' or by substituting rule for taste. . . . It can't come from labels or labeled mysticisms. It can't come from theory in place of taste."[34] Coady believed that art represented the most vital form of human expression: "Art is positive, it comes from a feeling of human being. It is an extension of life and travels the earth and goes on to eternity. It creates its own forms, many and enough for all its needs, and brings its own freedom with it. It spreads living into the superlative and by its magic it makes men of some and fools of others."[35] Coady's iconoclasm resulted from his missionary zeal rather than from philosophical nihilism. He believed that his attacks on vanguard academicism and modernist fads would contribute to the growth of a new American art.

Coady's vision of American art was part of his larger dream for progressive social reform. Shortly before his death, Coady unveiled his plans to found an American Tradition League. The proposed organization would have been dedicated to political and economic reform and to "a constructive program for the development of a real American tradition."[36] Although Coady's cultural nationalism would seem to have anticipated the rise of Regionalism in the following decade, his vision of American culture was more cosmopolitan and farsighted. Coady believed that "the center of cultural initiative has

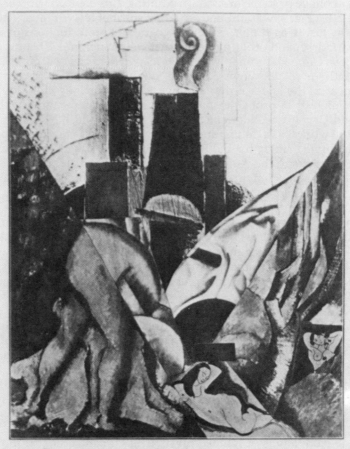

Cosmopsychographical Organization by R. J. Coady.

"COSMOPSYCHOGRAPHICAL Organization," or, the "plastic" "visualiza-
tion" of my "intellectualized sensations." Wherein is "infinity struggling
for birth in the womb of the soul," "surrounded by swift moving nudes." Wherein,
also, "I pay no heed to mere objects" for, "the path moves towards direction"
where I pay "homage" to "the absence of M..... D....." And, again, wherein, I
have "invented" "nativity" and "organized" "organization" 1, 2, 3, 4, 5, 6, 7 times.
"Thus" do I "kill the feeble and invigorate the strong," my "creative vision handling
the whole surface with supple control."

"What does 2.91 mean to you," when "in five months' time those pictures will
be worth twice what is being asked for them to-day?" And, besides, "we guarantee
these pictures"—"in so far as honest expert opinion can guarantee anything" although
"it is obviously impossible to guarantee anything which does not, as yet, exist."

Figure 7. Robert J. Coady. *Cosmopsychographical Organization.* 1916. Collage. Repro-
duced in *The Soil,* December 1916.

passed to America. . . . The prosperity of America entails assuming of cultural responsibility."[37] He called for public support for the fine and performing arts, architecture, athletics, and science in order that the United States might fulfill its destiny of cultural leadership: "There is more art here outside the 'art World' than there is in it. The Indian, the Negro, and the various units of European and Oriental culture that flock to our shores constitute a fast forming culture."[38] "Internationalism," he proclaimed, "is the interplay of national cultures."[39]

Notes

1. Robert A. Sanborn, letter to Henry McBride, January 18, 1921, Henry McBride Papers, Collection of American Literature, Beinecke Rare Book and Manuscript Library, Yale University, New Haven, Connecticut. Sanborn, a graduate of Harvard, was a member of the Others Group and contributed prose and poetry to *The Dial, Others, The Little Review,* and *Poetry.*

2. In correspondence with McBride, Sanborn revealed that Coady's collection and unpublished manuscripts were in the care of his brother Thomas and his landlady, Mrs. Rozel Butler. Thomas Coady refused to release his brother's papers to Sanborn: "I know all about the resistance of Bob's brother to the memorial scheme. I am afraid that rare collection will only be released by Tom Coady's translation to another climate where he can sleep his head off." (Robert A. Sanborn, letter to Henry McBride, May 1, 1921, McBride Papers.) Sanborn also tried to enlist Walt Kuhn's support in his efforts to publish a tribute to Robert Coady in *The New Republic.* (Robert A. Sanborn, letter to Henry McBride, May 14, 1921, McBride Papers.) There is no record of Kuhn's contact with either Coady or Sanborn in the Walt Kuhn Papers in the Archives of American Art. However, Walt Kuhn's daughter, Brenda Kuhn, confirms that her father was friendly with Robert Sanborn (letter to the author, May 19, 1985).

3. For Coady's biography, see Judith K. Zilczer, "Robert J. Coady, Forgotten Spokesman for Avant-Garde Culture in America," *American Art Review,* 2, No. 6 (November/December 1975), 77–89.

4. Francis Naumann discovered the photograph and Alfred Kreymborg's article on the Washington Square Gallery from *The Morning Telegraph,* December 6, 1914, sec. 2, p. 1. I am most grateful to him for sharing this new documentary material and for allowing me to publish these findings for the first time.

5. Alfred Kreymborg, "The New Washington Square," *The Morning Telegraph,* Sunday, December 6, 1914, sec. 2, p. 1. In his memoirs, Kreymborg recalled that the Sunday editor of *The Morning Telegraph* invited him to contribute full-page Sunday stories, and he used the opportunity to write about "individuals and haunts he believed in." See Alfred Kreymborg, *Troubadour: An Autobiography* (New York: Boni & Liveright, Inc., 1925), pp. 214–15.

6. Kreymborg, "The New Washington Square," p. 1.

7. Ibid.

8. Pamphlet from the Washington Square Gallery, 1914, unpaginated. I am grateful to William I. Homer for bringing this rare document to my attention.

9. Kreymborg, "The New Washington Square," p. 1.

10. See Zilczer, "Robert J. Coady," p. 78, and *Flowers of Friendship: Letters Written to Gertrude Stein,* ed. Donald Gallup (New York: Alfred A. Knopf, 1953), pp. 103, 111–13.

11. Pamphlet from the Washington Square Gallery, 1914, unpaginated.

12. Ibid.

13. Robert J. Coady, Introduction to Ambroise Vollard, *Cézanne's Studio* (New York: Liberty Print Shop, © 1915 Robert J. Coady). A copy of this publication is preserved in the Maurice Prendergast Papers, Archives of American Art, Smithsonian Institution, Washington, D.C. Vollard's text was also reprinted in the March issue of *The Soil*.

14. *The Soil*, 1, No. 1 (December 1916), 1, 15, 39–42.

15. Henry McBride, "*The Soil*, a Magazine of American Art," *The Sun*, December 17, 1916, sec. 5, p. 12, cols. 1–3.

16. Before the outbreak of World War I, McBride met Gertrude Stein in Paris, and, like Coady, he had gained introductions to the European vanguard through her salon. See Daniel Catton Rich, "The Art Criticism of Henry McBride," in *The Flow of Art: Essays and Criticisms of Henry McBride* (New York: Atheneum, 1975), p. 20.

17. McBride, "*The Soil*, a Magazine of American Art," p. 12.

18. See Zilczer, "Robert J. Coady," pp. 84–85.

19. Robert J. Coady, letter to Henry McBride, July 16, 1917, McBride Papers.

20. Coady attempted to bring out an American edition of Gertrude Stein's *Letters and Parcels and Wool*. See Zilczer, "Robert J. Coady," p. 89, n. 35

21. R. J. Coady, "American Art," *The Soil*, 1, No. 2 (January 1917), 54.

22. Ibid.

23. Kreymborg, "The New Washington Square," p. 1.

24. Ibid.

25. The masthead for the December 1916 issue of *The Soil* included the address 489 Fifth Avenue, the location of the Coady Gallery.

26. R. J. Coady, "American Art," *The Soil*, 1, No. 2 (January 1917) 54–55. According to Robert Sanborn, Coady did not believe that American popular culture represented a fully developed art: "His mind was too well balanced for him to indulge in excessive judgments, he did not credit the work of the cartoonists, sport-writers, and athletes, with the achievement of any permanent value. With a true sense of proportion he saw these men as scooping the raw material of art out of the soil, and his keen eyes noted in the shapeless handfuls the gleams of pure gold" (Robert Alden Sanborn, "A Champion in the Wilderness," *Broom* [1922], p. 177).

27. *The Soil*, 1, No. 3 (March 1917); R. C. [Robert Coady], "Toto," *The Soil*, 1, No. 1 (December 1916), 31.

28. Robert Coady, letter to Jean Crotti, *The Soil*, 1, No. 1 (December 1916), 32. Crotti's lost sculpture had been featured in an *Exhibition of Pictures by Jean Crotti, Marcel Duchamp, Albert Gleizes, and Jean Metzinger* at New York's Montross Gallery, April 4–22, 1916, no. 22. The assemblage was widely reproduced in the press. See for example "The Climax of Audacity in the Modern Art Revolution," *Current Opinion*, June 1916, p. 431. A photograph of the lost work is preserved in the Jean Crotti Papers, Archives of American Art, Smithsonian Institution. That Coady's criticism was not intended as antimodern is evident from Marcel Duchamp's reference to "our friend Coady" in a letter to his sister Suzanne Crotti, around October 20, 1920, Crotti Papers. See Francis M. Naumann, "Affectueusement, Marcel: Ten Letters from Marcel Duchamp to Suzanne Duchamp and Jean Crotti," *Archives of American Art Journal*, 22, No. 4 (1982), 14.

29. The upper portion of the collage appears to be a fragment of a Cubist collage still life by Pablo Picasso. The image of a violin does not correspond to any of the extant

collage compositions by Georges Braque. See Isabelle Monod-Fontaine et al., *Braque: The Papiers Collés* (Washington, D.C.: The National Gallery of Art, 1982).

30. *The Forum Exhibition of Modern American Painters* (New York: Anderson Galleries, March 13–25, 1916). See Judith Zilczer, "The World's New Art Center: Modern Art Exhibitions in New York City, 1913–1918," Archives of American Art *Journal,* 14, No. 3 (1974), 3; Anne Harrell, *The Forum Exhibition: Selections and Additions* (New York: Whitney Museum of American Art at Philip Morris, May 18–June 22, 1983); William C. Agee, "Willard Huntington Wright and the Synchromists: Notes on the Forum Exhibition," Archives of American Art *Journal,* 24, No. 2 (1984), 10–15.

31. See for example S. Macdonald-Wright's *Arm Organization in Blue Green* (cat. no. 43), Morgan Russell's *Cosmic Synchromy* (cat. no. 63), and Thomas Hart Benton's *Figure Organization No. 1* and *No. 2* (cat. nos. 144, 150) in the Forum Exhibition catalog.

32. See Zilczer, "The World's New Art Center," pp. 2–3, fig. 2.

33. Robert J. Coady, "Cosmopsychographical Organization," *The Soil,* 1, No. 1 (December 1916), 30. Compare "What Is '291'?" *Camera Work,* No. 47 (1914).

34. R. J. Coady, "American Art," p. 55.

35. R. J. Coady, "The Indeps," *The Soil,* 1, No. 5 (July 1917), 204.

36. Robert J. Coady, pamphlet for the American Tradition League, cited by Gorham B. Munson, in "The Skyscraper Primitives," *The Guardian,* 1, No. 5 (March 1925), 170. Coady presented his plans for the League at a dinner given in his honor at the Penguin Club on November 19, 1920. See [Hamilton Easter Field], "Comment on the Arts," *The Arts,* 1, No. 2 (January 1921), 34–36.

37. Robert J. Coady cited in Munson, "The Skyscraper Primitives," p. 172.

38. Robert J. Coady, letter to Mrs. H_____, February 12, 1916, published in Robert J. Coady, "Three Unpublished Letters," *The Guardian,* 2, No. 2 (August 1925), 373.

39. Robert J. Coady cited in Munson, "The Skyscraper Primitives," p. 174.

American Dada against Surrealism: Matthew Josephson

Dickran Tashjian

Cultural history is rarely straightforward. Consider the impact of Dada and Surrealism on American art. When I first traced the presence of Dada among American artists, the project seemed formidable. *Dada,* after all, meant nothing: the word was nonsensical in origin and intent. Subversive and ephemeral, Dada was understandably neglected by American art historians, who relegated it to a minor episode in their reconstruction of the origins of an American avant-garde in the early decades of this century. Yet Dada could be traced to New York – characteristically enough, before the word existed – through the presence of Francis Picabia and Marcel Duchamp in 1915. The two friends were fascinated by machine technology, epitomized, they thought, by the newly built skyscrapers of New York. Eventually, Americans caught up by Dada were dubbed "skyscraper primitives" for their celebration of an American culture and society transformed by technology.[1]

I had found not only a title for my study but a narrative as well. For all its diffuseness Dada was relatively self-contained in New York. A small cast of painters and poets surrounding Duchamp and Picabia congregated either at Stieglitz's small gallery or at the apartment of Walter Arensberg, a wealthy collector of avant-garde art.[2] New York Dada existed sporadically for a short period of six years, from 1915 to 1921, when Duchamp and Man Ray decamped for Paris. American interest in Dada shifted with them.

The Parisian episode for Americans was equally self-contained even as it was connected to the earlier phase in New York. Through Man Ray, who had quickly gained entrée to the Paris avant-garde, Matthew Josephson, a recent graduate of Columbia University, met André Breton, Philippe Soupault, and Louis Aragon, all of whom had been won over to Dada by Tristan Tzara. These young French poets, disillusioned survivors of the war, were enthusiastic nonetheless about the vitality of American life, its "primitive" qualities exemplified by American movies, jazz, skyscrapers, and advertising. So Josephson and his friends proselytized an American Dada, which flared briefly and subsided in New York upon their return in 1924.

This Dada scenario led me to believe that a study of Surrealism and American art would follow roughly the same format – perhaps with even greater ease. Surrealism was positively stable in contrast to Dada. There was no difficulty in identifying the origins of Surrealism, what with the publication of André Breton's manifesto in 1924. And the movement had a steady center

in Breton for more than twenty years. Yet consider the response of American writers and artists during the early 1920s, when Surrealism was in the making: their silence (or reticence) was nothing less than deafening, as though contacts with the French avant-garde, carried on over the previous decade, had almost never occurred.[3]

Thus I found discontinuities where I had expected connections. For one, Matthew Josephson's program for an American Dada never led to Surrealism and hence failed to conform to the familiar French model whereby Paris Dada gave way to Breton's Surrealist project. At the same time, Josephson's ambitions did not neatly subside. If I hadn't exactly placed a false closure on American Dada with a 1925 date, neither had I arrived at an entirely satisfactory conclusion. It was mainly during the 1930s that an American public came to know the Surrealists, who were exhibited in American museums and galleries, discussed in symposia and lectures, and published not only in the little magazines and anthologies of the avant-garde but also in the commercial press. This situation cannot be explained away with a few clichés, least of all with the concept of "culture lag," which is most often a catchphrase that glosses over the gap in our knowledge about gaps between groups.

I want to enter that gap by considering the ideas and attitudes of Matthew Josephson as he stood on the fringes of a Parisian Dada verging on Surrealism. To understand Josephson as a figure engaged in the process of cultural diffusion we require an adequate theoretical framework. That is, we need to develop a new model for the phenomenon of the avant-garde, a model predicated upon the politics of culture. Otherwise, Surrealism and its American possibilities will remain hidden and the significance of the entire venture will continue to elude us, as it has for over a half-century.

In an "open letter" for readers of *The Little Review* in 1926, Josephson felt compelled to insult his French friends as "chameleons" because of their change of colors from Dada to Surrealism, a movement he dismissed (with a switch of metaphors) as "the faint, ugly whine of a decrepit engine." There were several immediate reasons for Josephson's indignation: loyalty to the idea of Dada ("incontestably," he claimed, "a miraculous sideshow for the world"), no great attachment to Breton, and certainly a love for polemic.[4]

Josephson also saw an opportunity to even old scores, to get out from under a cultural inferiority spawned by the French. "In the winter of 1921–1922 when I met Aragon and Tzara and the others," Josephson recalled in his open letter, "I asked them anxiously how they had received Freud and Psychoanalysis. In their superior Parisian manner they replied that it was an old thing with them. And beside, the French had never been very repressed." Josephson, however, was not to be taken in: "a year later I heard of special pilgrimages to Vienna. When I returned to Paris [after a hiatus in Berlin] I burst upon a whole mob in Paul Eluard's house engaged in grandiloquent revelations of their unconscious love or hatred for each other. Then Spiritism and one silly game after another."[5] Rightly sensing that the French were in psychoanalytic arrears allowed the American to feel one-up on the all-knowing Parisians. Josephson was declaring his cultural and intellectual independence from the French in 1926.

The break came under the combined pressure of shifting attitudes and ideas. Josephson had admired the French Dadaists partly because he thought that they avoided turgid prose in skimming over the hard surfaces of modern life, in promoting a kind of literary (or antiliterary) behaviorism, so to speak, in their spare and precise writing. Now here they were in 1926 rallying to the banner of Surrealism and, from Josephson's view, engaging in the same sort of "impulsionism" he had attacked only a few years before, when a somewhat older generation of American writers had tried to write fiction based upon the ideas of psychoanalysis and the unconscious.[6]

Josephson had made a large investment in Dada upon his first visit to Paris in 1921. Although genuine friendships developed, the American had never been fully part of Dada, always on its fringes, always something of an outsider. Hence his satisfaction when he had been able to act Dada: to sign a manifesto, dash off a dirty limerick, or slug a waiter and precipitate a café brawl. But even in those instances the satisfaction had been limited, as Josephson's friends cautioned him that he really didn't understand the chaotic politics of the situation.[7] In the summer of 1922, with Dada entering its death throes, Josephson saw his chance for a new direction, which he proposed in an essay entitled "After and Beyond Dada" for *Broom* in its July issue. A quest beyond Dada was important to Josephson because it might provide him with the opportunity to gain equal footing with his French friends. In the process he hoped also to be propelled to the forefront of an American avant-garde.

"After and Beyond Dada" summarized the program that Josephson had begun to set forth for an American avant-garde in the pages of *Broom*. Dada's freedom from rationality, Josephson claimed, allowed the possibility of "astonishing encounters and adventures." This picaresque of the mind beyond Dada came upon "fresh booty" among "contemporary American flora and fauna." Josephson cited American movies, newspaper accounts, jazz, and, later, American advertising.[8] Essentially the result of machine technology, these lively and vital phenomena were radically transforming American society, Josephson argued, and should be heeded by American artists. It was their opportunity to create a new art genuinely distinct from the cultural standards of Europe, which had only begun to feel this social and cultural process which was so far advanced in America. New subject matter, certainly, but new forms and sensibilities were also at hand by virtue of the machine. Artists taken by Dada would be liberated to pursue these new possibilities.

Enthusiastic and articulate, Josephson returned to New York in the summer of 1923 with high hopes for an American Dada. His proposal generated controversy among his associates and indifference in the literary establishment. The send-up of *Aesthete 1925*, a Dada response to an attack in H. L. Mencken's *American Mercury*, only signaled the death of Josephson's plans.[9] In 1926 Josephson attributed the failure to transplant Dada to American soil primarily to the debilitating situation faced by American avant-gardists subsisting outside the commercial publishing network. So he railed against the "tepid dreams" of the Surrealists, who he thought squandered their prodigious talents in anti-art gestures.[10]

Josephson's 1926 letter in *The Little Review* broke his formal ties with the Surrealists as a group. Breton, characteristically, had little to do with him henceforth. Other Surrealists in and out of the fold renewed their friendship with him gradually and haltingly upon his return to Paris during the fall of 1927. Privately, the American could not cut loose. Surviving among his personal notes of 1927, written, perhaps, when Josephson had returned to France, was a meditation entitled "Microcosm: Concerning Super-realism," which leaves traces of his responses to Breton's 1924 *Manifesto of Surrealism* and the 1926 *Legitimate Defence* (against the depredations of the French Communist Party). "Microcosm" was a dialogue Josephson conducted with himself about the public role of the avant-garde as exemplified by the Surrealists. Despite his publicly stated antipathy the previous year, Josephson was not so much negative as highly ambivalent toward this group. There was Breton himself, "mandarin of the rue Blanche," but also a "fallen angel": Josephson observed that "with every year M. André Breton . . . becomes the more fascinating and tragic figure."[11]

Josephson was fascinated by the Surrealists precisely because he had felt the same problems during the 1920s. He admired their "prodigious" moral energy and the "singular purity of their motives," which he claimed, however, was dissipated by their public behavior, "the dispersion and the spattering of their fuel at random. . . ."[12] But the question of public address was mostly a matter of tactics. From Dada's openness to life Josephson thought that he had struck upon the major issue for artists of his time: the radical transformation of American and eventually European society by the machine. His largest bone of contention with the Surrealists had to do with their refusal to adopt his program.

Even though the former Dadaists had been Josephson's original inspiration, the probabilities of their conversion were slim, given the cultural and social disparities between Europe and America as Josephson rightly perceived them. Nevertheless, he acted out his secret desire by approaching Breton in his notes: "I plead with men like Breton to shape, to invent this art, to provoke the new wisdom of our world, which we demand for our age." Several passages later he once again broached this possibility, which "would have provided the most enchanting terrain for such cogitations as his [Breton's]. The good cause would have been to envisage this, to embrace this world with its promises of utter liberty and utter emprisonment."[13] That Josephson had failed to rally American artists to effective group activity was all too evident.

Thus the Surrealists could do nothing right. In 1926 Josephson advised them to take a consistent antiliterary stance and become political revolutionaries.[14] Yet he was not to be outflanked by their subsequent move leftward. In his 1927 "Microcosm" he granted that the iconoclastic antics of the Surrealists had been permissible under the banner of Dada, "but in the name of Communism—Heaven forfend!" His ironic tone equivocated somewhat, though in context his irony was directed primarily against the Surrealists rather than the party discipline of the Communists. Thus he judged the Surrealists against the standards of the Soviet Union and the Communist Party, comprised, he thought, of pragmatists who live and act in the "Real World."

By deferring to the privileged status commonly granted to the Soviet Union in the 1920s, Josephson failed to understand Breton's position in his *Legitimate Defence.* The Surrealist leader had taken pains to accept openly the economic and political program of the French Communist Party so as to reassure those who erroneously perceived Surrealism as a rival in revolution. But he was not, as a consequence, willing to concede his intellectual independence, nor was he willing to relinquish his authority in the realm of culture.[15]

The argument would not have made much difference to Josephson, who fundamentally misread and hence misunderstood Breton in his first *Manifesto of Surrealism.* He misconstrued Surrealism as "primarily an opposition to reality" and thus anticipated the main indictment of Surrealism by the Communist left during the 1930s.[16] From that point of view the Surrealists were mere dreamers and hence escapists from the material realities of economics and politics generating class conflict. On those grounds Josephson mocked the Surrealists for their ineptitude in the real world of politics. Yet he managed to ignore Breton's forthright rejection of such polarities in the *Legitimate Defence.* Josephson's reservations against the possibility of conceiving a viable relationship between avant-garde art and the life of social and political action became a deeply held and no less deeply misplaced article of faith among many of his contemporaries on the left during the 1920s and 1930s.

What are we to make of this disconnection? Josephson was not an atypical case. Quite clearly, he was engaged in what Hayden White has called the "politics of interpretation": by attempting to bend Dada to his own sense of American culture and society Josephson was "striving to share power amongst interpreters themselves." For White, "the activity of interpreting becomes political at the point where a given interpreter claims authority over rival interpreters." White construes such activity political only in a metaphorical sense unless there is recourse to the power of the state to enforce a particular interpretation.[17] This view of politics is too narrow. It doesn't take into consideration the fact that Josephson was important not only because he was the most vocal proponent of an American Dada but also because he was strategically situated in a network that had the potential to disseminate Surrealism. An experienced editor by virtue of his role in *Broom,* Josephson also had good connections with *The Little Review,* a magazine that initially had a deep commitment to the avant-garde. Others listened to him. Malcolm Cowley, for one, aped his friend's intellectual odyssey during the 1920s until he came to rest as literary editor at *The New Republic,* where he was a fellow traveler of the CPUSA. Obviously, we must go beyond the notion of individual influence to social and cultural analysis. What does the Josephson episode suggest?

Because cultural diffusion does not occur in a vacuum, Surrealism was hardly transferred in pristine form to an American avant-garde, which in any case did not exist whole to receive it. At the same time that Surrealism made its presence known, Americans actively responded to the movement. (Part of their response involved their participation in the communication of Surrealism according to their own perspectives.) Thus American artists and

writers did not comprise a collective tabula rasa to bear passively a Surrealist imprint. The cultural diffusion of Surrealism was a process of mutual and often uncoordinated interaction among French and American participants, each with their own motives and goals. The process was never neat and orderly.

In order to derive an adequate model of cultural diffusion we must first redefine the idea of avant-garde movement, especially as it has been predicated upon the idea of progress.[18] Even though movement accurately characterizes the dynamic and fluid qualities of avant-garde activity, the avant-garde has not always progressed, nor has it moved with continuity. Tristan Tzara was perhaps the first to explode this myth, when he claimed that Dada was not modern.[19] To imply progress when only change exists is to impose a false pattern on the history of the avant-garde. It is possible, however, to derive another conception of movement by replacing the underlying idea of progress with conflict as the driving force of the avant-garde: controversy, polemic, constant questioning, self-doubting, alienation, the subversion of authority, rebellion – all these characteristics at one time or another animate an avant-garde group (certainly the Surrealists and their predecessors the Dadaists) and simultaneously work against coherence and unity.[20] A movement, therefore, is intrinsically volatile and threatens the very sense of community that it fosters. Liberated from the idea that avant-garde movements are supposed to succeed one another, we can entertain the historical possibilities of avant-garde risk and failure; we can examine the rubble of avant-garde movements; we can explore the origins of an avant-garde in the wake of another movement, precisely the situation with Josephson.

A final question remains. How should we define those conflicts? They are hardly random events; rather, they occur over issues concerning culture, and thus permeate the entire social and economic process of cultural diffusion. We have entered the realm of cultural politics. Here we can readily identify a number of cultural institutions that comprise the Culture network in western society: musuems, music groups, publishing houses, literary societies, academies, universities, and the mass media.[21] As Hayden White has observed, state involvement in the Culture network "politicizes" culture, insofar as the network gets caught up in the legislative and administrative processes of government. But such involvement simply underscores an ongoing process of cultural politics within those institutions themselves, including not only the allocation of resources but also the decisions concerning cultural issues. While the internal rules of governance vary in such cultural institutions, status, prestige, money, friendships, alliances, antagonisms, and personal biases all play an important role in the decision-making process. These factors should be obvious, but they often are overlooked because of the erroneous assumption that cultural issues are resolved in a disinterested fashion.

Historically, the avant-garde arose in opposition to the socially sanctioned institutions of the Culture network. This conflict has resulted in the marginal status of the avant-garde and hence its own anti-institutional character. Economic resources for the avant-garde are usually much more precarious

than they are for established cultural institutions approved by the dominant society. Hence the little magazines in opposition to the commercial press; the meetings in small apartments and Parisian cafés in lieu of formal salons. But the informal and often impoverished status of these activities should not obscure their crucial function within the avant-garde. What is at stake is the determination and dissemination of art and ideas. Hence the jockeying for control of resources, however meager they might be. In this light the avant-garde has never been a monolithic entity but rather a loose amalgam of factions, sometimes in uneasy truce, sometimes in conflict; even internally a given group is often in vital controversy over the crucial question "Where next?"

And so we find Josephson moving in and out of Dada, opposed to the literary establishment in New York but gaining no consensus among his peers, in conflict finally with a Breton whom he wanted desperately to enlist in *his* cause. Breton, of course, was iron-willed and hardly disposed to bend to an upstart American. He had his own battles to fight with the French Communist Party as well as his own adherents. Out of this farrago of cross-purposes and misunderstandings, Franco-American alliances suffered in the 1920s. Not until the next decade did Surrealism reach America for another round of cultural politics.

Notes

1. See Tashjian, *Skyscraper Primitives: Dada and the American Avant-Garde, 1910–1925* (Middletown: Wesleyan University Press, 1975).

2. For a study of Arensberg in New York, see Francis Naumann, "Walter Conrad Arensberg: Poet, Patron, and Participant in the New York Avant-Garde, 1915–1920," *Bulletin, Philadelphia Museum of Art*, 76, No. 328 (Spring 1980).

3. See, for example, Roger Shattuck, who claims that most Americans found only "a fleeting engagement [with Surrealism] in the course of a full career" ("Love and Laughter: Surrealism Reappraised," Introduction to Maurice Nadeau, *The History of Surrealism*, tr. Richard Howard [New York: The Macmillan Company, 1968], p. 32).

4. "A Letter to My Friends," *The Little Review*, 12, No. 1 (Spring-Summer 1926), p. 17.

5. Ibid, pp. 17–18.

6. "Instant Note on Waldo Frank," *Broom*, 4, No. 1 (December 1922), 59–69.

7. For an account of the bearded heart episode and Breton's Congress of Paris, see William A. Camfield, *Francis Picabia* (Princeton: Princeton University Press, 1979), pp. 176–82.

8. "After and Beyond Dada," *Broom*, 2, No. 4 (July 1922), 347; "The Great American Billposter," *Broom*, 3, No. 4 (November 1922), 304–12.

9. See the provocation of Ernest Boyd, "Aesthete: Model 1924," *The American Mercury*, 1 (January 1924), 54–56.

10. "A Letter to My Friends," p. 18.

11. "Microcosm: Concerning Super-realism," in Miscellaneous Fragments File, Josephson Papers, Yale University, unpaginated.

12. Ibid.

13. Ibid.

14. "A Letter to My Friends," p. 18.

15. *Legitimate Defence,* in André Breton, *What is Surrealism?: Selected Writings,* ed. Franklin Rosemont (New York: Monad Press, 1978), pp. 32, 39.

16. "Microcosm."

17. Hayden White, "The Politics of Historical Interpretation: Discipline and De-Sublimation," in *The Politics of Interpretation,* ed. W. J. T. Mitchell (Chicago: University of Chicago Press, 1983), pp. 119–21.

18. For a discussion of the concept of avant-garde movement, see Renato Poggioli, *The Theory of the Avant-Garde* (New York: Harper and Row, 1971), pp. 17–40.

19. *Lecture on Dada* (1922), in *The Dada Painters and Poets,* ed. Robert Motherwell (New York: Wittenborn, 1967), pp. 246–47.

20. For a view of culture that has conflict intrinsic to it, see Anthony F. C. Wallace: "culture . . . is characterized internally not by uniformity, but by diversity of both individuals and groups, many of whom are in continuous and overt conflict in one sub-system and in active cooperation in another" (*Culture and Personality* [New York: Random House, 1969], p. 28). Another theoretical study that attempts to establish relationships between the cultural life of urban groups and their political activities is Abner Cohen, *Two-Dimensional Man: An Essay on the Anthropology of Power and Symbolism in Complex Society* (Berkeley: University of California Press, 1976). Cohen does not take up the avant-garde as an urban group, although it would certainly fall within his purview.

21. I have coined the term "Culture network" as a variation on "art network," used by Jacques Maquet, *Introduction to Aesthetic Anthropology* (Reading, Mass.: Addison-Wesley, 1971), pp. 3–6.

Marcel Duchamp's Approach to New York: "Find an Inscription for the Woolworth Building as a Ready-Made."

Craig Adcock

Many aspects of Marcel Duchamp's influential oeuvre were completed, or perhaps one should say "incompleted," during the period that he was involved with New York Dada. He arrived in America in July 1915 and soon began the actual construction of the *Large Glass* (Fig. 1) and the process of working out the final conceptualization and intellectualization of the ready-mades. These activities contributed to the strongly intellectual disposition of New York Dada. Duchamp's earliest ideas about his interrelated projects of making the *Large Glass* and the ready-mades had been formulated in Paris during the preceding few years – from say late 1912 to mid 1915 – but they owed an important part of their ultimate character to New York and to America.

Among other things, Duchamp's basic vocabulary was affected by his arrival in the United States. As he learned English, he discovered that certain terms in the new language did not have exact equivalents in French and vice versa. The most important such term was *ready-made*. One of the first things that he did in the United States was to adopt this useful word and apply it to one of the central aspects of his work. Earlier he had used the French expression "le tout fait, en série" for the mass-produced objects that he occasionally brought within the boundaries of the art process through acts of choice. The early Parisian "ready-mades" include the Bicycle Wheel of 1913 and the Bottlerack of 1914, but only retroactively were these objects called "ready-mades."

The English term was derived from a particular New York usage associated with the fashion industry: "ready-made garments." Part of Duchamp's fascination with the term had to do with the way he could use it to imply that works of art were cloaked in mere appearance and that their interpretation and evaluation changed according to systems amounting to nothing more serious than fashion.[1] The use of the English designation thus gave the ready-mades another dimension of meaning – one that added to the significance of the original French expression without wholly supplanting it. By intricating subtle language variations into the ready-mades, Duchamp could engage in a kind of transatlantic interchange of meaning.

Figure 1. Marcel Duchamp. *The Bride Stripped Bare by Her Bachelors, Even* (the *Large Glass*). 1915–23. Oil and lead wire on glass. 109¼ x 69⅛ in. Philadelphia Museum of Art: Bequest of Katherine S. Dreier.

Both the English, with its connotative associations involving fashion, and the French, with its references to the iterative actions of manufactured objects coming off assembly lines, were essential to the ways Duchamp thought about ready-mades, but, beyond the simple intentional overlay of the terms, he discovered that he could use the shifts in meaning – shifts that were in some sense related to the transformational nature of moving himself and other objects from place to place – as an additional level of metaphor. His philosophical examinations involved arbitrariness in art and art making. Perhaps what Duchamp considered most Dada about the process was how easily things could be transformed through movement. Moving something from place to place – both physically and conceptually – seemed to have far more power than was reasonable. *Nude Descending a Staircase* had been transformed by its trip across the ocean in 1913. It had moved from a position of virtual obscurity to the center of a cause célèbre. Equally interesting things seemed to happen when ordinary objects – like snow shovels or urinals – were displaced from their ordinary world and moved into the more rarefied world of art. Their re-placements transformed their significance.

Duchamp's transformational approach to meaning is well demonstrated by one of the first objects in New York that he considered naming a ready-made. In one of the notes that he wrote shortly after his arrival, he suggests using the Woolworth Building as a ready-made. I will quote the entire note here in translation for convenient reference:

Recopy and correct
I. Show case with sliding glass panes – place some *fragile* objects inside. – Inconvenience – narrowness – reduction of a space, i.e., a way of being able to experiment in three dimensions as one operates on planes in plane geometry –
– Placing on a table the largest number of *fragile* objects and of different shapes but without angles and standing upright on a level base of some width, i.e., providing some stability. – *Assemble as many objects as possible on the table in height* and consequently avoid the danger of their falling, of breaking them, – but nevertheless *squeeze them together as much as possible* so that they fit together one into the other (in height I mean).
Perhaps: make a good photo of a table thus prepared, make *one* good print and then break the plate. –
– Same exercise in a box. 1st: Make a kind of background with the same objects this time lying on their rounded parts in semi-stability, *prop them up* one with the other. 2nd: Put a paper on top and remake a second *layer* above, using the *holes* left by the layer underneath, and continue thus.
– Shoe polish. Red and yellow.
II. With a glass-front highboy closed by sliding glass panes on ball bearings, etc. – one obtains the figure of a space, a figure analogous to the figure of a plane in geometry, i.e., one can use this figure of a space and demonstrate as one demonstrates theorems by constructing, on paper, lines corresponding to the hypothesis. Do not be tempted to make the ridiculous comparision – objection – that a table or a glass pane for example is to the drawing [of a plane] what this glass-front highboy is in relation to . . .

Find an inscription for the Woolworth Building as a ready-made. January 1916[2]

If the specific date on this note is correct, Duchamp had only been in New York for five or six months when he had his idea of using an entire building

for a ready-made. His recent transatlantic movement had altered his possible choices. The specific reference to the famous New York monument gives the note an American cast. Begun in 1913, the Woolworth Building was still under construction when Duchamp wrote his note. When the building was completed in 1918, its height of 792 feet made it the world's tallest skyscraper. Duchamp's desire to use the neo-Gothic building as a ready-made is indicative of one of his most interesting strategies: he often conjoined the topical, even the trivial, with concepts that had far greater importance.

The radicality of Duchamp's combinatorial approach becomes evident when the context of his reference to the Woolworth Building is taken into consideration – a context that locks the potential ready-made's meaning into the iconography of the *Large Glass.* The world's tallest building, when taken as a ready-made, becomes a humorous Dada object. But it can also stand for a mathematical situation. More specifically, the building can be used to symbolize certain characteristics of the fourth dimension – and this last is apparently what Duchamp had in mind. By 1916, he had already incorporated a great deal of speculative geometry into the iconographical program that he was working out for the *Large Glass.*[3]

Duchamp used several branches of advanced geometry to enrich and to complicate his art. At first glance, the reference to the Woolworth Building may seem nothing more than an offhand addendum, but it becomes significant when considered in relation to Duchamp's architectural method of describing four-dimensional geometry – even more so when his purposes for using such a geometry are taken into consideration. During the nineteenth century, these kinds of mathematical systems had had profound impacts upon philosophy – and from there, they had had profound impacts upon Duchamp.[4] That the Woolworth Building was implicated in his program of combining art and mathematics is supported by one of his notes from *À l'Infinitif.* Here, he explains that:

The shadow cast by a four-dimensional figure on our space is a *three-dimensional* shadow (see Jouffret, "Geometry of Four Dimensions," page 186, last three lines).
Three-dimensional sections of four-dimensional figures by a space: by analogy with the method by which architects depict the plan of each *story* of a house, a four-dimensional figure can be represented (in each one of its *stories*) by three-dimensional sections. These different stories will be bound to one another by the fourth dimension. Construct all the three-dimensional states of the four-dimensional figure the same way one determines all the planes or sides of a three-dimensional figure – in other words:
A four-dimensional figure is perceived (?) through an infinity of three-dimensional sides which are the sections of this four-dimensional figure by the infinite number of spaces (in three dimensions) which envelope this figure. – In other words: one can *move* around the four-dimensional figure according to the four directions of the continuum. The number of positions of the perceiver is infinite but one can reduce to a finite number these different positions (as in the case of *regular* three-dimensional figures) and then each perception, in these different positions, is a three-dimensional figure. The set of these three-dimensional perceptions of the four-dimensional figure would be the foundation for a reconstruction of the four-dimensional figure.[5]

With the workings of this note in mind, the metaphorical potential of an appropriated piece of architecture becomes clear. The note refers to Esprit Pascal Jouffret, the mathematician who, along with Henri Poincaré, provided Duchamp with most of what he knew about mathematics.[6] The book mentioned is Jouffret's *Elementary Treatise on Four-Dimensional Geometry*.[7] In this general textbook, Jouffret explains the workings of *n*-dimensional geometry. At one important point, he says that although our world seems to have only three dimensions, and while it is thus perfectly understandable that we should think of three-space as the *only* space, more complex arrangements can be imagined: normal space can be thought of as a field of the third degree immersed in a field of higher degree, namely, a four-dimensional continuum, or an "étendue," as he calls it in French. Jouffret explains that, when conceptualized in such terms, "our space is only an elementary *slice* out of the four-dimensional continuum surrounding it on every side. From the point of view of the fourth dimension, space is infinitely thin and absolutely flat, and this is true for every entity it contains" (pp. 183–84). Duchamp uses a similar kind of argument, but adds his own architectural metaphors. He explains that an architectural plan, which amounts to a two-dimensional plane, can be thought of as a "section," or "slice," through the three-dimensional space of a building. If the plan is displaced vertically, it generates the entire structure. The space can also be generated by displacing one of the sides of the building horizontally. In more general terms, this approach is, of course, still a standard way of constructing figures in elementary geometry: a point is displaced to generate a line, a line to generate a plane, a plane to generate a solid, etc. Duchamp applies this kind of constructive method to architecture. From his point of view, the three-dimensional space of a building can be thought of as a stack of infinitely thin "plans" or planes. If, as a next logical step, the entire three-dimensional building is thought of as an "infinitely thin slice" contained within the "étendue," it becomes, in some sense, a "plan" for a four-dimensional structure. In these terms, the ready-made Woolworth Building can serve as an embodiment of Duchamp's geometrical metaphors.

When Duchamp extrapolates from his discussion of three-space to a discussion of four-space, he enters a speculative world. He argues that "a four-dimensional figure is perceived (?) through an infinity of three-dimensional sides which are the sections of this four-dimensional figure by the infinite number of spaces (in three dimensions) which envelope this figure." In this analysis, Duchamp follows the word "perceived" with a question mark. Jouffret had also expressed a certain amount of skepticism about seeing four-dimensional figures: he says that while it is perfectly possible to conceive of the fourth dimension, and of four-dimensional objects, it is impossible to *perceive* them. Duchamp, at this same juncture, again adds his own speculations: he suggests that through movement, through changing points of view, it might be possible, if not to see, at least to reconstruct four-dimensional figures. He suggests that if perceivers could get into the fourth dimension and move around, they would then be able to look back and perceive a series of three-dimensional "sections" of four-dimensional objects. As he puts it in the note, "the set of these three-dimensional perceptions would be the foundation for a reconstruction of the four-dimensional figure."

Duchamp learned much of what he knew about multi-dimensional spaces from Jouffret's discussions of different *n*-dimensional "fields." Duchamp's mathematical notes examine the same kinds of mathematical structures. In general, he is concerned with establishing ways of conceptualizing a "field of the fourth degree" or a four-dimensional continuum. One approach that he uses involves going down one step in dimensionality. Because it is difficult to imagine a four-dimensional space, a space "superior" to ours, it might be helpful to imagine how beings living in a two-dimensional space, a space "inferior" to ours, might operate.

For this analogy, Duchamp relies upon Jouffret. When we turn to the passage in Jouffret's book that Duchamp specifically mentions, we encounter the concept of a cast shadow. In the "last three lines of page 186," Jouffret suggests doing the following: "In this regard [imagining what the fourth dimension is like], consider the horizontal shadow that attaches itself to you as you walk along in the sun, and that, long or short, wide or narrow, repeats your movements as if it understood you, although it is only an empty semblance" (p. 186). Jouffret uses his example of the behavior of a two-dimensional cast shadow to introduce a discussion of the perceptual world of "flat-beings" and the more general problem of perceiving $(n + 1)$-dimensional configurations from *n*-dimensional points of view. He argues that "the things that are in [the horizontal plane on which we walk] are only the *sections* made through it by the three-dimensional bodies occupying the space in which it is immersed, or better the *contact surfaces,* the *interfaces,* of these same bodies with the plane." Solid, three-dimensional "figures" are, in their turn, "the *intersections* or the *interfaces* of space with *four-dimensional bodies*" (pp. x–xi).

Jouffret and Duchamp following his lead use the analogy of the cast shadow in relation to these kinds of "intersections." If we could somehow get into the four-dimensional continuum, we would be able to see the three-dimensional "shadows" cast by four-dimensional objects. These "shadows" would be "at the superficies" of the fourth dimension and they would be perceptible only "for an eye that looked at space as we look at the plane which is under our feet" (pp. x–xi). The force of the analogy is this: if we were inside a given *n*-dimensional space, we would not be able to see any kind of projection made on that space. Two-dimensional beings cannot see the shadows that are cast on their surface world; they can only perceive them edge-on as infinitely thin lines. The same situation would obtain for three-dimensional beings (ourselves) in relation to projections made on our space from the fourth dimension: we would only be able to perceive such projections as shadows, "edge-on."

Because four-dimensional objects cannot be observed, and also because the observation of "regular" three-dimensional solids is not really equivalent to the perception of projections from the fourth dimension, but rather to the perception of some strange kind of edge, Jouffret argues that they are "abstractions existing only in our thoughts." They are intellectual extrapolations built up from the geometrical components of the normal three-dimensional world. But even these kinds of mental reconstructions are very difficult to imagine: "certain brains are not easily accustomed to [thinking about the fourth dimension]" (pp. x–xi). Duchamp was also concerned with difficult

abstractions. He was interested in manipulating the ways that "brains" conceived aesthetic "facts."

In one of his notes from the *Green Box,* Duchamp suggests "losing the possibility of recognizing or identifying two similar things."[8] He is concerned with "brain facts," or "cervellités," as he calls them in his French neologism. He arranges his discussion around categories of objects that are closely related to ready-mades – ones that seem particularly aligned with notions of fashion: "two colors, two laces, two hats, two forms whatsoever." In terms of such ready-mades, he wants "to reach the impossibility of sufficient visual memory to transfer from one like object to another the memory imprint. Same possibility with sounds, with brain facts."[9] From the point of view of the fourth dimension, any three-dimensional form can be thought of as "infinitely thin"; it can be conceptualized as a very complex kind of shadow. With these points in mind, it seems likely that Duchamp was interested in the fourth dimension as a "leveling" device.

This interpretation is reinforced by a statement in another of Duchamp's notes: "Two forms cast in the same mold (?) differ from each other by an infra-thin separative amount."[10] When the forms of Duchamp's ready-mades are cast as shadows, they become "infra-thin." In a certain sense, the projective characteristics of *n*-dimensional geometry, in general, act as Duchamp's "mold." It was through this process that he manipulated "brain facts." The "infra-thin" separation that he was concerned with had something to do with the "separation" between "works of art" and "ready-mades." As it worked out in the subsequent history of art, such separations were much thinner than anyone expected – shadows could be cast from any object whatsoever.

In the first part of his Woolworth Building note, Duchamp is concerned with a kind of showcase with sliding glass panes – with a "glass-front highboy." The notion of a glass case suggests the way Duchamp thought about the *Large Glass* as being a kind of "container." In one of his early notes included in the *Green Box,* he suggests putting "the whole bride under a glass case, or into a transparent cage."[11] Thus, when he suggests doing geometrical experiments with three-dimensional objects inside the space of the highboy in a way that would be similar to doing experiments with drawn figures on a plane, *n*-dimensional geometry immediately comes to mind. We know that Duchamp intended to carry out such geometrical experiments on the two-dimensional glass panes of the *Large Glass:* on several occasions he says that the "bride" was supposed to be "four-dimensional."[12]

In his discussion of the highboy, Duchamp has gone up one step from the two-dimensional surface of the *Large Glass* into the three-dimensional space of the glass showcase. Central to any interpretation of this situation is that the objects inside the showcase would, almost by necessity, be ready-mades; they would be everyday mass-produced objects placed on shelves for display. As such, they would be "fragile": the status of ready-mades is still debated. They teeter on some edge between art and nonart – and their continued existence within the world of aesthetics suggests that what we claim as knowledge about the makeup of art objects, in general, is still very much in doubt.

This aspect of the iconography of the *Large Glass* can be related back to the

"shadow" and "section" analogies that Duchamp uses in relation to the fourth dimension. If the glass case of the highboy were flattened by undergoing a projective transformation, the ready-made objects it contained would also be flattened; they would, essentially, become shadows. That Duchamp was interested in such transformations is strongly reinforced by the fact that he took photographs of shadows cast by ready-mades in his New York apartment in 1918 (see Fig. 2). What makes these shadows especially interesting in the present context is their close formal similarities to the flat shapes of the "Bride" in the upper panel of the *Large Glass* (compare Fig. 1). The flat forms of the "Bride" are very much like the flat forms of shadows cast from ready-mades. As we have already seen, the projective metaphor of a "shadow" can, in a sense, be "cast" on the superficies that may exist between different *n*-dimensional spaces. If the "glass case" of the *Large Glass* is taken to be a flattened highboy, then the "bride" becomes a "figure of a space" — namely, an "infinitely thin" layer containing ready-mades.

It is in this same sense that Duchamp uses the concept of a "section" in his discussions of the "étages" of buildings. With the workings of *n*-dimensional geometry in mind, the Woolworth Building can be thought of as a large-scale "glass case" or a very tall "highboy." This suggestion becomes more plausible when we remember that Duchamp proposed using size differences in the reconstruction of an image of the fourth dimension. In another note from *À l'Infinitif*, he says that "two 'similar' objects, i.e. of different dimensions but one being the replica of the other (like two deck chairs [chaises 'transatlantiques'], one large and one doll size), could be used to establish a four-dimensional perspective — not by placing them in relative positions with respect to each other in three-dimensional space, but simply by considering the optical illusions produced by the difference in their dimensions."[13] Duchamp is here using the term *dimension* in its more mundane sense of "size" to get at the more complex notion of inter-dimensionality.

In the Woolworth Building note, Duchamp appears to have something similar in mind. He is, if not directly comparing, at least juxtaposing a small-scale glass case — the highboy — with a large-scale glass case — the world's tallest skyscraper. The French term that he uses for his "cases" provides additional credence for this idea: a *vitrine* is both a "showcase" and a "shop window." In ways that are analogous to what happens in showcases, the shop windows of the Woolworth Building, floor after floor, would have contained ready-mades; they would have contained commonplace, "five and dime" manufactured goods. Also, in some larger sense, the spaces of the building would have housed ready-made sections of the three-dimensional world. The "self-contained" components of the building were part of its contemporary appeal. It was advertised as a kind of microcosm of the city: it had its own generators, barber shops, stores, and restaurants. These could be taken as cross-sections, or slices of life. Given that the "Bride" in the *Large Glass* is four-dimensional and that the Woolworth Building is a kind of "plan" for a four-dimensional configuration, she might have been right at home within its spaces — flattened as she was by the exigencies of Duchamp's speculative geometry.

When considered as an inhabitant of a four-dimensional space, the "Bride"

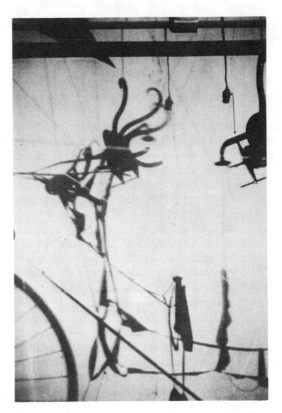

Figure 2. Marcel Duchamp. "Shadows of Readymades." Photograph taken in Duchamp's studio, 33 West 67 Street, New York, 1918. Collection Mme. Marcel Duchamp, Villiers-sous-Grez.

begins to resemble figures in Duchamp's earlier cubo-futurist paintings. Among the most important precursors to the "Bride" in the *Large Glass* were the "nudes" in his two versions of *Nude Descending a Staircase*. These works can also be interpreted in terms of Duchamp's interest in n-dimensional geometry.[14] In the present context of a discussion of the Woolworth Building being a metaphor for the fourth dimension, it is perhaps important to remember that the different stories of buildings are connected with staircases. At any rate, the geometrical implications of Duchamp's earlier paintings are related to the "translational" similarities that he finds between geometrical "sections" and the "étages" of multistoried buildings. Moreover, the moving nudes in the paintings can be used as illustrations for his suggested method of moving around the "interfaces" between the third and the fourth dimensions in order to accumulate a sufficient number of different views to "reconstruct" the four-dimensional figure.

Nude Descending a Staircase, No. 1 (Fig. 3) depicts a more or less recognizable "nude." Various "sections" are repeated "cinematically" as the figure spirals down the staircase. The movement generates multiple images that

are then frozen, or "demultiplied," in a painting technique that emulates chronophotography. *Nude Descending a Staircase, No. 2* (Fig. 4) is more complex. One possible reason for Duchamp's making the second version more intricate is that he was trying to represent a more complex kind of space. From this point of view, the first version, rather than being simply a study, would represent an intermediary in a sequence of spatial transformations leading up to the fourth dimension. "Elementary parallelism" is the term that Duchamp uses for his constructive method of generating $(n + 1)$-dimensional configurations by displacing n-dimensional configurations. The first three steps in this process—from point to line to solid—are perfectly straightforward, but the next step of displacing a solid to generate a four-dimensional object is quite complex. This complexity is suggested, but only suggested, by an illustration from Jouffret (Fig. 5). A displacement into the fourth dimension would have to occur along some strange set of "axes," simultaneously perpendicular to every possible axis in three-dimensional space, but not contained within three-dimensional space; in other words, the displacement would have to be in directions that were 90 degrees from everything else. This kind of complexity is only hinted at by the dotted line in the fourth diagram of Jouffret's illustration.

Duchamp's second version of *Nude Descending a Staircase* may have been intended to represent a four-dimensional situation. The "sections" through "Nude No. 2" seem to be interfused, rather than just repeated. In the first version, we can take the space of the stairwell to be three-dimensional. The nude then becomes a series of flat images generated through the movement of a normal object through normal space—much like the situations represented in chronophotographic images. If, in the second version, we take the stairwell to represent some part of a hypothetical four-space—as Duchamp's geometrical use of buildings would seem to legitimate—then the forms describe something far less familiar. As Jouffret pointed out, three-dimensional space and all the objects in it are "infinitely thin," when seen from the fourth dimension. From such a vantage, they are perceptually compressed into something like two-dimensional planes. A fundamental analogical problem arises at this point, however, because three-dimensional space as an "infinitely thin slice" is not a plane; it is a three-space that has been folded back upon itself in an infinite number of ways. Movement through such a multilayered space may be what Duchamp intended to represent in *Nude Descending a Staircase, No. 2*—the flat "sections" in the painting seem to reverberate through the canvas; they seem to interpenetrate, to fold back into one another, as if the figure generating them were moving through some multiply compressed environment.

In this paper, it has been suggested that Duchamp used geometrical complication as a metaphor for the more general complication involved in the interpretation and evaluation of art objects. His arrival in New York facilitated this process. Duchamp wrote his suggestion about the Woolworth Building in January 1916. During that same month, he wrote a letter to his sister Suzanne in Paris.[15] He explains to her that he had decided to use the English word "ready-made" for the "tout fait" sculptures that he had been choosing since 1913. In his apartment in Paris she would find two such objects: the

Figure 3. Marcel Duchamp. *Nude Descending a Staircase, No. 1.* 1911. Oil on cardboard. 37¾ x 23½ in. Philadelphia Museum of Art: The Louise and Walter Arensberg Collection.

Bicycle Wheel and the Bottlerack. The activity of making "ready-mades," in his newly developed English sense of the term, involved inscribing them with a more or less nonsensical English expression. He explains that since he had been in New York he had added the inscription "In Advance of the Broken Arm" to a Snow Shovel and "Emergency in favor of twice" to another object that he does not specify in the letter.[16] He then suggests that he would like to retroactively create a "ready-made" out of the Bottlerack by having her write an inscription, that he would send along later, on the inside of its bottom rung.[17] She should also sign it for him with the phrase: "[after] Marcel Duchamp."

Duchamp's activities in New York thus take on some interesting parameters. At the moment he was considering inscribing the Woolworth Building—a then very prominent example of a particularly American phenomenon, the skyscraper—he was engaged in additional transatlantic interchanges involving objects that had not quite yet become "ready-mades." His arrival in New York allowed him to transform ordinary objects (some French and some American) into "ready-mades" through both action and retroaction. Snow Shovels are American hardware items; Bottleracks are

Figure 4. Marcel Duchamp. *Nude Descending a Staircase, No. 2.* 1912. Oil on canvas. 58 x 35 in. Philadelphia Museum of Art: The Louise and Walter Arensberg Collection.

French.[18] Duchamp was concerned with their "Americanness" and their "Frenchness" as "slices" of cultural difference. In this sense, his position in New York provided him with a useful approach to his Dada activity. He could use the cultural distance between France and the United States and his own movement from country to country as a way of implicating additional levels of doubt into his analysis of how things were chosen to be art or not art.

Infra-thin slices, geometrical sections, shadows, castings, the *Large Glass*, ready-mades—they were all associative concepts in Duchamp's thinking. By conflating them, he could imply that, in some sense, geometrical transformations were analogous to aesthetic transformations. From certain points of view, works of art—and ready-mades—appeared to be as flattened, as diminished, as geometrical solids seen from the vantage of the fourth dimension. Duchamp's approach certainly has its humorous side, but he put the lighthearted together with the serious. Their interrelationships were complex. By associating his ready-mades with the transformational nature of n-dimensional geometry, he could entail profound epistemic considerations within his own intellectual, and funny, brand of New York Dada.

Figure 5. "The first four fields and their perpendicular," from E. Jouffret, *Traité élémentaire de géométrie à quatre dimensions* (Paris: Gauthier-Villars, 1903), p. 195.

Notes

1. For one of Duchamp's later statements explaining this attitude, see his interview with Otto Hahn, "Marcel Duchamp," *L'Express* (Paris), No. 684 (July 23, 1964), p. 22: "Le goût est momentané, c'est une mode. Mais ce que l'on considère comme une forme esthétique est débarrassé du goût. On attend donc cinquante ans, et la mode disparaît. Les choses prennent alors un sens. En fin de compte, c'est une entourloupette: une autre forme de goût. Ce qui ne l'était pas sur le moment le devient plus tard. Si on est logique, on doute de l'histoire de l'art."

2. Marcel Duchamp, *Salt Seller: The Writings of Marcel Duchamp (Marchand du Sel)*, ed. Michel Sanouillet and Elmer Peterson (New York: Oxford University Press, 1973), pp. 74–75.

3. For more detailed analyses of Duchamp's uses of geometry, see Craig Adcock, *Marcel Duchamp's Notes from the Large Glass: An N-Dimensional Analysis* (Ann Arbor: UMI Research Press, 1983); and Linda Dalrymple Henderson, *The Fourth Dimension and Non-Euclidean Geometry in Modern Art* (Princeton: Princeton University Press, 1983).

4. For a discussion of the philosophical influences of mathematics on Duchamp's development, see Craig Adcock, "Conventionalism in Henri Poincaré and Marcel Duchamp," *Art Journal,* 44 (Fall 1984), 249–58.

5. Duchamp, *Salt Seller,* pp. 89–90.

6. For a more complete discussion of Duchamp's possible mathematical sources and their relative importance, see Adcock, *Marcel Duchamp's Notes from the Large Glass,* pp. 29–39; and Henderson, pp. 117–30.

7. E. Jouffret, *Traité élémentaire de géométrie à quatre dimensions et introduction à la géométrie à n dimensions* (Paris: Gauthier-Villars, 1903); subsequent references to this edition appear in the text.

8. Duchamp, *Salt Seller*, p. 31.

9. Ibid.

10. Marcel Duchamp, *Notes*, ed. and tr. Paul Matisse (Paris: Centre National d'Art et de Culture Georges Pompidou, 1980), No. 18.

11. Duchamp, *Salt Seller*, p. 30.

12. See, for example, his statement to Pierre Cabanne, *Dialogues with Marcel Duchamp*, tr. Ron Padgett (New York: Viking, 1971), p. 40.

13. Duchamp, *Salt Seller*, p. 75.

14. For a more detailed discussion of the geometrical implications of these paintings, see Adcock, *Marcel Duchamp's Notes for the Large Glass*, pp. 141–46.

15. The original letter is now in the Archives of American Art, Washington, D.C. A translation of the letter has been published by Francis M. Naumann, "Affectueusement, Marcel: Ten Letters from Marcel Duchamp to Suzanne Duchamp and Jean Crotti," *Archives of American Art Journal*, 22, No. 4 (1982), 5.

16. This readymade has either been lost or the connection between the phrase and an extant object (or idea for an object) has been lost.

17. This phrase has apparently been lost. By the time Duchamp wrote his letter, Suzanne had probably already thrown out the Bottlerack when she cleaned his apartment. See Cabanne, p. 43; also Naumann, p. 18, n. 10.

18. The specifically American and French qualities of the Snow Shovel and the Bottlerack are noted in a review article by Michel Butor, "Reproduction interdite," *Critique* (Paris), No. 334 (March 1975), pp. 270–72.

Morton Livingston Schamberg: Notes on the Sources of the Machine Images

William C. Agee

The machine images produced in 1916 by the short-lived Morton Livingston Schamberg (1881–1918) are among the most compelling Dada-related works done by any American artist. Until 1982, the extant body of these images was thought to consist of eight oils and one watercolor, the most famous of them the paintings at Philadelphia (Fig. 1) and Yale (Fig. 2). However, the number and scope of machine works increased dramatically in the fall of 1982 with the discovery of fourteen pastels from a private collection in Philadelphia. The discovery came in the final stages of the preparation of a Schamberg retrospective at the Salander-O'Reilly Galleries in New York, as this writer's catalog was on press.[1] Although the pastels were reproduced and a short note included, their full implications for Schamberg's art only began to unfold after they were viewed in the context of the exhibition. Thereafter, sixteen other machine pastels have come to light, bringing the total to thirty and establishing a significantly larger and more complex group of machine images than was thought to have existed at the time of the initial discovery.

Taken together, the pastels and oils have spurred interest in the evolution of Schamberg's machine imagery. Fundamental to this study has been research on the sources of the machines depicted. Just what, we want to know, are these machines? This is no idle question, for if we can properly determine their origin we can gain useful and illuminating insights into Schamberg's working methods and his point of view toward the modern industrial world during the midst of the cataclysmic upheavals of the First World War. In turn,we may then ask further questions on the nature of the relationship of American art to the aesthetic revolution wrought by the international Dada movement.

Schamberg was born in Philadelphia on October 15, 1881,[2] the youngest of four children in a prosperous and conservative German family. He lived in Philadelphia his entire life, although he spent considerable time in Europe and New York. He apparently turned most of his attention to New York during 1916 and thereafter, until he succumbed to the flu epidemic and died in Philadelphia, on October 13, 1918. Schamberg was one of a long line of im-

Figure 1. Morton Schamberg. *Painting VIII.* 1916. Oil on canvas. 30 x 20¼ in. Philadelphia Museum of Art: The Louise and Walter Arensberg Collection.

portant American artists who either studied or taught at the Pennsylvania Academy of the Fine Arts, Eakins, Anschutz, Marin, Sheeler, Demuth, Carles, and H. Layman Säyen among them. Schamberg studied at the Academy from 1903 to 1906 under William Merritt Chase, and established there a lifelong friendship with Charles Sheeler. Schamberg traveled often to Europe from 1904 on, absorbing the lessons of Whistler, Manet, and Impressionism. In 1908–1909, joined by Sheeler, he studied the Renaissance masters in Rome and Florence. The work of Giotto, Masaccio, and Piero della Francesca, among others, taught the young artists to look beyond the fleeting

Figure 2. Morton Schamberg. *Painting IX.* 1916. Oil on canvas. 30⅛ x 22¾ in. Yale University Art Gallery: Gift of Collection Société Anonyme.

effects of nature to the underlying architectonic structure of painting. This shift reflects the thinking of Leo Stein, whom Schamberg had met in Florence through his friend and fellow student Walter Pach. In early 1909, Schamberg and Sheeler traveled to Paris and in a whirlwind visit saw extensively, for the first time, paintings by Cézanne, Van Gogh, Picasso, Matisse, Braque, and Derain, influences that were apparent in Schamberg's art of 1909–1912. At this time, Schamberg concentrated on landscapes and portraits, marked by strong color and clear structure, placing him among the most accomplished artists of his generation working in a post-Impressionist vein.

68

Schamberg's predilection for the monumental figurative style of Matisse was quickened by the pivotal Armory Show. There, both he and Sheeler were startled by Matisse's "arbitrary use of natural forms which at times amounted to short hand . . . and [which] was more disconcerting than Picasso."[3] In particular, they were struck by Mastisse's *Red Studio* (The Museum of Modern Art, New York), a painting that gave further proof that a work could be "as arbitrarily conceived as an artist wished."[4] Schamberg, however, also absorbed the cubist painting he saw at the Armory Show, particularly the work of the Puteaux Cubists, Gleizes, Villon, Metzinger, Picabia, and Delaunay, and most especially Duchamp's famous *Nude Descending a Staircase* (Philadelphia Museum of Art). These sources launched Schamberg into a series of powerful figures and landscapes during the years 1913–1915, important works in the history of American cubism. His work became increasingly abstract in the course of 1915, and in *Landscape* (Philadelphia Museum of Art) and an untitled abstraction (The Regis Collection, Minneapolis) virtually no recognizable elements are evident. Like most artists of his generation, however, be they American or European, Schamberg at this time pulled back from pursuing a course of cubist-based abstraction.

Rather, in 1916 he pursued the detailed, precisely rendered machine images that associate him with the Dada use of non-traditional, non-art subject matter. The immediate inspiration for these works surely was the veristic illusionism employed by Duchamp in paintings such as the *Chocolate Grinder No. 2* (Philadelphia Museum of Art) of 1914 and Picabia's linear machine style, begun in 1915. Yet the evolution of Schamberg's machine art was far more complex than might be supposed. Although Duchamp and Picabia provided a crucial impetus, it did not appear overnight, full-blown from their example. Schamberg apparently had conceived of mechanical subjects as early as 1912. Constance Rourke, in her 1938 book on Sheeler, reported that Schamberg "talked constantly about pictures he was going to paint in which mechanical objects were to be a major subject, describing them in detail down to the last line and nuance of color. He had, as it turned out, only half a dozen more years to live, but he seems to have refrained from painting in abundance less because of lowered physical vitality than from a sense of frustration."[5]

Even earlier, Schamberg had studied mechanical drawing and architectural drafting while an architectural student at the University of Pennsylvania, where he had graduated in 1903. These subjects would have exposed him to a variety of machine images; and, even more telling, the tools and techniques of drawing used in these disciplines were to reappear in the machine pastels.[6] Twenty pastels, a full two-thirds of the known total, incorporate, to one degree or another, pencil lines drawn in by the compass and/or the ruler, straightedge, and french curve. Some are based primarily on a sequence of circles, curves, and straight lines; in others, only an occasional line drawn by a ruler or compass is apparent. But the pastels, for all their richness of color and surface, can ultimately be traced to techniques learned while Schamberg was a college student, at the turn of the century. While we do not know if Schamberg could have been aware of it, an even earlier tradition of fascination with a machine image existed in Philadelphia. A carefully

rendered ink and watercolor drawing of a lathe by Thomas Eakins (Hirshhorn Museum and Sculpture Garden, Smithsonian Institution) of ca. 1860 shows the same type of drive wheels, belts, and pulleys that Schamberg later found so compelling, and which form the basic elements of his pastels.

Schamberg's first machine painting was formerly thought to be the well-known *Telephone* in the Columbus Museum of Art (Schamberg actually titled these works *Painting;* I have added Roman numerals for purposes of identification, and the Columbus painting is thus *Painting I*). However, the full complexity of the evolution of Schamberg's machine paintings was indicated by the discovery of a photograph of a now-lost painting, also depicting a telephone. (The subject befits a Philadelphia artist, since the telephone was introduced there in 1876 at the Centennial Exhibition.) This painting can be dated to early 1915, prior to the emergence of Picabia's machinist style in the summer of 1915, since it was exhibited in a group show at the Montross Gallery, New York, from March 23 to April 24, 1915. It is a more fragmented, painterly image than the full-blown machine style of either Picabia or Schamberg, but it does establish that Schamberg employed machine images at an earlier date than had been supposed. Thereafter, Schamberg's participation in the Arensberg salon, a hotbed of Dada ideas in New York, doubtless encouraged him to pursue this type of picture.

Walter Pach, his friend and colleague, pointed out in his review of Schamberg's posthumous retrospective held at M. Knoedler and Co., Inc., New York, in May 1919, that Schamberg had indeed appreciated the "work of the Frenchmen, notably Duchamp."[7] Pach, however, always an accurate, considered critic and historian, pointed out that Schamberg did not respond to them "until by a chance, he was led by circumstances outside of his painting to consider the beauty which the makers of machines lent to their work. His incentive in painting themes drawn from the field of mechanics was therefore first-hand observation quite as much as the lead given by other men."[8] Pach's account gives substance to the family tradition that Schamberg took his inspiration from the machines (and machinery catalogs) used by his brother-in-law, who was a manufacturer of ladies' cotton stockings.[9] Investigation into the machines used in hosiery manufacture, while still ongoing, provides important clues for the sources of Schamberg's machine images. Schamberg could have found, in addition to material provided by his brother-in-law, myriad other sources for a wide range of machines in his native city, since Philadelphia had long since been the textile and hosiery manufacturing center of the country. By 1810, for example, Pennsylvania had 136 looms making over 100,000 pairs of hosiery a year; by 1860, there were 71 looms making knit goods, of which 31 alone were making cotton hosiery.[10] That growth continued unabated during Schamberg's lifetime.

Much, and varied, speculation as to the nature and source of Schamberg's machine images has been postulated by historians, including this writer, in the past. Much of it has been inaccurate; however, in light of new research, we can now describe with more, if not always full, confidence just what the machines are that Schamberg depicts in his oil paintings and pastels. Certainly, we are now well past the early stages of research on Schamberg when it was a not uncommon conclusion that these images "eliminate the

70

machine's function"[11] or that they bear "little or no relationship to actual machinery."[12] There can be no doubt that, given the exactitude of the literally rendered elements in both the paintings and pastels, Schamberg drew on specific machines that he knew well and studied carefully. The new research has been fostered, to a great extent, by the images in the pastels. However, it should be emphasized that research is continuing and that positive identification for all the paintings and pastels continues to elude us. Most machines, no matter what their purpose, function on the same principles, and the principles of a given machine's design generally evolve slowly, if at all. Thus, because a few elements such as drive wheels, balance wheels, cams, camshafts, flanges, gears, belts, and pulleys form the core of manufacturing machines, it is difficult to locate precisely the source of the internal workings of one specific machine. In the pastels, Schamberg most often focused on a particular element, removed from its larger context of the full machine.

With this in mind, we can now usefully review those oils for which we have new information, and examine, for the first time, the machine sources of the pastels.

I previously believed that *Painting II* (Neuberger Museum, State University of New York at Purchase, Gift of Mr. Roy R. Neuberger) was an exception among the oils and was an abstract composition and not based on a real machine.[13] I had speculated that this small, gemlike painting was composed of abstract forms related, not to Duchamp or Picabia, but to Jean Crotti's *Les Forces méchaniques de l'amour en mouvement* (Private Collection), a machinist-type painting done while Crotti was in New York in 1916, and reproduced in the New York *Evening World* for April 4, 1916. There are compositional parallels in the way both pictures employ a curved form connecting with circular elements, but I now believe that Schamberg's painting was based on a specific machine, and that it is not an abstract painting at all. First, since all the other 1916 works by Schamberg are based on real machines or machine parts, there is little reason to think that one painting would be the exception. By the same measure, I am now certain that Schamberg's fluid *Watercolor* (Columbus Museum of Art), which I had previously termed as "abstract" except for the prominent flywheel centering the picture,[14] is also based primarily on a specific machine, although he appears to have distilled the machine elements and placed them within a cubist setting of generalized machine forms.

In each case, the revision in the perception of these pictures has been prompted by these pastels, which contain similar elements. While the curving element in the Neuberger picture has not been identified, it may be a metal flange – but certainly it is a real machine element. This identification is suggested by partial forms of this shape in two pastels. We can, however, be surer about the two circular forms at center right and lower right of *Painting II*. The element closest to us appears to be a cam, a part common, of course, to all types of machines, and a part suggested by what may be cams bolted to plates depicted in at least twelve pastels. Partially visible behind this element, at the lower right, is half of a pulley system; we see only a portion of the wheel, with the right-hand portion of the belt descending in full

view, and the left half barely visible amid other machine shapes. Pulleys, or partial views of the wheels and belts of a pulley system, comprise the sole subject of at least seven pastels, and may be part of the depicted machinery in several others. In the Columbus watercolor, the linear, rectangular zones at the center, played off against the two arcs at center right, clearly suggest similar shapes and contrasts in certain pastels.

Painting VI (The Regis Collection, Minneapolis), in some ways the most realistic of the machines, was until recently the most frequently misidentified. It was viewed as a camera flashlight[15] until 1982, when closer study demonstrated that Schamberg had depicted a textile machine. The image became evident when the painting was turned ninety degrees to the right. As he did in all his machine images, Schamberg removed the machine from the industrial environment, but its basic function was not disguised. For the sake of the picture's balance, to pinpoint the image as closely as possible to the center of the canvas, Schamberg tilted the machine and suspended it in a neutral space. This compositional device is a hallmark of virtually all of Schamberg's machinist works. I identified the painting in 1982 as depicting a textile splicing or threading machine. It is not a splicing machine, but it does relate to threading: we can now identify it as a "roll-feed" or "in-feed" machine for tape or textiles, which introduces the fabric from the large roll at upper left to the main apparatus of the textile manufacturing machine.[16] Speculation that it might have been connected to a splicing function was prompted by incorrectly viewing the band of the fabric at the far right as split or as two separate bands. In fact, it should be read as the same band, although Schamberg does not literally show it as such. The fabric forms a single loop, falling off the edge of the machine, and indicating that the machine itself is at rest, not moving, with the fabric slack, not in tension. A major distinction between the oils and the pastels is just this—the oils show the machines in a state of suspension, while the pastels often depict the machine in motion, creating extraordinary effects of the flow of machine and fabric, of the energy of the machine itself in movement.

Perhaps because certain elements suggest a pump, *Painting VII* (Rose Art Museum, Brandeis University, Waltham, Massachusetts) was originally called *The Well*. The detailing of the machine parts, further elaborated in three related drawings in The Metropolitan Museum of Art, discounted that possibility. In 1982, I suggested it might be a drill press of some sort, but that, too, was off the mark.[17] Rather, the machine is an automatic mixer, a common and basic machine for many industries, including textiles and printing. (It would have been quite possible for Schamberg to have drawn on machine sources in the printing industry since Philadelphia was also a major printing center at that time.) The mixer, which shows a central shaft, propelled by a belt-and-worm drive, extending into a vat, would have been used to mix fabric dyes if employed in textile manufacturing, or paints, inks, or chemicals if used in any one of many diverse industries.

The pictures at Philadelphia and Yale, *Painting VIII* and *Painting IX*, certainly the last in the series of the 1916 oils, represent the culmination of Schamberg's sleek, distilled machines drawing from the formal beauty he found in the industrial machine, a subject theretofore not deemed appropri-

ate for high art. Yet until now they have eluded precise description of their machine sources. Three years ago I related these images to the textile industry, pointing out what I took to be spools of thread or some type of textile, and what appeared to be a mechanical needle in the lower right of the Philadelphia painting.[18]

More recently, the new catalog of the Société Anonyme Collection at Yale identified both paintings as deriving from a sewing machine, pointing out that "because it is viewed from the unfamiliar vantage point of the working end, this has never been noted. The most recognizable parts are the curving forms that hold the thread, and the bobbin in the upper right from which the thread is released."[19] Indeed, certain elements, particularly the balance wheel, do suggest a sewing machine. However, in a search of the catalogs of the Singer Sewing Machine Co., Inc, in New York, for all types of sewing machines made from 1913 to ca. 1922, we do not find one that truly resembles the machine depicted in these two paintings. There were literally hundreds of different types and models, including about twenty-five in a 1913 catalog of sewing machines used solely in the manufacture of men's clothing. In addition to machines for sewing clothing, Singer made machines for, among other uses, sewing dress gloves, work gloves, baseball gloves, tents, sails, tarps, leather goods, shoes, and even for retreading rubber tires. In all except one, there is a wooden bobbin at the top to hold the thread, an element which in fact is not present in either the Yale or Philadelphia pictures. We find instead a metal spool on top of the balance wheel, the main element in the paintings. In only one sewing machine – Singer model number 25–26 of ca. 1922, which was used for stitching straw hats – is there a spool instead of a bobbin.[20] However, other elements of that machine do not coincide with those in the two paintings. Nor do we find in any sewing machine the type of parts detailed along the central axis of the two paintings. Finally, the most telling distinction is that no sewing machine has the curving armature holding the thread that we find as a key element at the upper left in each picture.

Rather, Schamberg took as his model a standard, even classic machine used in the printing industry: the wire stitcher used to bind books (Fig. 3).[21] Since this machine can be modified for use in stapling boxes, for example, it is possible that Schamberg encountered it in a textile mill, but it is so fundamental to printing that Schamberg probably encountered it in this context. The most pronounced aspect of the wire stitcher is the spool and curved armature holding the wire, precisely those elements that distinguish the Yale and Philadelphia paintings. That these images are not of sewing machines can now be further verified by two pastels (e.g. Fig. 4) that clearly relate to the paintings. These pastels show more detailed and more extensive cross sections of the working parts of the machine, all heavier and more complex than those found in sewing machines. One puzzling element found in the pastels, but not in the paintings, is the S-curved line superimposed laterally over the top spool. This hook shape and several variants appear in ten other pastels. It has not yet been identified, but it may have something to do with textile manufacturing, perhaps even a needle or part of a take-up system. Until the precise source can be identified, we are left with the possibility

Acme-Champion Model A Book Stitcher

Figure 3. Wire book stitcher, ca. 1950.

that in these two pastels Schamberg combined elements from a wire stitcher and a textile machine for the enhancement of the design. The two paintings are depicted from opposite sides, thus accounting for the variance in the way we view the curving armature as well as for the more elaborate machinery in the Yale picture. In each painting, however, we can see Schamberg flattening and compressing the elements in images that are less illusionistic than any of the other machine oils. The forty-five-degree angle of the wire spool, for instance, is made nearly vertical, and the distance between this spool, and the balance wheel and pulley, is all but eliminated for the sake of the paintings' composition. With a surer sense of what machine Schamberg actually depicted in these two paintings, we are now able to understand better just how he approached the process of painting. We will be closer yet to this art when we are able to identify accurately two other oils, *Painting IV* (Philadelphia Museum of Art) and *Painting V* (Mrs. Jean L. Whitehill, New York), whose precise sources continue to elude us.

The thirty pastels are much different in their mood and frame of reference

from the oils, since, unlike the paintings, they pulsate with movement and energy. They were probably done simultaneously with the oils and thus they all probably date from 1916, although I earlier felt that a few of the first pastels, those which are more textured and painterly, might conceivably date from late 1915. I have assigned them the title of *Composition,* although we have no evidence as to how Schamberg actually termed them. (To date, no evidence that he ever exhibited them has surfaced. The neutral term *Composition* is in keeping with the spirit behind the straightforward, nonassociative titles, *Painting* and *Watercolor,* that Schamberg gave to his other machine works.) These earliest pastels (Schamberg catalog[22] Nos. 48–52) depict what appear to be cam wheels, seen singly or in pairs, attached to camshafts. Two (Nos. 50 and 52) are connected by seth pins, another (No. 51) is bolted to a plate. At least five (Nos. 53–55, 60, and Fig. 5) focus on the gears and belts of pulley systems, shimmering in high-speed vibration and

Figure 4. Morton Schamberg. *Composition.* 1916. Pastel and pencil on paper. 16 x 10 in.

75

Figure 5. Morton Schamberg. *Composition*. 1916. Pastel and pencil on paper. 5⅝ x 7⅞ in.

motion. They are part of the gear reduction system, connected to the same shaft, used to speed up or reduce the speed of the machine as it runs through its cycle. As Schamberg mastered the pastel medium, he used increasingly refined, sophisticated, and complex compositions in at least nine later works which elaborated on the single cam, or wheel, or combinations of these parts. One of the most successful (Fig. 6) depicts a cam, the camshaft, a drive wheel, and a spool with a bolted plate over which we see the material flowing, even undulating, with the high-speed movement of the machine as it goes through a "take-up" cycle. This cycle may be that of a machine used to examine yarn.[23]

If in fact the pastels derive from a textile knitting machine, we can narrow the possible sources dramatically. Standard texts in the field tell us that the manufacture of ladies' hosiery (the business run by Schamberg's brother-in-law) was based primarily on the "flat full-fashioned knitting machine." Further, as late as the mid-1930s, more than 80 percent of the machines of this type in use in the United States were Reading machines manufactured by the Textile Machine Works in Reading, Pennsylvania. The relatively few other available machines were so similar in design that it is enough to know this most common type.[24] The study of this machine, therefore, will yield preliminary identifications for the machine parts Schamberg may have used in the pastels other than the two related to the wire stitcher.

A group of four pastels, for example, have configurations which are among the most puzzling (e.g. Fig. 7). Examination of photographs of the Reading

machine yields at least three possible sources for the parts depicted. The shaft, which we may call the arm, joins to a cam, which we may call the racer or roller, and may be part of the "fabric-tension release motion."[25] Another possibility is that the arm and "roller" may relate to the parts comprising the "Jack-spring motion" that connects to an operating shaft; or, the parts may belong to the "needle-bar-motion" mechanism, related to the actual sewing of the textile. Also to be considered as a likely source is the hosiery winder (known in ca. 1920 as the Foster winder), a machine used widely since the winding of yarn was essential to the manufacturing process. Here, the yarn would pass over the racer, and this may be precisely what we see indicated by the blurred motion in these pastels. The S curve, or hooked shape across the bottom racer, the same type of element found in the pastels of the wire stitching machine, continues to be a puzzle.

While we can at least define the range of possible sources for these works with some degree of confidence, there is a group of four pastels (Nos. 56–57 and Fig. 8) whose possible sources are completely mysterious. They are the most linear, open, and schematic of all the pastels, with a minimum of color applied as highlights to the curious configurations of line and shape. The circular elements suggest cams, wheels, or spools, and the freely moving linear patterns will at points call to mind the interweaving lines formed by the thread on the most complex sewing machines. However, no further identification is currently possible, for here Schamberg moves to the opposite pole from the rich, illusionistic detail of the wire-stitching pastel to an extreme of delicate, inventive, almost fanciful, distillation. They demonstrate the broad spectrum of mood and composition Schamberg could find in the modern industrial machine.

The pastels speak of a new order, and a new world, departing from the old

Figure 6. Morton Schamberg. *Composition*. 1916. Pastel and pencil on paper. 10¼ x 16 in.

Figure 7. Morton Schamberg. *Composition*. 1916. Pastel and pencil on paper. 9 x
6¾ in.

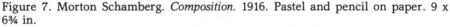

and thus clearly relating Schamberg to a distinctive vein of Dada thought.[26]
At the same time, they demonstrate just how independent Schamberg's
machine art is from that of Duchamp and Picabia, for Schamberg's works
have none of the irony and mockery found in the work of the two French art-
ists. Schamberg's pastels and oils, nevertheless, stand as a major achieve-
ment of American art. They help us to realize the perception of the great art
historian George Heard Hamilton, who, in the original catalog of the Société
Anonyme Collection in 1949, was perhaps the first to understand Scham-
berg's importance, stating "It is not too much to hope that a revival of interest
in his work will reveal his accomplishments in their proper dimensions."[27]

Figure 8. Morton Schamberg. *Composition.* 1916. Pastel and pencil on paper. 7¾ x 6 in.

Notes

1. They are reproduced in William C. Agee, *Morton Livingston Schamberg (1881–1918)* (New York: Salander-O'Reilly Galleries, Inc., 1982). Hereafter referred to as Agee, *Schamberg.*

2. Schamberg's birth date has been sometimes cited as 1882. However, the City of Philadelphia, despite repeated tries in the last three years, has been unable to provide a valid birth certificate.

3. Charles Sheeler, *Autobiography.* Unpublished manuscript, Archives of American Art, Smithsonian Institution, microfilm roll NSHI, frame 73.

4. Ibid., frame 74.

5. Constance Rourke, *Charles Sheeler: Artist in the American Tradition* (New York: Harcourt, 1938), p. 37.

6. The use of these tools and techniques might be usefully compared to the way

they were employed by Patrick Henry Bruce (1881–1936), who also studied mechanical drawing. See William C. Agee, "The Recovery of a Forgotten Modern Master," in William C. Agee and Barbara Rose, *Patrick Henry Bruce: American Modernist: A Catalogue Raisonné* (New York and Houston: The Museum of Modern Art and The Museum of Fine Arts, Houston), esp. pp. 14 and 28–40.

7. Walter Pach, "The Schamberg Exhibition," *The Dial*, 66 (May 17, 1919), 506.

8. Ibid.

9. Ben Wolf, *Morton Livingston Schamberg* (Philadelphia: University of Pennsylvania Press, 1963), p. 30. This has also been confirmed by Schamberg's niece, Mrs. Jean Loeb Whitehill, New York, in conversation with the author, July 1982.

10. Ira J. Haskell, *Hosiery thru the Years* (Lynn, Massachusetts: Carile Mailing Service, 1956), n.p.

11. Dickran Tashjian, *Skyscraper Primitives: Dada and The American Avant-Garde, 1910–1925* (Middleton, Connecticut: Wesleyan University Press, 1975), p. 207.

12. Ibid. See also Earl A. Powell, III, "Morton Schamberg: The Machine as Icon," *Arts Magazine,* 51 (May 1977), 123.

13. Agee, *Schamberg,* p. 14.

14. Ibid.

15. Ibid.

16. Ibid. I am indebted to Lloyd Morgan, Co-Director of The Morgan Press, Inc., Dobbs Ferry, New York, and an expert on printing typography and machinery, for his generous assistance in helping me to identify this and other machines.

17. Ibid.

18. Ibid.

19. Robert L. Herbert, Eleanor S. Apter, Elise K. Kenney, *The Société Anonyme and the Dreier Bequest at Yale University: A Catalogue Raisonné* (New Haven and London: Yale University Press, 1984), p. 586. Schamberg entry prepared with some assistance from Louise Scott.

20. *Catalogue of The Singer Sewing Machine Co., Inc., New York,* 1922, n.p.

21. The model illustrated here is from about 1950, but the basic design has varied little. I owe this first identification of the machine as a wire stitcher to Lawrence Sunden, of Marcus Ratliff, Inc., New York, who designed Agee, *Schamberg* in 1982. He showed the machine to his father and brother, who are printers, and they identified the source. This was confirmed by Lloyd Morgan, who showed me the machine in his plant.

22. Schamberg catalog numbers here and in following entries refer to Agee, *Schamberg,* where the pastels are reproduced.

23. This and the following information has been found primarily in Max C. Miller, *Knitting Full-Fashioned Hosiery* (New York and London: McGraw-Hill Book Company, Inc., 1937) and William Davis, *Hosiery Manufacture* (New York and London: Pitman and Sons, 1920).

24. Miller, p. v.

25. See Miller and Davis.

26. John Elderfield has spoken eloquently of these matters in his "On the Dada-Constructivist Axis," *Dada/Surrealism,* No. 13 (1984), pp. 5–15.

27. George Heard Hamilton, "Morton L. Schamberg," in *Collection of the Société Anonyme: Museum of Modern Art* (New Haven, Connecticut: Yale University Art Gallery, 1950), p. 44.

"My Baroness":
Elsa von Freytag-Loringhoven
Robert Reiss

She was "The Baroness." Scores of friends called her "My Baroness," the Baroness Elsa von Freytag-Loringhoven. Artist, poet, and artist's model, she wore many hats – not to mention coal scuttles and other improvisatory attire – and she held her place in her friends' affections long after her death in Paris in 1927. To the proto-Dadaists – recently emigrated to New York City at the century's teens – the Baroness became a sort of mascot of their cultural program, described by her contemporaries variously as "the mother of Dada" and "the first surrealist." Decidedly original in her art making, she was the creator of much work coeval with that of other seminal participants in the then-emerging New York Dada group. Chronicles of the period tend to footnote the presence of the Baroness in this community, and then only as comic relief to otherwise sound narratives; however, as we shall show, Baroness Elsa was quite literally the *embodiment* of those characteristics we have come to associate with the term *Dada*.

Arriving in New York City from Germany sometime before the Great War, the Baroness and her husband were soon ensconced in a suite at the Ritz Hotel. Her husband returned to his homeland with the declaration of war, and back on native soil is said to have taken his own life in protest against the war's organized fratricide. The Baroness was left in New York widowed, stranded, and impoverished. She migrated downtown, to become one of the uninhibited inhabitants of Greenwich Village. Here she earned a scant living as a model for artists. She is known to have posed for Henri, Bellows, and Glackens, and at the New York School of Art and at the Ferrer School, the anarchist institute associated with Emma Goldman. The writer Bessie Breuer recalled she beheld the Baroness for the first time in the life study class at the anarchist headquarters: "I stood in the rear of the studio. A nude woman – at that time she seemed old, was posing. I was struck not so much by the uglyness of her body but that it seemed used, worn, the legs sinewy and her colour, like her hennaed hair, greenish purple – her breasts and her general colour. She was the first model of the nude I had ever seen. Later on she was to become a familiar and became as I knew her better The Baroness."[1] To visual artists, however, the allure wielded by the Baroness was considerable: she had "the body of a Greek ephebe, with small firm breasts, narrow hips and long smooth shanks," wrote the painter George Biddle.

The artist Sarah McPherson, enrolled in one of the life study classes where the Baroness posed, recalled that the Baroness Elsa asked her, "Sarah, if you find a tin can on the street stand by it until a truck runs over it. Then bring it to me."[2] The Baroness was a pioneer in the fashioning of found objects into the gestural inventory of what is, today, the canon of Dada. Besides posing, she made her own art (Fig. 1). It was Sarah McPherson, together with her sister Bessie Breuer, then Sunday editor-in-chief at the *New York Tribune,* who introduced Marcel Duchamp to Baroness Elsa. Breuer was responsible for the first printed American interview with Duchamp upon his arrival in New York.[3] Sarah's pastel drawings of the Baroness's shapely feet elicited from Duchamp, and other avant-garde artists, whoops of delight,[4] for this generation of artists celebrated playfulness on the canvas of serious art. In another benchmark introduction, Duchamp, in turn, introduced the photographer Berenice Abbott to Baroness Freytag-Loringhoven, a propitious encounter, as the Baroness encouraged Abbott to set her sights toward Europe. There in Paris, of course, Abbott established that portfolio of portraiture relied upon ever since by scholars in documenting the expatriate movement of the twenties. Berenice Abbott has reflected: "The Baroness was like Jesus Christ and Shakespeare all rolled into one and perhaps she was the most influential person to me in the early part of my life."[5]

When she grew tired of modeling, Freytag-Loringhoven worked for a time in a cigarette factory. There, two of her front teeth were knocked out by a sister worker. It was a pugilistic epoch altogether; indeed, the Baroness herself once punched the poet William Carlos Williams—an oft-quoted contretemps—anticipating the Dada impulse of Malcolm Cowley when in Paris he

Figure 1. Elsa von Freytag-Loringhoven. *Portrait of Marcel Duchamp.* Ca. 1919. 31 x 46 cm. Private Collection, Milan.

82

declared, "let's go over and assault the proprietor of the Rotund" café, and did just that.

The Baroness was also writing poems. Margaret Anderson and Jane Heap, editors of *The Little Review,* and also the publishers of a Dada manifesto, brought their magazine to New York City, to the Village, and the poems of Baroness Elsa began to appear in the pages of the magazine. Miss Anderson hailed her new author as "the only figure of our generation who deserves the epithet extraordinary" for achieving an oeuvre "perhaps the best of any woman's of our time."[6] Poems like "Mefk Maru Mustir Daas,"[7] dedicated to Marcel Duchamp, were published, and in many of these works readers took note of a kind of Jamesian dialogue of the Old World and the New transmuted into the patois and linguistic texture of New York Dada.

Mefk Maru Mustir Daas

The sweet corners of thine tired mouth Mustir
So world-old tired tired to nobility
To more to shame to hatred of thineself
So noble soul so weak a body
Thine body is the prey of mice

And every day the corners of thine tired mouth Mustir
Grow sweeter helpless sneer the more despair
And bloody pale-red poison foams from them
At every noble thing to kill thine soul
Because thine body is the prey of mice
And dies so slowly

So noble is thine tired soul Mustir
She cannot help to mourn out of thine eyes
Thine eyelids nostrils pallor of thine cheek
To mourn upon the curving of thine lip
Upon the crystal of thine pallid ear
To beg forgiveness with flashing smile
Like amber-coloured honey

The sweet corners of thine tired mouth Mustir
Undo thine sin. Thine pain is killed in play
Thine body's torture stimulates in play
And silly little bells of perfect tune
Ring in thine throat
Thou art a country devasted bare Mustir
Exhausted soil with sandy trembling hills
No food no water and ashamed of it
Thou shiver and an amber-yellow sun
Goes down the horizon
Thou art desert with mirages which drive the mind insane
To walk and die a-starving. –

The terminological perspective implicit in the poetry and essays of the Baroness provided a grounding for the antics, motives, and artifacts of art constructed by both herself and her contemporaries. One such work of hers is the *Portrait of Marcel Duchamp* (Fig. 2). At the apartment of Anderson and Heap, this sculptural essay enthralled Dr. William Carlos Williams: "I saw

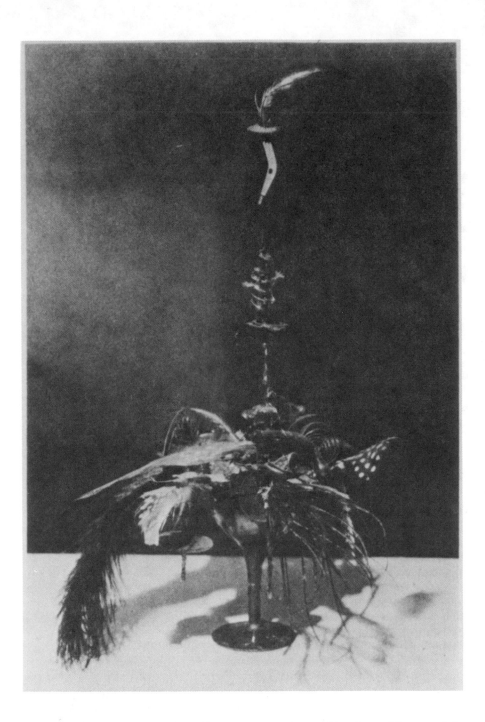

Figure 2. Elsa von Freytag-Loringhoven. *Portrait of Marcel Duchamp.* Photograph by Charles Sheeler. *The Little Review* (Winter 1922), p. 41.

for the first time, under a glass bell, a piece of sculpture that appeared to be chicken guts, possibly imitated in wax. It caught my eye." The doctor-poet derived from it new orientations about art and life. The work was photographed by Charles Sheeler and published in *The Little Review*. Its graceful disposition of organic features and contrasting industrial-age parts orbed below the (coldly aloof) superincumbent vertical motif is, at one moment, compositionally pure in its abstraction, and, in the next moment, allusive, summoning up the psychological motives of Duchamp, both in his personality and in his artistic considerations. Inspired by his admiration for her sculpture, Williams wrote a love letter to the Baroness and paid her a visit in her fetid cold-water flat on 14th Street. Ultimately, each misperceived the other in matters erotic, the Baroness punching Williams sometime later. Nevertheless, Baroness Elsa wrote perceptive criticism of Williams' notable *Kora in Hell* for *The Little Review* of 1921.[8]

The offices of *The Little Review* provided the meeting ground for the first encounter between Baroness Elsa and Djuna Barnes, who also contributed to the magazine. The personality of the former was baroque, that of the latter rococo. At first they did not cohere, regarding life through divergent linguistic screens. Margaret Anderson recalled the event in her autobiography: "I cannot read your stories Djuna Barnes," said the Baroness, "I don't know where your stories come from. You make them fly on magic carpets – what is worse, you try to make pigs fly." Anderson also notes that it took a while for Djuna Barnes, author of the epochal *Nightwood*, to appreciate the Baroness's work. Eventually, as Peggy Guggenheim was to become patron to Miss Barnes, Barnes – in Paris – became patron to the Baroness, selling the original annotated manuscript of *Ulysses* presented to Miss Barnes by Joyce, so that funds might be procured to sustain the Baroness's final period of life, writing poetry in Paris before her untimely death in 1927.

Djuna Barnes's biographer, Andrew Field, claims that "if Dada existed in America it existed largely in the person and poetry of Elsa Baroness von Freytag-Loringhoven." George Biddle, muralist and later leader of the Federal Arts Project, referred to Freytag-Loringhoven as "perhaps the first surrealist." All those privileged to be within her ambit felt she authorized the particular spectacle of life called New York Dada. That Baroness Elsa too often has been no more than a footnote to posthumously constructed accounts of the movement (which was really a landmark in the history of manners) tends to thwart a true appreciation of this artist's contributions. The Baroness's output of poetry alone, hundreds of methodically written works, is staggering, worth attentive reconsideration today. An acoustician of vers libre, the Baroness had a linguistic range that pulsed Whitmanically to a German-throated timbre, and she achieved a poetics that festooned her soul's interior much as her physical exterior was decorated by the appliqué of found objects.

Man Ray, writing in 1921 from New York to Tristan Tzara in Europe, conveyed the intelligence that "dada cannot live in New York." In this message, he fashioned a picture-description representing all that Dada had been in America: the nude photographic figure that Man Ray chose for this personification was none other than that of Baroness Freytag-Loringhoven, her legs

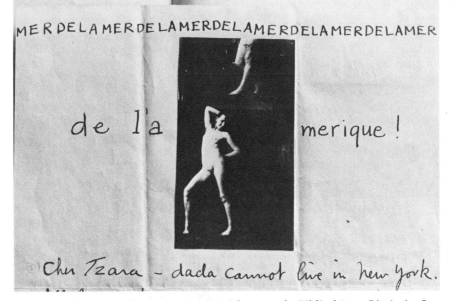

MER DE LA MER DE LA MER DE LA MER DE LA MER DE LA MER

de l'a merique !

Cher Tzara — dada cannot live in new york.

Figure 3. Man Ray. *The Baroness*. 1921. Photograph. Bibliothèque Littéraire Jacques Doucet, Paris.

articulating the letter *A* in the word *America* (Fig. 3). This photograph originally came from a movie filmed by Man Ray for Duchamp, the moving picture ruined in the developing process. Man Ray himself had portrayed a barber shaving the pubic hairs of the Baroness Elsa. Of that footage of the negative that survived the darkroom mishap was the image used by Man Ray in his letter to Tzara.[9] The death of Dada in America was announced by the shearing of hair upon the womb of the Baroness, a woman who was called the "mother of Dada," a woman who, according to Georges Hugnet, author of *The Dada Spirit in Painting,* lived out her days as if her "whole life was Dada."

In a period of feminist experimentation with dress reform, when Greenwich Villagers like Henrietta Rodman bore witness to controversy simply by wearing sandals, loose flowing gowns, and bobbed hair, the Baroness audaciously sought a simultaneous victory for Dada and dress reform through the Dada strategy of her own invention: she shellacked her shaven skull, colored it vermilion, wore an inverted coal scuttle for a cap, and applied to her body as decorative elements mechanistic implements such as metal teaballs. These were her counterefforts in an age of corsets. For such potent Dadaist gestures she would again and again suffer police arrest, until she became skilled in the agile art of jumping off the backs of paddy wagons.

Just as Ada Clare, in the mid-1800s, had been regarded by Walt Whitman and others as "The Queen of Bohemia" in New York's Latin Quarter, so, in the teens of the twentieth century, Elsa Baroness Freytag-Loringhoven had become the "mother of Dada" to a consensus of Greenwich Villagers and to the luminaries of the uptown Arensberg salon. Here is the recollection of the

Baroness during this period by the artist Louis Bouché, writing of the years 1915–17:

We all used the same models, and a favorite one was called "The Baroness." I first laid eyes on the Baroness in a Broadway subway. She was wearing a French Poilu's blue trenchcoat helmet. As I later found out this was only one of her odd "get-ups." The Baroness was a professional model. She married a German cavalry officer, but she loved the French. She was the Original Dada. She wore also at times a black dress with a bustle on which rested an electric battery tail light. When I asked her why she wore it she said: "Cars and bicycles have tail lights. Why not I? Also, people won't bump into me in the dark." Still another time on the street she had a wooden bird cage around her neck housing a live canary. The hem of her skirt was decorated with horse blanket pins, and she had five dogs on five leashes.

Her figure was good. She adored everything French, she a German and Germany and France in mortal combat. She had a passion for Marcel Duchamp. One day while posing for me, I brought her a clipping of Duchamp's *Nude Descending a Staircase*. She was all joy, took the clipping and gave herself a rub down with it, missing no part of her anatomy.

This must have been the one time Duchamp's *Staircase* descended a nude! Bouché continues: "The climax was a poem she had composed for Duchamp. It went: 'Marcel, Marcel, I love you like Hell, Marcel.' Her German accent was a riot."[10]

George Biddle, too, provides a crucial portrait of the Baroness at this time, in his memoir *An American Artist's Story*.

I have known famous collectors in New York, Rome, Boston, Baltimore. Some of them were acquisitive, arrogant, pathological; others, without sensitivity or understanding; while a rare few showed intelligence and sympathy, not only in their possessions, but toward the occasional artists who came to enjoy them. Among these later collectors was my friend the Baroness. I met her in my studio in the spring of 1917. Having asked me in her high pitched German stridency, whether I required a model, I told her I should like to see her in the nude. With a royal gesture she swept apart the folds of a scarlet raincoat. She stood before me quite naked – or nearly so. Over the nipples of her breast were two tin tomato cans, fastened with a green string around her back. Between the tomato cans hung a very small bird-cage and within it a crestfallen canary. One arm was covered from wrist to shoulder with celluloid curtain rings, pilfered from a furniture display in Wannamaker's. She removed her hat, trimmed with gilded carrots, beets, and other vegetables. Her hair was close cropped and dyed vermillion.

She asked me if I would care to look at one of her colour poems. It was painted on a bit of celluloid and was at once a portrait of, and an apostrophe to, Marcel Duchamp. His face was indicated by an electric bulb shedding icicles, with large pendulous ears and other symbols.

"You see, he is so tremendously in love with me," she said. I asked,
"And the ears?" She shuddered:
"Genitals – the emblem of his frightful and creative potency."
"And the incandescent electric bulb?" She curled her lip at me in scorn,
"Because he is so frightfully cold. You see all his heat flows into his art. For that reason, although he loves me, he would never even touch the hem of my red oilskin slicker. Something of his dynamic warmth – electrically – would be dissipated by the contact."

Biddle offers further trenchant impressions:

I have spoken of Elsa as an art collector. It was in an unheated loft near the river on 14th Street where she collected. Here it was crowded and reeking with the strange relics which she had purloined over a period of years from the New York gutters. Old bits of ironware, automobile tires, gilded vegetables, a dozen starved dogs, celluloid paintings, ash cans, horrors which to her highly sensitized perception became objects of formal beauty. Except for the sinister and tragic setting, it had to me quite the authenticity as, for instance, Brancusi's studio in Paris, that of Picabia, or the many exhibitions of children's work, lunatics' work, or DADA or Surrealist shows. For the Baroness *had* validity. As I stood there, partly in admiration, yet cold with horror, she stepped close to me so that I smelt her filthy body. An expression of cruelty yet of fear, spread over her tortured face. She looked at me through her blue-white crazy eyes.

She said, "Are you afraid to let me kiss you?" I knew she was suffering agony. I shrugged my shoulders and said "Why not, Elsa?"

She smiled faintly, emerging from her nightmare. Enveloping me slowly, as a snake would its prey, she glued her wet lips on mine. I was shaking all over when I left the dark stairway and came out on 14th Street.

Of all the art collectors I have known, the Baroness Elsa von Freytag von Loringhoven was the most sensitive, critically understanding and emotionally generous.

The artist Sarah McPherson was another who would make an entrance into the abode of the Baroness's art collection. Friends such as artist Magda Pach, wife of Armory Show organizer Walter Pach, would always ask Sarah to be on the lookout at the Baroness's apartment for jewelry "borrowed" by the Baroness and added to her art collection. McPherson would always decline this task.

Today, of course, the studios and storehouses of sculptors, such as that of Louise Nevelson, are stocked with objects rescued from the curbside and elsewhere, awaiting occasions of transformation into art. Many contemporary artists are thus heirs of a procedure which in this country was encouraged by the example of Baroness Freytag-Loringhoven. About 1916, the artist produced the canonic sculpture *God,* today in the Arensberg Collection, Philadelphia Museum of Art (Fig. 4). An assemblage of plumbing pipes mounted on a miter box, it is spiritual kin to Duchamp's *Fountain.* In a way the title *God* pays homage to Duchamp himself, for we have read of Elsa's inclination to Duchamp-worship. This sculpture has been attributed to Morton Schamberg, occasionally with the citation "assisted by Baroness Freytag-Loringhoven." Certain scholars, however, believe that the work may have been the noncollaborative, unitary creation of the Baroness.[11] It has been suggested that *God* might have only been photographed by Schamberg. Indeed, it is said, the photograph is typical of Schamberg's style, while the sculpture is typical of other major work by the Baroness – in the dexterous massing of forms, for example, which in themselves, in the hands of others, would defy masterful sculptural juxtapositions. Here the felicitous combination of dissimilar forms – miter box and inverted plumbing apparatus – offers revelation of how very much Freytag-Loringhoven understood that Dada, with its repertoire of readymades and assemblages, could release one's perceptions through and past the comic spirit and, soberly, into the perhaps profounder reaches of *discordia concors,* a comprehension of "occult resemblances."

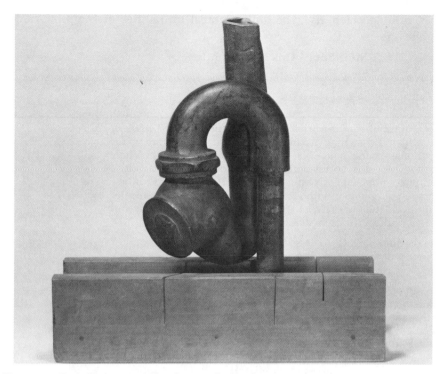

Figure 4. God. Ca. 1916. Miter box and plumbing trap. 10½ in. high. Philadelphia Museum of Art: Louise and Walter Arensberg Collection.

Although Baroness Elsa's association with Duchamp was, we have seen, an inspirational source for her many works, these works were never quotations from the personal vocabulary of Duchamp; Freytag-Loringhoven sought out her own quarries, and from this largely underivative material she crafted her own enduring compositions. The study of her output, poems and art objects, yields a comprehensive iconography of the meanings and achievements of the fullest flowering of New York Dada.

The work of the Baroness may, in the most basic meaning of the term, be too humanistic for the program of Dada as explored by others. Where Duchamp and Man Ray are, seemingly, detached and aloof, Baroness Elsa is passional. Her verse outpourings are the efflorescence of the life of human emotions. Thus, while her work is the unalloyed embodiment of Dada, it transcends Dada and thereby offers itself as a pivotal passage of transition between Dada and Surrealism. Her use of her own body as a canvas for the applied art of found objects is elementally, in her fashion, humanistic, and is at odds with the other stances of Dada. Freytag-Loringhoven contributes her remarkably feminine Dada to the canon, foretelling the inevitable reintroduction of deep emotionality into art. Refulgent and stirring, her poetry is emotive humanism.

In "Mineself – Minesoul – and – Mine – Cast-Iron Lover"[12] Baroness Elsa

traces, among much else, the philosophical formalities of the mind-body relationship:

Mine Soul—This Is What Mine
Soul Singeth:

His hair is molten gold and a red pelt—
His hair is glorious!

Yea—mine soul—and he brushes it and combeth it—he maketh it shining and glistening around his head—and he is vain about it—but alas—mine soul—his hair is without sense—his hair does not live—it is no revelation, no symbol! HE is not gold—not animal—not GOLDEN animal—he is GILDED animal only—mine soul! his vanity is without sense—it is the vanity of one who has little and who weareth a treasure meaningless! O—mine soul—THAT soulless beauty maketh me sad!

"His nostrils"—singeth mine soul—"his nostrils!" seeest thou not the sweep of the scythe with which they curveth up his cheek swiftly?

Iron—mine soul—cast-iron! his nostrils maketh me sad! there is no breath of the animal that they may quiver? they do not curve swiftly—the scythe moveth—mine soul—they are still—they are motionless like death! NOT like death—in death has been life—they are iron—mine soul—cast-iron! a poor attempt to picture life—a mockery of life—as I see cast-iron animals and monuments a mockery of life— —alas—mine soul—HIS soul is cast-iron!
"Iron" singeth mine soul—"iron thou canst hammer with strength—iron thou canst shape—bend—iron thou canst make quiver—iron alive to flame— —
ART THOU FLAME?"

Mine soul—alas—I COULD BE!
And WHY—mine body—dost thou say: "I COULD BE" and WHY—mine body—dost thou ALL THE WHILE SAY: "ALAS"? Thine "ALAS" maketh me sad!

Mine soul dost not be mischievious! THOU KNOWEST we are One—thou knowest thou ART flame! it is THOU—mine soul—and thine desire to flare by thineself which maketh thine body say: "alas"! thou hast so changed! dost thou not hinder mine wish to touch—mine right since olden times which was granted me ever? because thou art now very strong—I gave thee much fuel—NOW—mine soul—thou art stronger than I and thou mocketh thine body! and—mine soul—are we artisans—are we not artists who flare by themselves—FOR themselves? we do not bend any more out of our way to catch and touch—to mold be molded—to feed be fed— —we flare HIGH—mine soul—we are SATIS-FIED!— — —

And yet—mine body—thou sayest "alas"!
Ha—mine soul—I say "alas" and I say "alas" and "alas" and "alas"! because I am thine BODY! and this is mine flaming de-sire to-day: that he shall step into THEE through ME as it was

in olden times and that we will play again that old WONDERFUL play of the "TWOTOGETHER"! – –mine soul–if thus it will be–willst thou flare around him–about him–over him–hide him with shining curtain– – –hiss that song of savage joy– starry-eyes– –willst thou heat–melt–make quiver–break down–dissolve–build up– –SHAKE HIM–SHAKE HIM– SHAKE HIM–O mine starry-eyed soul?

Heia! ja-hoho! hisses mine starry-eyed soul in her own language.

I see mine soul–we still understand each other! I LOVE THEE thou very great darling! we must wait and smile– – –PERHAPS SARDONICALY– – –mine very great soul– – – because we now are artists– – –and: NOTHING MATTERS ! ! !
(pp. 3–5)

Those few who are today intimate with the Freytag-Loringhoven oeuvre continue to marvel over her fashioning of some notable works of verse in English, a language not her own. The hundreds of poems written in German have never been translated. After her own work had been largely forgotten, her program of poetic composition remained a point of departure for others embarked upon modernist poetry, her legatees unacknowledged.

In modern Manhattan, the Baroness was in the forefront of those poets and painters deriving impetus for their work–"ash can" through Dada to Precisionism–from the accelerated growth and staccato pace of skyscraper cities. Indeed, where a majority of the architects of the period still found a haven in beaux-arts classicism, the Baroness and other "skyscraper primitives" among the avant-garde thrilled to the newly revealed thematics of their period, in which engineering feats and industrial-age bravura were everywhere in the ascendant. *The Little Review* published the Baroness's "Appalling Heart":[13]

City stir–wind on eardrum–
dancewind: herbstained–
flowerstained–silken–rustling–
tripping–swishing–frolicking–
courtesing–careening–brushing–
flowing–lying down–bending–
teasing–kissing: treearms–grass–
limbs–lips.
City stir on eardrum–.
In night lonely
peers–:
moon–riding!
pale–with beauty aghast–
too exalted to share!
in space blue–rides she away from mine chest–
illumined strangely–
appalling sister!

Herbstained–flowerstained–
shellscented–seafaring–
foresthunting–junglewise–

desert gazing —
rides heart from chest —
lashing with beauty —
afleet —
across chimney —
tinfoil river
to meet
another's dark heart!

Bless mine feet!

The Freytag-Loringhoven verse was much read and quoted as it appeared in the pages of *The Little Review,* which championed her work. Her poetry spoke vividly to those young people who joined in the artistic heyday of Greenwich Village, one of the urban loci attracting creative young minds comprising the period's decisive "revolt from the village." In New York City some of these émigrés to Greenwich Village became subsidiary Dadaists, and for these, too, the Baroness was mascot. Though she was at least a generation older than they, she, who herself had revolted from the confines of her native Swinoujście, on the East Sea, was at heart the youthful and eternal Dadaist, though perhaps less overtly cynical than some of the youngest Dada followers she encountered and with whom she throve. Her American friends found in the Baroness contact with European tendencies — lingering decadence, belle epoch, fin de siècle — all of which the Baroness appeared to personify, particularly in that her widowhood was caused by the upheaval of the Great War, which had brought about her husband's suicide and Elsa's abrupt impoverishment, departure from the Ritz, and descent into the bohemian tide of Greenwich Village. The cultural disjunction that had resulted from the war and had helped to create Dada, she, Baroness Elsa, knew firsthand, and in her very bones. American youth living in the Village learned much through the Baroness.

In the following passages, we turn to the heretofore untold story of Freytag-Loringhoven's life and earliest art experiences. Her own words, these recollections are part of an ebullient account of her life up to the age of twenty-one in 1896. From memoir material left at the time of her death in Paris, these extracts are here published for the first time.[14]

She was born in Swinoujście, on the Baltic, today bordering Poland and East Germany, on July 12, 1874. According to her memoirs, commissioned of her by Djuna Barnes, the Baroness's father was "a prosperous middle-class businessman, a contractor, coming from the small master skilled workers." Elsa's mother, brought up "within the radius of Goethe," died when the Baroness was about eighteen years of age. Elsa soon moved to Berlin, fleeing the nausea created in her by the presence of her stepmother's "bourgeois harness of respectability." She stayed with an aunt. In the new city she had "various exciting adventures, all of which had to do with flirtation, rejuvenating my aunt despite her horror and anger, hence her patience, for I had become mansick up to my eartips — no, over the top of my head, permeating my brain, stabbing out my eyeballs," Elsa was to recollect for Djuna. Looking for

work, she responded to a newspaper ad looking for "girls with good figures" to play the Wintergarten Theater, a first-class variety outlet. Elsa, later destined to become a sought-after artist's model in America, now for the first time undraped before a stranger's eyes: "All dreams materialized miraculously. Marvelous things happened to me; I was told to strip, with a young woman assisting me. Though it was incredibly impossible, like a trance, I did it, she was helping me with a sophistication that even I noticed, becoming more confident. I was clad in tights and Henri de Vris, head of the Living Pictures, looked me over. To my utter bewilderment I was taken immediately for the 'Marble Figures,' which I later leanred called for the best figures." Elsa first went to Leipzig with the company, then to Halle. Of this period, she was to writte: "Now I began to know what life meant."

At the close of the Halle month Elsa received a letter from her aunt "asking me," she recalled, "to return to her, for if I wished to go on the stage I should study it and do it in the proper fashion. She was innocent of my life." Returned to Berlin, Elsa seriously studied the arts of the drama for a year. With her new command of her field she found roles at the Central Theater, the "most fashionable stage," she wrote, at that time. "Handsome, with a straight figure and nimble legs," Elsa danced in the lavish production numbers. All the while she was "searching for my counterpart." Illness intervened for a time. When recovered, Elsa found she had come into a small fortune, then due from her mother's estate for the first time. Now, she wrote, "I took a nice furnished room with a darling of a landlady. Some three or four days later I met my first artist friend," an effete youth dressed in velvet green who looked like a medieval monk. The gothicized personality of her new friend was, she wrote, her first introduction to the incense-burning aesthetic crowd of the fin de siècle.

Elsa coursed through the literary circles and arts enclaves of those heady times, falling in and out of love. Eventually she went to Dachau, an artist's colony near Munich, there "trying to do art." She wrote:

I could do nothing but wait. I couldn't do art for I didn't know how . . . I had a terrible dread of it. But I succeeded in buying all the necessary artist's materials . . . not to be in want . . . should the spirit seize me, even to a large canvas umbrella for outdoor sketching; though I never before sketched in my life, it was all a big assurance of artship.

I even took a teacher who was no use at all, excepting to himself, receiving monthly fifty marks fee for telling me something mysteriously important, but entirely ununderstandable, at least to me. Also, I could never rid myself of the suspicion that he himself did not understand it.

At the time I kept him, as I bought and kept my sketch umbrella and paint box, as the right thing to do to keep up my prestige before myself and others. I pretended to understand his twaddle about the "golden section" which he, bombastically, endeavoured to prove with reproductions of Rembrandt and with the "system of a grown rose" . . . both very impressive and awe inspiring, certainly I would have given something to grasp their relationship, but my fifty marks a month didn't seem to be sufficient even for that, so I began to think myself dull brained, so that in spite of my suspicious better self . . . just for the love of the mysterious in want of clearness . . . I tried to make myself believe in it and him. Otherwise he left me entirely to my own devices . . . never putting a paint brush into my paralyzed fingers . . . though I never had painted oil, or drawn from nature having merely done, years before, some water-

colours in the deadly spinster fashion of a lady teacher who had "graduated from an art school and even been to the Riviera for some months" which would make her genius unquestionable in Swinamunde.

Elsa left the artist's colony and, more confidently, enrolled in an art school in Berlin. She spent hours decorating her studio. She turned to the study of applied art, seeking the assistance of a man regarded as "one of the coming luminaries in the sky of applied art and architecture." As recounted in her autobiography, to this man of genius she wrote:

Dear Sir, I made your acquaintance some few months ago at Dr. _____ as I trust you will remember. You were kind enough to look at some drawings of mine. I am here in art school trying to do art but I find that I cannot. Could you and would you be kind enough to show me the way one may earn money in doing applied art? I have just now discovered that I have very little money left . . . and I should like to earn some more, but I have never done anything in that way and really have no idea nor any art training. That is why I turn to you . . . because you seem to know so very much about it. Yours very truly . . .

Elsa felt herself veritably heroic asking advice pertaining to the deepest theme of her life, then and always: being an artist. Of the response to her letter, she wrote, "I waited with great composure . . . passionately curious about the soon to be unveiled mystery of money making as a real free lady artist . . . *Now* I had cast the dice and chosen *Applied Art*." The mentor to whom she wrote arrived in person, bearing a package of tea and the advice that Elsa ought to give up that "idiotic art teacher" she had retained all the while. Under the new man's tutelage, Elsa commenced to thrive in her enlargement of art's mastery, working four to six hours a day.

After the period covered in her narrative, Elsa became Baroness Elsa, marrying Freytag von Loringhoven, the wealthy German businessman who took her to New York, where they settled at the Ritz for a number of years. Following the fatal moment of her widowhood, when Baroness Elsa moved to Greenwich Village and thence to her cold-water flat on East 14th Street with a congeries of collectables and mangy curs, her early training in the arts gave her the impetus to renew the artistic purpose of her life; and her earlier training as a performer in the public eye allowed her the courage, amidst a lingering Victorianism still regnant in America, to pose nude as a model in the studios of many of New York's most maverick artists. These were, first, the "ashcan" principles and their disciples, and, next, the Dada-based modernists. In fact, both schools tended to overlap socially, and the Baroness made admiring friends of a wide circle of New York's arts community.

As we have seen, Man Ray eventually had occasion to write Tzara of the death of Dada in New York City. It was observed of the Baroness about that time that "her spirit was withering in the sordid materialism of New York. She felt she had not long to live. Friends of hers gathered a small fund to help her back to Germany," according to George Biddle. In 1923, the Baroness returned to Europe and to all the associations of her birth. When she arrived in Germany, she took to selling newspapers on the street. Here, now, her heart became "an abode of terror and a snake – they stare at each other, always," she wrote, in a letter published posthumously in the final number of *The Little Review*. Readers learned of her lament:

I need, for a few quiet hours – human sympathy – talk – love – in my terrible plight – because it is terrific. No joy, no light, not the satisfaction of the pride of my faculties – my art that carries me. I am beset by great multitudes of small worries – I almost despise myself for the trouble I make and the trouble that troubles me. But what shall I do ? I am stunned nearly to exhaustion. Forgive me, but I am mourning destruction of high quality – as I know myself to be – to do my art – to live humanly decent – but it is not in your power, I know. I am poor and deserted – – if I had not to stand the experience of my person – my country is slowly wearing me to rags – body and spirit. . . .many ants can kill the strongest, proudest life if it is fettered to ant heap – as I am to life in Germany – to life – to terrible poverty and its obligations – one may perish on a formality – winter approaching – rain, hail – cold, – I on the streets – freezing – to boot, in such weather people do not buy. I wish you would give me some time for comfort – once ! Stroke my hands – and give me "cheer up". Talk with me, listen to me. I am human, and I am not newspaper seller ! I have no more time – must go to sell – I should like to laugh with you – to be gay, I can be that ! It is my nature – that sounds ghastly now. . .that is the tragedy – I still feel deep in me glittering wealth. . .[15]

Thus, readers unexpectedly read an unexampled firsthand account of life in postwar Germany.

In a private letter to Djuna Barnes, later published in *transition*, Baroness Elsa more explicitly unbosomed her travail:

I cannot stand the Germans, I cannot stand their language. I am traitor here!
I left my father's house, protection, money, now I am in his house back again, trodden on, jeered at . . . it is my father's clutch! he has me again where once he left me . . . my spirit leaves me, I seek love – to live – the tears pour down my cheeks – I am fifty and I am eighteen, there is no difference in me, but around me! Good bye. I love you all so.

. .

Djuna, I cannot anymore see it otherwise . . . I will probably – yes, yes, yes, probably *have* to die. When life is not, one has to die. That is simple, terribly simple!

Yet in another letter to Djuna Barnes, Baroness Elsa stated: "I have just discovered that I am not, and why I am not made for suicide – unless it could be done gaily – victoriously – with flourish I think that is death in battle or tournament – self destruction by God, but to act God is weakness and will be punished and can never be strong – gay. He punishes his weakness in members weak, he is terrible – I am dead already. Death cannot commit suicide. I am safe. . . ."[16]

In 1926 Baroness Elsa Freytag-Loringhoven did arrive in Paris, where, a few months later, wrote Margaret Anderson, she "died tragically and alone." Janet Flanner, informing American readers of this fact in her letter-from-Paris column for the *New Yorker* magazine, amended this with the notation: "installed, through the kindness of Parisian friends, in the first comfortable quarters she had known, the Baroness and her little dog were asphyxiated by gas in the night, both victims of a luxury they had gone too long without." Suicide? The crowd around the Baroness denied this. The Baroness had, in Paris, been writing poems for *transition*, and perhaps writing more gaily than she had ever done before. The journal published the poems "Café du Dome" and "X-Ray":

Café du Dome

For the love of Mike!
Look at that—
Marcelled—
Be-whiskered—
Be-spatted—
Pathetic—
Lymphatic—
Aesthetic—
Pigpink—
Quaint—
Natty—
Saintkyk!

Garçon

Un pneumatic cross avec suctiondiscs topped avec
 thistle-tire . . . s'il vous plait.

X-Ray

Nature causes brass to oxidize
People to congest—
By dull-radiopenetrated soil
Destined
Cosmic hand's dynamic gang
Polish—
Kill—
For fastidious
Brilliant boss' "idee fixe"
Sum total:
 Radiance[17]

The February 1928 number of *transition* printed a photograph of the Baroness's death mask and Barnes's obituary homage to the "mother of Dada" (Figs. 5 and 6).

The important, if not widely reproduced, photographs of our subject, by Man Ray and others, might suggest to readers that the mien of the Baroness was that of a Dada mannequin, if you will; for Elsa was statuesque as her modeling had trained her to be (Figs. 7 and 8). In truth she was someone whose face shone with ebullience and expressiveness. Warm and charismatic featured, her private glances belied the mask she assumed on public occasions of Dadaist provocation or simply iconoclastic merrymaking, as during the febrile salon conversation at the Arensbergs or at the freakish bohemian balls held late into the night at Webster Hall. When her life was over and she was laid out in her coffin in Paris, Berenice Abbott "had to turn quickly away! I couldn't believe anyone as vibrant as Elsa could die."[18]

In the 1980s, there is renewed interest in Baroness Elsa. Her poems circulate in what amounts to an underground samizdat. In a special supplement to *The American Poetry Review* in the spring of 1985, William Heyen presents his epic poem immortalizing, anew, the encounter of fisticuffs between

ELSA BARONESS VON
FREYTAG-LORINGHOVEN

Born 1874, died 1927.

On the fourteenth of December, sometime in the night, Elsa von Freytag-Loringhoven came to her death by gas, a stupid joke that had not even the decency of maliciousness.

In most cases death is neither more nor less than that which we must suffer, in some lonely instances it becomes high tragedy. So it was in her case, because she fought it so knowingly all the latter part of her life, rated it for what it was, feared it, and honored it, adding to it the high tempo of dread and love that set it above her, enormous and evil, by this splendid appraisal.

She was, as a woman, amply appreciated by those who had loved her in youth, mentally she was never appropriately appreciated. A few of her verses saw print, many did not. Such of her things as are in my possession, letters written in her time of agony, when in that Germany that had given her birth, and to which she returned to find her knowledge of death, in mad home and poor house, I now give parts, as they make a monument to this her inappropriate end, in the only fitting language which could reveal it, her own.

DJUNA BARNES. December 1927.

Figure 5. From *transition*, No. 11 (February 1928), p. 19.

Baroness Elsa and Dr. Williams. The Sun Press will publish a collection of Freytag-Loringhoven's poems for a new generation, and the Sun and Moon Press plans to publish the Baroness's *Memoir*, quoted from above, with an in-

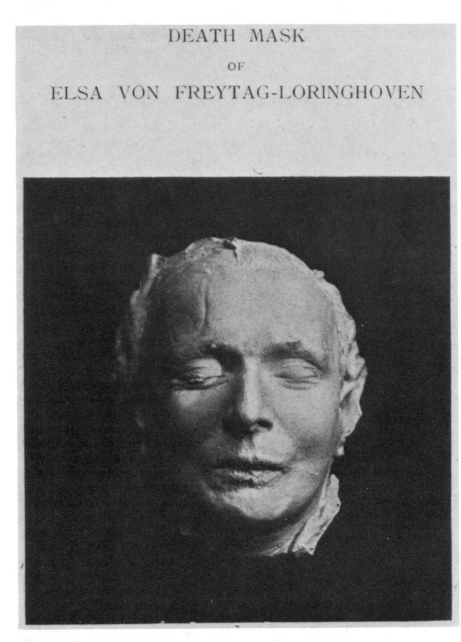

DEATH MASK

OF

ELSA VON FREYTAG-LORINGHOVEN

Figure 6. From *transition,* No. 11 (February 1928), p. 91.

troduction by Djuna Barnes, who commissioned the work. A one-woman performance piece may see production in the near future.

Baroness Elsa von Freytag-Loringhoven was the embodiment of Dada to the marrow of her bones, an advocate of a personalized dress reform code,

Figure 7. Man Ray. Photograph of Elsa
von Freytag-Loringhoven. *The Little Review,*
7, No. 3 (1920), p. 4.

Figure 8. Two photographs of Elsa von
Freytag-Loringhoven from *New York Dada,*
April 1921, unpaginated [p. 4].

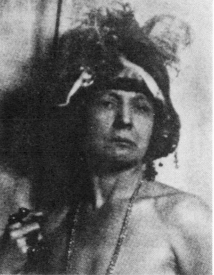

99

sought-after artist's model depicted by ashcan artists, Dadaists, Surrealists, and expressionists of all titles, a featured subject in the only issue of *New York Dada,* and, in the pages of *The Little Review,* a poet and an ardent defender of the new literature of James Joyce. A friend of New York- and Parisian-based writers and artists like Djuna Barnes and Sarah McPherson, the Baroness was never totally forgotten by those of her period. To these she remained in memory "My Baroness." Her life, letters, and art objects continue to wield a fascination; and, as recent scholarly activity indicates, interest in the Baroness is breaking forth once again.

Primary Published Sources

Anderson, Margaret, *My Thirty Years War.* New York: Horizon, 1969, pp. 179- 83.

Anderson, Margaret, ed. *The Little Review Anthology.* New York: Horizon, 1953, p. 189.

Biddle, George. *An American Artist's Story.* Boston: Little, Brown, 1939, pp. 139–41; 203; 212–13.

Flanner, Janet. *Paris Was Yesterday.* New York: Viking, 1972, p. 39.

Josephson, Matthew. *Life Among the Surrealists.* New York: Holt, Rinehart and Winston, 1962, pp. 75–76.

Ray, Man. *Self Portrait.* New York: Andre Deutsch, 1963, pp. 262–63.

Williams, William Carlos. *The Autobiography of William Carlos Williams.* New York: New Directions, 1951, pp. 164–69.

Secondary Published Sources

Churchill, Allen. *The Improper Bohemians.* New York: E. P. Dutton, 1959, pp. 168–69; 188–89.

Field, Andrew. *Djuna: The Life and Times of Djuna Barnes.* New York: Putnam, 1983, p. 83.

Hugnet, Georges. "The Dada Spirit in Painting." In *The Dada Painters and Poets.* Ed. Robert Motherwell. New York: Wittenborn, 1951, pp. 185–86.

O'Neal, Hank. *Berenice Abbott: American Photographer.* New York: McGraw-Hill, 1982, p. 9.

Pane, Mariani. *William Carlos Williams: A New World Naked.* New York: McGraw-Hill, 1981, pp. 160–64.

[Reiss, Robert.] "Freytag-Loringhoven, Baroness Elsa von." *Dictionary of Women Artists: An International Dictionary of Women Artists Born before 1900.* Ed. Chris Petteys. Boston: G. K. Hall, 1985.

Rubin, William S. *Dada and Surrealist Art.* New York: Abrams, 1968, pp. 12, 63, 424.

Acknowledgments

The author wishes to acknowledge the following people for their assistance in the preparation of this essay: Mr. Hank O'Neal, Mr. Douglas Messerli,

and Mr. Bill Zavatski. As well, thanks go to the Librarians at Sarah Lawrence College for invaluable guidance and, importantly, to Mr. Francis Naumann for his recognition of the role played by the Baroness in the life of New York Dada. The late Djuna Barnes was of great help, in many ways, as has been Miss Laura Foulke. Finally, my deepest thanks must go to Mr. Walter Vangreen, himself a "golden section."

Notes

1. Bessie Breuer, "Memoir," unpublished manuscript, the estate of Henry Varnum Poor, New York, New York. These papers of Bessie Breuer (Mrs. Henry Varnum Poor) contain an account of Breuer's association with the New York Dada group.

2. "Remembrances of Sarah 'The Kid,'" interview with the author conducted by Jerry Tallmer, New York Post, September 5, 1981, p. 12.

3. "The Nude-Descending-a-Staircase Man Surveys Us," New York Tribune, September 12, 1915, Special Feature Section, p. 2.

4. Anne Poor, Sarah McPherson; see McPherson Papers, Archives of American Art, Smithsonian Institution, Washington D.C. Here Miss Poor, niece of Sarah McPherson, comments upon McPherson's drawings, such as those of the Baroness's feet: "Brutally frank in their realism, cubist form and fauve primary color, these drawings, apparently the direct result of an unselfconscious extraordinary eye and sensibility, were so compelling in their vision that Marcel Duchamp and other avant-garde artist friends of the time were, in their special worldly sophistication, dumbfounded by this 'original.'"

5. Berenice Abbott in conversation with Hank O'Neal, ca. 1975.

6. Margaret Anderson, quoted in Churchill, p. 188.

7. Elsa von Freytag-Loringhoven, The Little Review, 5, No. 8 (December 1918), 41.

8. Elsa von Freytag-Loringhoven, "Thee I call 'Hamlet of Wedding-Ring'; Criticism of William Carlos William's [sic] 'Kora in Hell' and why . . ." (poem), The Little Review, 7, No. 4 (January–March 1921), 48–55.

9. Man Ray, p. 263. The nude model alluded to by Man Ray in his autobiography has now been identified as the Baroness; conversation of Mme. Juliet Ray with Mr. Francis Naumann.

10. From the papers of Louis Bouché, unpublished manuscript, Archives of American Art, Smithsonian Institution, Washington, D.C.

11. These distinctions in attribution were first drawn to my attention by Francis Naumann, who is preparing a book on the subject of New York Dada.

12. Elsa von Freytag-Loringhoven, The Little Review, 6, No. 5 (September 1919), 3–11.

13. Elsa von Freytag-Loringhoven, The Little Review, 7, No. 3 (September–December 1920), 47.

14. Elsa von Freytag-Loringhoven, "Memoir," collection Mr. Hank O'Neal.

15. Elsa von Freytag-Loringhoven, The Little Review, 12, No. 2 (May 1929), 35.

16. "Selections from the Letters of Elsa Baroness von Freytag-Loringhoven," with foreword by Djuna Barnes, transition, No. 11 (February 1928), pp. 19–30. The last extract also appeared in the May 1929 Little Review, cited above.

17. Elsa von Freytag-Loringhoven, transition, No. 7 (October 1927), pp. 134–35.

18. Berenice Abbott, in conversation with Mr. Hank O'Neal, ca. 1975.

Mina Loy's "Colossus":
Arthur Cravan Undressed

Roger L. Conover

Nearly seventy years after he mysteriously dropped off the face of the earth, Arthur Cravan remains one of the most perplexing and tantalizing figures in the annals of Dada. Although officially pronounced dead and widely presumed murdered after a search of prisons, hospitals, and offshore islands failed to turn up any trace of a body, occasional "sightings" and persistent legends about his whereabouts in the underground survived into the 1960s, when the identity of B. Traven, Cravan's most plausible "double," became known. Although most of the "evidence" for Cravan's self-contrived eclipse and secret existence under an assumed identity falls apart under scrutiny, these theories remain psychologically attractive to those of us who have followed Cravan's footsteps into thin air. He was a born drifter and chronic itinerant who seemed bent on living a biographer-proof existence.

Indeed his penchant for authoring literary works under pseudonyms, disguising his identity behind aliases, and faking manuscripts and paintings which he then "discovered" and offered to dealers were among the signatures of his career. So given was he to perpetrating identity hoaxes and playing persona games that wherever he went rumors and bets followed him and anticipated his next move. In 1913 he claimed to have been visited by his uncle, Oscar Wilde, who had died a dozen years earlier. A respectful six months after the fabricated episode, he published a circumspect story honoring the "conditions" of his uncle's "disclosure," releasing just enough innuendo and "fact" about Wilde's incognito existence to attract the interest of a gullible American reporter. A story appeared in the *New York Sun,* and evoked a number of earnest refutations, validating the artfulness of what Cravan had done.

Mina Loy, his bride of six months when he vanished, spent the rest of her life not knowing whether she was a wife or a widow. She may have been with him when he applied for a Russian passport shortly before his disappearance in Mexico. It is known that he made Leon Trotsky's acquaintance crossing the Atlantic aboard the *Monserrat,* and that he was under surveillance by the FBI in New York and the U.S. Secret Service in Mexico. It is time that these facts entered the file, for they may point to a less than artistic ending to Cravan's life.

But it is not my intention to perpetrate or embellish the considerable apocrypha that already surrounds Arthur Cravan. Because he lived such an im-

plausible life, and had the fabulist's knack for adorning his own past, much that has been written about him picks up on false clues he dropped. It may be useful, at this juncture, to wipe the slate clean and simply state the known facts.

Born Fabian Avenarius Lloyd in Lausanne, Switzerland, on May 22, 1887, he was the son of Otho Holland Lloyd, whose sister Constance Mary Lloyd was Oscar Wilde's wife. Endowed from birth, it seems, with a rebellious and stormy nature, he was expelled from several schools by the time he was 16, and struck out for America in 1903. In 1904 he turned up in Berlin, but was kicked out of the city after a series of encounters with the police. He managed to get to Australia in 1906, then back to Munich where he landed on his brother's doorstep in 1907. Somewhere along the way he had learned to use his fists, and in 1909 won his division in the Amateur Boxing Championship of France sponsored by the Club Pugiliste of Paris. In March, 1910, he entered the light-heavyweight competition organized by the French Federation of Boxing Clubs, and, through a bizarre series of defaults, disqualifications, and withdrawals on the part of his opponents, succeeded in becoming the amateur light-heavyweight champion of France.

In 1911 he adopted the name Arthur Cravan. His Paris address, 29 rue de l'Observatoire, was also the editorial office of *Maintenant,* the polemical art journal he launched the following year. In 1914 he brought out the fifth and final number of this vituperative little magazine, having offended virtually every artist of standing in Paris. Two years later he surfaced in Barcelona, and launched a massive publicity campaign to give credibility to his challenge to former world heavyweight champion Jack Johnson, then a fugitive under the Mann Act seeking asylum in Spain. On April 23, 1916, Cravan fought a pathetic six rounds before being put away by Johnson. That ended his boxing career in Europe, but earned him 50,000 pesetas, enough to buy passage to New York, where he landed on January 13, 1917.

Through Francis Picabia and other Barcelona contacts he met Walter Conrad Arensberg, who—along with Marcel Duchamp—was instrumental in launching Cravan's succès de scandale at the Independents Exhibition in April of that year. In October of 1917 he turned up in Newfoundland, eluding conscription authorities by wearing a military uniform and posing as a soldier on furlough. By December, he was sending letters to Mina Loy with postmarks stamped Mexico City, and she responded to his beckoning by joining him in Mexico City in January, and marrying him in Salina Cruz the following month. After their marriage, Cravan gave up his post as "Professor of Boxing" at the Escuela de Cultura Fisica, and the newlyweds made their way to Vera Cruz. There they planned to book passage to Europe; Mina Loy had left two children by a previous marriage with a nurse in Florence, and her return was long overdue. She took the one available berth on a passing Japanese hospital ship bound for Buenos Aires; Cravan was to follow. He never did, and by the time Mina Loy returned to Mexico to look for him, a year had passed. The rest is legend.

Mina Loy remained romantically attached to Cravan long after his disappearance, and never fully adjusted to the loss. Her career as a poet blossomed in the 1920s, and then eclipsed as her own instincts toward isolation

developed. Like Cravan, she began camouflaging her once demonstrative and theatrical first-persons behind inscrutable selves, and adopted increasingly reclusive habits. Though she stopped publishing her work in the late 1920s, she continued to write poetry for three more decades, a fact that was not recognized until 1982 when her collected poems were finally issued (*The Last Lunar Baedeker* [Highlands, N.C.: The Jargon Society]). Not included in that posthumous volume were a number of unpublished prose works which existed as typescripts at the time of her death.

One of these, *Colossus,* is a thinly disguised roman à clef or series of prose "newsreels" about her life with Arthur Cravan. As an intimate profile by his wife, this is probably as accurate a psychological profile of Cravan as anyone has written, and it is the only piece of writing on him that dwells on his emotional life as opposed to his public behavior. To enhance the advantage of Mina Loy's unique perspective, I have chosen excerpts which offer a view of Cravan's private, offstage existence; Cravan the Performer has been featured in every other profile written.

All of the known personages mentioned in *Colossus* by code names are represented here by their real names except, of course, "Colossus," the name which Mina Loy assigned her mythologically proportioned husband. No portion of *Colossus* has ever been published before, and I wish to thank Mina Loy's daughters for permission to break ground in this forum.

Excerpts from "Colossus," by Mina Loy

Even before Colossus arrived in America, the legends surrounding him were so extravagant that the very idea of encountering him frightened me. From all accounts – he was amateur boxing champion of France – he would assault a building if it stood in his way. I would have preferred to forego the almost imperative ritual of meeting him, but "haven't you met the prizefighter who writes poetry?" assailed me on all sides. In a certain circle, it was becoming 'the thing' to make his acquaintance, and my dislike of knowing less of what is going on than my friends spurred my ambition.

I had first seen his portrait in an art review in which a certain sleekness of feature gave him the air of a homosexual, and this, for the time, stripped him of all mystery for me. There is nothing mysterious about a homosexual, for a woman. Man's intrigue for a woman lies in his preposterous relationship to herself. "This is a mind which would snub mine," I surmised, as I studied the portrait. "It deals in values of luxury." His clothes, his surroundings, looked expensive. A couple of Siamese cats lay among his negligent hands.

But when I first saw him standing, stubbornly it seemed, beside Arensberg, he looked dull and square in merely respectable tweeds; not at all homosexual, but not handsome – more like a farmer, a husband. I felt no premonition of the psychological infinity he would later offer my indiscreet curiosity as to the mechanism of man.

It was on my second meeting with him that I perceived him as beautiful. But his huge bulk, his empty stare, only called up a comparison with that still more unwieldy beauty of Grecian feature, *il gigante* Ugo, the light of whose eyes had also fallen petrified upon his reason and who, like a tower-

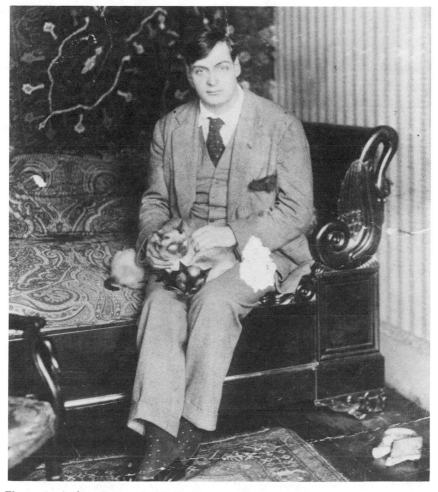

Figure 1. Arthur Cravan in his Paris apartment, ca. 1914.

ing statue of animated stone, had swayed lethargically above the spectators in the side-show of a circus in Italy.

This second encounter took place at a party in Walter's apartment preceding the Blind Man's Ball. Colossus, after various telephone calls of inducement, turned up alone among the elegant couples gathered there. He was wrapped in a sheet evidently ripped at the last minute from his bed, his head swathed in a towel. This white encasement gave the perfect construction of his face the significance of sculpture.

When I passed by him, he took a paper from his pocket and pressed it upon me. "Read it," he urged, his face stolid. It was a letter from a woman of whom I had never heard, throwing a jealous fit on account of *my* relationship to this creature Colossus with whom I had not yet exchanged a word.

That winter instantaneous affairs were fashionable. Our party at the Ball,

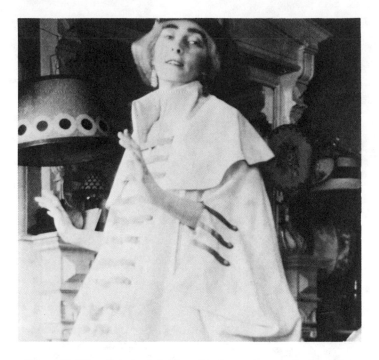

Figure 2. Mina Loy in her New York apartment, dressed for
the Blind Man's Ball (May 25, 1917).

frankly bored, sat round a table. Marcel, because he had begged me to come
to this ball *with him,* was making love right under my nose to a horse-like
woman wearing a toby frill. That left me sitting beside Louise, a perfect
dear, who, however, just could not acquire the knack of misbehaving, and
so always seemed somewhat wistfully 'out of it.' Colossus, with whom I had
still not spoken, slunk down beside me in his best (by this time he had taken
off his sheet and towel) and draped his great bare arm around my décoltée
shoulders. Slouched in his chair, the sneering muscles of his mouth and chin
sunk into his chest, his gaze fixed on his monstrous boots, he looked as if at
any moment he might vomit disgust in the faces of his twittering compan-
ions.

The putrefaction of unspoken obscenities issuing from this tomb of flesh,
devoid of any magnetism, chilled my powdered skin. It was, to say the least,
a negative initiation, this leaning flesh to flesh, as it were, upon a fount of
physical repulsion. I had never been encircled by a stranger or by anyone
who revolted me before. It was only satisfying to rise and leave him.

Toward the end of the Ball I came upon him again; by this time he was
completely drunk, lurching among the mob, demanding women for their
telephone numbers. "You may give my yours," he instructed me, "I will ring
you up *if* I find the time. So many other women desire me."

But somehow as the winter drew on we did—I suppose by virtue of being
the most dislocated members of that set—drift into a kind of spontaneous

106

partnership. At evening parties we would bury ourselves in the same deep armchair, sharing an inverted book. When other couples strolled past us we would break our habitual silence, concluding enigmatic remarks which, in our unwatched moments, we had not troubled to begin. All of this must have come about naturally, as if our predestined friendship had to pass laboriously through silence before creation.

I remember feeling as if I were lounging on the flanks of an indolent mountain whose summit was lost in heavy clouds – so convinced was I that this partner of mine had received too many blows to the brain. When at last a coherent phrase fell from his sufficient mouth it stirred in me an unconcerned regret that what must once have been a pretty humor should have tarnished in premature senility. [. . . .]

"*Won't* you take me home with you? – – No? Well, I wouldn't have come. I only asked as I presumed it was expected of me; I have been so very well brought up."

And again: "Do let me come home with you . . . the mere idea of sleeping in my own place makes me neurasthenic – Do."

"I have no extra bed."

"But a table, surely? I will sleep on the table and swear I will not address a single word to you."

This theme was a continuous one.

One night King Dada and Colossus lolled about a divan in Walter's parlor, engaged in the privileged male sport of the evening which consisted of drawing their forefingers along the green stockings of the blond Countess stretched among the cushions. Every now and then a man would rise, giving his place to another. Colossus had been occupied with one leg for ages, and when he had had enough, he came and laid on the floor beside me, tilting the brim of my hat onto the tip of my nose to cover my eyes – so as to hide from them the approval in his.

"Don't *have* him," urged Carlos, joining us. "You will only find yourself in a ridiculous situation. All these pugilists are bunglers in bed. I'm off," said the Doctor, kissing me good night. "You're all so damned sophisticated, I might as well be deaf and dumb."

If Colossus was lumbering, Marcel was slick as a prestidigitator; he could insinuate his hand under a woman's bodice and caress her with utter grace. "On peut dire," he began, his beautiful streamlined face pressed to mine, "Madame, vous avez un joli caleçon de satin. On ne peut dire," he concluded with a whimsical kiss, "Madame vous avez un sale con de Catin."

"Will you come *away* from that 'petit calicot,'" Colossus intervened, hauling me into another room overflowing with guests. He drew me down to his knees, and I felt like a bunch of silk tossed about from man to man – a face of silk – being passed from cheek to cheek of shaven men the French so exactly describe as 'glabre.' No longer drowsy, but his body still as granite, he held himself aloof from his words as he spoke of his loneliness, his love.

"All your irony is assumed," he whispered to me, "You have really the heart of the romantic. Why will you not let me show you what life can be in the embrace of my boundless love? My one desire," he continued, parting the ethereal green grapes that hung from my hat and burying his lips in my hair,

"my one desire is to be so very tender to you that you will smile without irony."

While I laughed inwardly at how unknowingly men use stock phrases to advance their amour, Colossus importuned me again. "If you won't take me home with you, I shall never address you again."

"Colossus, I couldn't *bear* that. I give you my word of honor that the next time I meet you I will take you home with me."

"You needn't shout," he reproached with severe pudency, as if the whole scene had been staged in private, "everyone can hear you."

Throughout that winter one heard little else than exhortations to love. The men planning conquests, the wary women preening before one another the plumage of their spurious valuations.

Led by mysterious cocktails magically expanding their universe, these scintillating modernists entered an unusual dimension where men cooed assertively 'modern' women into the nests of their astringent lusts, then crushed them 'tomorrow' in the contracting pupils of their wandering eyes.

'Modern' women!

I noticed how, afterwards, they could not sit still. And I noticed their sudden despairing kindliness to their husbands.

To take a lover? What lover? Colossus was heavy. The 'moderns' accused him of admiring Victor Hugo! What was he doing in this crowd, anyway? "Well, he *has* a title," the Americans reminded one another.

Having nothing of the modern spirit, he was at a disadvantage, and men at a social disadvantage are likelier to fall back upon 'love.' Therefore, I confided to myself, he might make a passable lover. I had forgotten how afraid of him I had once been. My image of the half-imbecile savage had likewise slipped from my mind, and in its place I had merely a commonplace man to reckon with – one who happened to be tremendous and handsome, but who had no arts for winning a woman. Suppose I took him for my lover. This granite lump – although he held no magnetism – might perhaps prove affectionate.

Only later would I realize that to most of those early encounters he had come as an entirely different persona, and wonder how it was that I had been able to recognize any identity behind his frequent transformations. Not until those separate elements had, through intimacy, coalesced into a single man did those 'first people' I met 'of him' become entirely alien.

To take a lover in cold blood? – on the chance of finding a degree of affection? I thought of how disinterestedly he held me in his arms. Well, he was born an Englishman – had inherited the Continent only via his education. *Why* was I considering taking Colossus above all the other men who had included me in their rounds when paying their illicit addresses to the seductive organisms whose lovely clothes made them appear to be so pathetically complete? Did my subconsciousness register that he, singularly, must put himself to great pains to *achieve* coarseness, while others exerted the same effort to overcome it?

I had been invited to a painters' party. Colossus would be there to collect my promise, so before leaving home I attempted to disguise the drabness of my studio with an orange light – to make it habitable for 'love.'

108

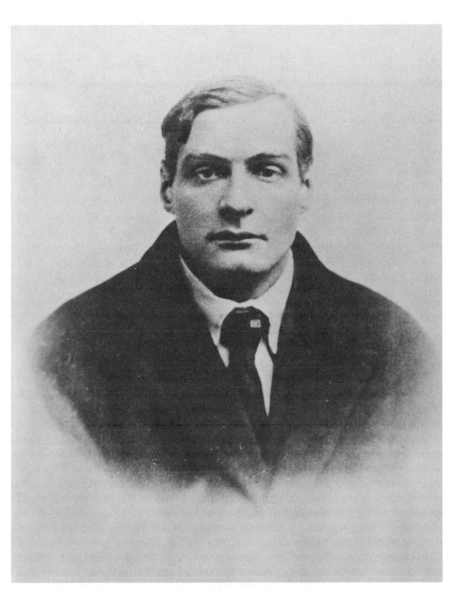

Figure 3. Arthur Cravan, passport photo, ca. 1917.

How did Colossus happen to be waiting at the door for me when I arrived at the home of Professeur de Spotte? He must have already been inside and just come out, for he wore no hat or coat. He had the key in his pocket and took me up a flight of stairs, into a vast studio where a woman who looked like a starling was perched on the edge of a sofa. She had an almost jewel-like complexion, black almond eyes, a dainty beakiness about her nose, and a darting alertness.

"You two should get on together," Colossus remarked, drawing off, as from a street brawl, to observe us from a safe distance. "Both being designers . . ."

As soon as we were out of doors, Colossus hardened to the cold air. Swaggering like an apache, he diffused on the subject of Art. "The world has always exploited the Artist – it is time for the Artist to exploit the world."

He followed me home tacitly – all the while continuing his discourse, and when we got to my studio he continued, uninterruptedly, on the subject of Greek art. After two hours of arresting monologue I realized he was hardly even conscious of his words, but was involved in trying to solve quite another order of puzzle – whether some irksome obligation had been thrust upon him or not. Then suddenly, as if a solution had occurred to him, "Can I have a bath?"

"Certainly, it's that door . . ."

"Now while I'm having my bath, cherie, you can undress and get into bed."

Colossus was taking a long time to walk across the floor. He had put on my bathrobe and it was flung open, displaying the frontal plane of his so solid, snow-white torso. He looked like something escaped from the British Museum. Drawn up to his full height, he lowered his sculptured eyelids beneath an exalted pride and camped his gorgeous head backwards in the grandeur of the old theater –.

I thought of cock-fighting – how the swelling of blood vessels and the conceit of conquest turn the victor's pace into a strut and give him an air of cruel surety.

He possessed me with an icy inertia, contriving the illusion that he was not, himself, involved in the curt, chill, passive union of flesh, and that had I stirred he would have tossed me out of bed like so much flesh that wearied his spirit.

"Of course, you regret that I am not a swine like other men."

"I consider that certain gestures degrade a man," I lied with the same frozen detachment.

Whereupon Colossus began blustering about the depravity of the herd. Other men extolled themselves above 'woman.' Colossus extolled himself above the world, emptying with invective its garbage into my stoic ears. He harangued me on the subject of his unique, unassailable purity, and on 'the filth of sex.' Then, with the precision of a dagger, he aimed, "If ever I should love a woman, I would never 'know her' carnally."

All the bunkum values of my female upbringing rose from the subconscious to souse my intellect. Reason hooted at me as I sat so everlastingly alone, cut off from the world by drawn blinds, and from the *husband,* the search for whom I had consecrated my life, who crept along the street entirely occupied with keeping an eye on my window without turning his head.

I hardly expected, the next morning, to hear Colossus cooing on the telephone, "Darling, do you realize this great thing that has happened to you? You have a lover!"

"I had not noticed it."

"Little angel," he inquired hopefully, "do you regret it?"

"I never regret wasted time." And then we both laughed.

110

"Listen – oh, my love, I am coming this evening to take you far out into the beautiful country. How happy we shall be together . . ."

Of course at that time I knew almost nothing of Colossus' life, but when we became lovers he confided to me as nearly as is possible every moment of his experience. He required, it seemed, a witness to his reserve, a companion insofar as a companion served to measure the degree of his aloofness. He sometimes insinuated the impression that rather than accepting companionship, he felt his footsteps were being dogged. New York, as we wandered through it, reduced under his devouring stride to a garbage dump on which the works of man were regenerated in the poetry of his appreciation.

It was not only in his proportions that Colossus varied from the average man – but in the telescopic properties of those dimensions. He could push his entire consciousness into a wisp of grass, plunge his whole being through a dish of frost in a wheel rut – for when he halted to observe he seemed to leave his immeasurable carcass on the threshold of his interest. And when he had engulfed in his regard every pebble, every wish, every perpendicular of skyscraper, every metallic suspension and every square millimeter of the city he roamed in tenacious idleness – a sort of inquietude would invade his motor centers.

He was always looking for something of his own among all this – that something the poet always seems to have mislaid. He was occupied with identifying himself with every degree of height and depth – in that indescribable interchange he interrogated the earth in order to bear it away as his seed. The secrets of the earth 're-minded' his creative will. He would hang for hours over splinters of quartz with their distinct diamantine resemblances until his eyes would glitter and reillumine their object. This I know – that Cravan meant by the "eternal quality" the poet's obligation to augment through his own knowledge the value of the universal essentials, of which he knew himself to be one exponent and which his entire life was constructed to preserve.

His pleasures, stupendous yet costless – the greatest of all was the open air – he found in such places as the Museum of Natural History, the Aquarium, Central Park, the Hudson River, a railroad siding. By the time I became aware of whatever it was he pointed out to me, it had already become an integral part of his consciousness.

Far out into the beautiful country proved to be Van Cortlandt Park. Rearing above the turmoil that swayed toward the opening doors of a subway train, Colossus held up a benedictory hand.

"Fear not," he said, "you have the Christ with you."

When we got out into the park the 'Christ motive' continued in an old song:

> "C'est pour moi, c'est pour toi
> Petit Jesus est mort en croix."

His voice was an organ of gorgeous sonority, but forbade appreciation, projecting an inaudible corrective *at* me. He was really singing, "*I* am pure as a little child – *You*, lascivious woman at my elbow, partake not of the little Jesus."

His companionship was at times an antagonism, his consciousness pulling away from me, "the mistress presumptive."

We came to a wide flat plain. The wistful fog of the moon leaned upon it. Colossus brooded there beside me, his gigantic shoulders with their gentle droop stacked beneath his profile, heroic in perfection.

Colossus often called to take me into the country, and it was not only my curiosity that made me accompany him. I would use these occasions to try to excavate my way into his consciousness, for I found him – the more I knew him – an utterly unprecedented biographical and psychological enigma. He appeared to live a life of extreme leisure, and indeed there were those who assumed he was wealthy. He often spoke of his bungalow, and although one supposed he must somewhere keep a furnished room, he spent many nights sleeping in Central Park. It was only after he left New York that someone discovered his quarters – an exhibit structure on the roof of the Pennsylvania Railway Station.

It is impossible, or at least dangerous, to remember Colossus after he left New York, for by this time I had magnified his being to such proportions that all comparisons vanished, which is the trick of falling in love. During the period of our New York acquaintance I had gradually become aware of the adventures that preceded his coming to America, and the manuscripts he left behind set in motion a cerebral newsreel depicting his life as vivid as the terse remarks he had sown in my mind.

* * * *

Evasive, inviolable before the onset of the war, this dragonfly in the carapace of a tortoise would appear at different points on the globe defying the snares of encroaching carnage. "On ne me fait pas marcher, moi!" – They can't put anything over on me – "Je ne marche pas pour leur art moderne. Je ne marche pas pour la grande guerre!"

All he said seemed too easy to say; he refused all affiliations. Conscientious objectors he rebuffed: "But I don't object! They may *all* allow themselves to be murdered for aught I care, only they need not expect me to follow suit. If their collective insanity suggests to them that they must sacrifice their lives for my sake, I will not trouble to stop them."

For him humanity drew its essential breath from an all-pervasive element superceding the air, the ether. Illimitable imbecility, spontaneous, irreducible, he foresaw in it the everlasting victor of our illusory intellection.

"Of course," he had arraigned me, "you do not consider it your business to pause and reflect on 'what it is' that delivers millions of men into the jaws of death at the beck of a handful who happen to be slyer than they are."

"Out of the whole political bunch," he decided, "there is only one who is sincere – Trotsky – poor lunatic! He really loves humanity. He really does desire to make others happy, and he actually imagines war is to be done away with. He is laughable and I respect him. But even he is trying to put something over – on himself. It was useless my telling him that his revolution will result in the founding of a red army to protect the red liberty, or that he, because he *is* sincere, will be turned upon by his followers. The only right the masses will accept from the idealist is the right to destroy. But he no more believed me than I believe him."

112

"*Your* war," Colossus would hoot, "will be the last war if it never leaves off. But it is going to be over sooner than expected, followed by an inextricable confusion. For one thing the whole world will go bankrupt in consequence, and remember what I say, – not at once, not for at least ten years – probably twenty."

He sounded preposterous. An uncultured heretic shooting the farcical arrows of his predictions into the glorious holocaust of heroism. (How I regret having paid so little attention to these predictions).

He must have hated the war more than anyone in Europe when it broke out, and more than anyone in America when he once again headed for the border. It had broken out when he was in the Balkans on the eve of a lecture tour under the auspices of a manager with whom he could only speak German. Haphazardly – for this manager, I am sure, was about as insolvent as Colossus – they got back to France where an excited soldier, hearing them speak the enemy language, was on the point of running Colossus through with his bayonette. His scream of "sale boche" was arrested by so obscene a flow of Parisien argot that it assured him he had after all confronted a patriot.

Once, for a free fare to Paris, Colossus enlisted, announcing upon arrival, "there is a little matter I must arrange with my consul." That night he escaped to Barcelona, driven across the border by an irresponsible millionheir.

In Barcelona he boxed Jack Johnson on a bet, and spent countless hours conforming to the national custom of mute gazing at senoritas cloistered in glittering windows because he fancied the conceit of wearing a flower over his ear.

The newsreel of my memory – as if to retrace the initial impetus which unaccountably determines a personality from birth – now flashes back to a frame from Colossus' infancy.

He had a faded photo of himself in an embroidered dress. It gave a surprising impression of the seated baby's backbone being a rod of iron. He had said, when he showed it to me, "As soon as I could speak, I knew that everything people told me was a lie. All they say – all they do," he mused disgustedly, "is an attempt to drag me down to their own level."

There followed brief episodes – a truant school-boy sleeping a fortnight under the London bridge, cornering the fried chips market in the dormitories; and then taking the schoolmaster across his knee and caning him. His parents' confusion over his being expelled, the schoolmaster's farewell: "I am heartily glad to get rid of you, but I like you better than any boy I ever had in school."

He was expelled – everywhere – from schools, colleges, gymnasiums. Later he was sacked from offices. At last, through a friend, he got a job in Berlin. It was with Siemen Zuckertswerke [sic]. Here follow, on the mental film, some close-ups of him.

Colossus was commissioned to drive back the Kaiser's car which the Siemen Zuckertswerke had been overhauling. He impermissibly drove it up the Sieger's Allee and had the royal guard out in salute. (On his friend's guarantee, he had got a driver's licence – he was underage). When he upset his sponsor and his car in a ditch, Colossus ambled off down the road, remarking over his shoulder, "you can pick it up yourself."

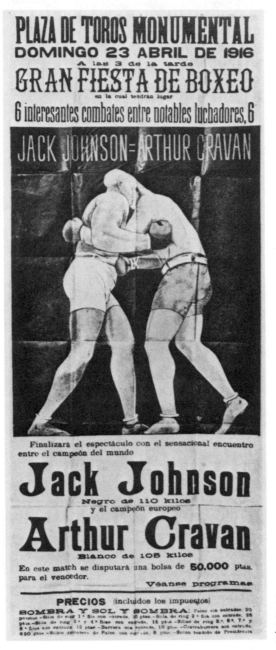

Figure 4. Fight poster, Arthur Cravan vs. Jack Johnson; Barcelona, Spain, 1916.

Here another vague shot of Colossus, still in Berlin. He decided to overnight with a prostitute as it would be cheaper than staying in a hotel. After half an hour, when he was turning over to go to sleep, she called in her bouncer, as big a brute as Cravan himself, who was out of training and ob-

Figure 5. Fabian Lloyd (Arthur Cravan), age 13 months. Previously unpublished photograph. Collection of Roger L. Conover.

liged to make room for another caller. To revenge himself, he snatched up the girl's handbag, took it to her 'bosom friend,' and made her a present of it.

"Imagine their meeting! It took them some time to make friends again, and when they did, they set the police on me. It appears that this offense has a name – Pompadour Diebstahl, and is considered very grave in Germany. I was in a tight corner."

Still, he got out of it. The magistrate realized it was only a practical joke played by the son of respectable parents whose son had already brought them enough sorrow.

"I *thought* there was something fishy about *your* bringing me a present," said the pretty little prostitute when he met her again.

I love the story of his parading down Unter den Linden with four of these girls on his shoulders – tremendous muscles, exuberant with adolescence, his face singing out from among their laces, the sparkling sequins on their

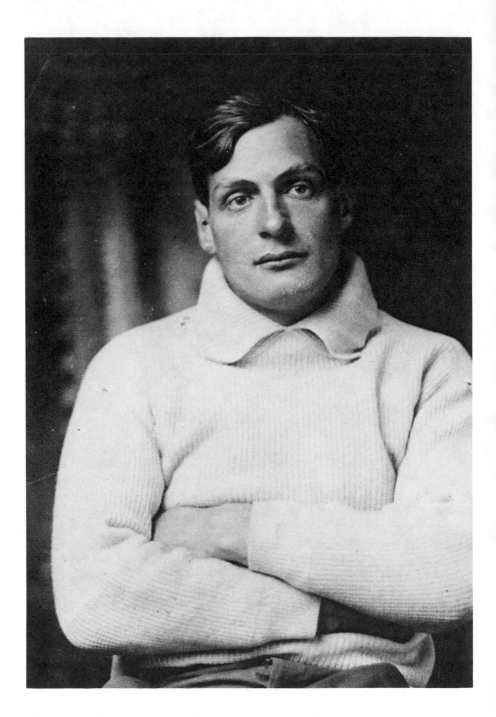

Figure 6. Arthur Cravan, ca. 1910. Previously unpublished photograph. Collection of Roger L. Conover.

skirts playing hide-and-seek with flimsy shadows dancing off the trees, the crowds that followed him everywhere appended to him a tail lashing the city's sensibility.

So Colossus was once more expelled—from Berlin!

"Am I permitted to ask," he inquired courteously, "the *reason* for my expulsion?"

"Berlin ist kein Cirkus—Berlin is not a circus," replied the head of the police.

He was home again in Lausanne. "What need have you to travel?" his mother protested, eyeing him with outrage. "You want to write? Well, why don't you sit down and write?"

This was too much for Colossus. He ran away to sea, signing on as a 'fireman.' He expected to wear a shining helmet—to drill on deck in swaggering readiness lest at any moment the ship should catch on fire! But a 'fireman' turned out to be a stoker, and the life of a stoker was a physical shock so grim it tore Colossus apart. His habitual self of semi-destitute ease in its unsoiled skin refused to inhabit a laborious substitute dripping with sweat over an iron shovel.

So Colossus deserted with a Frenchman when they reached Australia. He described their first night to me, creeping like snakes in a field of potatoes, digging with their nails and clinching their teeth in the raw flesh of the tubers as their eyes, from under the plants, followed the farmer searching for them with his gun.

* * * *

In New York our relationship was so accepted that none of our friends would have dreamed of inviting one of us without the other. But joining him in Mexico was official. Play was over.

"I don't think one visit could do any harm. However you needn't if you don't trust me," beckoned Colossus by letter.

Those first days in Mexico we wandered ceaselessly arm in arm. It never made any difference what we were doing—making love or respectfully eyeing canned foods in groceries, eating our tomatoes at street corners or walking among weeds. Somehow we had tapped the source of enchantment, and it suffused the world. We must have anticipated the embrace of reunion as the consolatory Absolute which no perspective of Time could augment or reduce.

After straining our hearts so long across so many miles, when that distance got telescoped by locomotive power, Our Separation, finding its two correlatives, had become an entity. It laid its embodiment of our late solitude between our bodies of flesh—thrust its aborted mouth of nostalgia between our lips. Longing had aroused our emotions to such crescendo it crashed the senses. Our fingers fell numb in their caresses. No nerves are strung to that pitch our affections had reached during the dissonant interval. When all that is left of being alive is a ferocious longing to unlock the center of oneself with the center of someone else . . . exquisite flood.

"But what do the Mexicans *do?*" I beseeched. The formal dream of my life,

117

a marriage of love, turning out to be true, was about to fade away because the 'wedding shop' was shut.

"Du courage ma mignonne," Colossus counselled me as he accosted a policeman. "How does one get married in this city?"

"*Who* wants to get married?" asked the policeman.

"*I* do," answered Colossus, whereupon the policeman informed us we were facing the very municipal building we required.

The mayor, or whoever the marrier was, informed us that we had to visit a doctor. It appeared that in this backward land a law which civilized countries had only tentatively proposed had actually been passed. All candidates for matrimony were required to produce a medical certificate certifying that they didn't have venereal disease.

"You'd better go together," advised the mayor. "It's cheaper."

That, in our circumstances, made sense. But for a chaste fiancée? Even the most virtuous of fiancées could have passed through the ordeal without shock, however. The doctor seemed principally concerned with Colossus' family name as it appeared on his immigration papers.

"It says here you are Swiss," he observed suspiciously. "Surely Hayes is an English name."

Figure 7. Mina Loy (Mrs. Arthur Cravan), poet.

"Oh," said Colossus, "There are English names everywhere. Take, for instance, Lloyd. There's the North German Lloyd, the Lloyd Sabaudo."

"That's true," the doctor acquiesced. Then negligently, "Do you happen to have any ailments?"

"Do I look like it?" roared Colossus.

"No," said the doctor. "I presume the senorita is English," he added, as he made out our certificates.

"But he didn't ask me anything," I exclaimed when we got out. "Must every law end in a mockery? No wonder Europe has not sanctioned venereal regulations — they are useless."

"Why all the fuss about venereal disease, anyhow?" asked Colossus. "It does one good. In Paris we felt we had not attained our manhood unless we had 'done' that part of it," he boasted.

"You'd commit suicide," I retorted, "you with your alabaster flesh — if you got syphillis. But men like you *never* get syphillis. You could sleep with a whole venereal ward without becoming infected."

We both wanted to 'really' marry in a rosy Mexican cathedral, spill our excessive delight in receptive aisles splashed with the wine and gold of stained-glass windows. Of course the money ran short of this fantasy and the mayor had to find two witnesses. I was so convinced of the mere formality of Mexican ceremonies that after the vows Colossus had to nudge me. "If you don't make any response," he whispered severely, "he'll refuse to marry us."

"I will," I hurriedly exclaimed.

"Now I have caught you. I am at ease."

* * * *

Chasing Butterflies with Arthur Cravan

Willard Bohn

Of all the amazing characters associated with the Dada movement, Arthur Cravan is probably the most memorable. An eccentric among eccentrics, Cravan exemplified the Dada spirit before there was such a thing, becoming a legend in his own time. First in prewar Paris, then in Barcelona and New York where he married the poetess Mina Loy, he served as a model for a whole generation of poets and painters who adopted his aggressive posture and scandalous behavior. Appropriately, Cravan's brief existence is shrouded in mystery and mystification. Constructed around principles such as insouciance, impermanence, defiance, and revolt, his life is best seen as the ultimate Dada gesture. "Tout grand artiste a le sens de la provocation," he used to proclaim, and he refused to distinguish between art and life in applying this principle.

Although several tantalizing glimpses of Cravan's life exist, more is known about his wife, for example, than about the poet himself.[1] Except for a letter to Félix Fénéon, dated September 27, 1916, autobiographical statements are rare and must be culled from the few remaining documents: his review *Maintenant* and a half dozen poems.[2] In addition, José Pierre has assembled several brief *témoignages* by people who knew Cravan or who came in contact with him. Not only do these reminiscences tell us much about his activities, they indicate how he was viewed by his contemporaries—friends as well as enemies, modernists as well as traditionalists. Thus the painter Kees Van Dongen recalls that Cravan "était très sportif . . . et nous avons souvent organisé dans mon atelier des 'Boxing Exhibitions.'"[3] And in her copious memoirs of Montparnasse, which discuss Cravan's abusive review of the 1914 Salon des Indepéndants (*Maintenant*, No. 4), Nina Hamnett concludes that "the criticism was very funny and a great deal of it very true."[4] She also makes reference to the boxing matches mentioned by Van Dongen, which seem to have been regular events organized on Cravan's behalf:

I never met him, but I saw him often sparring with Negro boxers at Van Dongen's studio on Thursday afternoons. Van Dongen lived near the Boulevard St. Michel, and all the critics came and drank liqueurs on Thursdays. In one corner boxing went on. One day they asked me to dance, so I took off all my clothes and danced in a black veil. Everyone seemed pleased, as I was very well-made. (pp. 51–52)

Judging from the precarious state of Cravan's finances, these matches may have been an important source of income for him. Certainly he could not have earned much from the sale of *Maintenant,* and the commissions he occasionally received from artists and collectors were infrequent at best.

An important insight into the latter activity is furnished by the art collector André Level, who knew Cravan well and who had various dealings with him. Writing in 1959 Level recalled that the poet was

a curious man . . . , supposedly Oscar Wilde's son [sic], who published *Maintenant,* an irregular and outrageously funny review in which he took to task almost all the painters and writers, except his reputed father, using barrack-room language. As one might imagine, he barely scraped by at that period from the rare commissions on paintings that he obtained, and thus it was that I encountered him one day in Georges Aubry's shop on the Blvd. de Clichy, near the corner of the rue des Martyrs, a favorite hunting ground of mine. His financial straits, coupled with his undeniable poetic gifts, moved me, and I was happy to give him several commissions.[5]

As proof of Cravan's poetic talent, Level quotes the last ten lines of "Sifflet" (*Maintenant,* No. 1), in which a locomotive streaks across the Canadian prairie. He then goes on to relate another encounter with the pugnacious poet shortly after the outbreak of World War I. Anxious to escape the hostilities by fleeing to Spain, Cravan developed an interesting strategy for raising the necessary funds, a strategy born of desperation:

At this time he brought me a rather old Matisse together with a Picasso which I thought exceptional, dating from the beginning of Cubism he assured me, which he asked me not to show its creator because he had promised the seller not to reveal it – a transaction in which I let myself be caught because of my confidence in him which until then had been entirely justified. For, disregarding his violence, he possessed great taste and sensitivity as a critic of art. Thus by buying these two paintings I unwittingly furnished him with the means to reach Barcelona. . . .

Meanwhile I learned rather quickly that my Picasso was by Ortiz de Zarate who kindly signed it for me later. On the other hand, as I had thought, Matisse acknowledged the second painting to be his work.

I had forgotten all that and retained only pleasant memories of poor Cravan, while pitying him, when in January 1916 I received the following letter from Barcelona which depicts him completely:

Dear Sir,

I had promised myself to write this letter ever since my arrival in Spain, but I have put it off from one day to the next. . . . I fell ill here, and I am still not completely recovered. Which means that although I have come to Barcelona to box, I must wait awhile. However I cannot stay here. I am going to leave, first for the Canary Islands, probably Las Palmas, and from there for America, for Brazil. What will I do there? I can only reply that I will be going to see the butterflies. Perhaps it is absurd, ridiculous, impractical, but it is stronger than I, and if I have perhaps some worth as a poet, it is precisely because I have irrational passions, excessive needs; I would like to see spring in Peru, to make friends with a giraffe, and when I read in the *Petit Larousse* that the Amazon is 6,420 kilometers long and has the largest volume in the world, it has such an effect on me that I cannot even express it in prose.

[He says he is happy to have left] Montparnasse where art only exists by theft, by deception, and by intrigue, where ardor is calculated, where tenderness is replaced by syntax and the heart by reason and where not a single noble artist

breathes and where a hundred people make a living by manipulating novelty.

You were one of the people. . . . and if we found ourselves estranged – an estrangement that I would like to think is only temporary – as a result of a difference of opinion about a certain subject – I should tell you that you always have someone, no matter how little, you can count on. . . . Not wanting to ask you to convey my greetings to anyone, since I absolutely detest everybody except one or two people, Monsieur Fénéon and a certain Brummer, not including simple folk, it only remains to send you my best wishes for the New Year and to ask you to believe that I am very sincerely yours,

<div align="right">
Arthur Cravan

10 Calle Albijesas 10

Gracia

Barcelona

(Level, pp. 54–55)
</div>

Felix Fénéon, who received a letter from Cravan seven months later (from the same address), was a writer and art critic who seems to have preferred the company of Americans. Apollinaire jokingly calls him "le faux Yankee de la rue Richepanse" and outlines his activities in 1914.[6] According to the sculptor Ossip Zadkine, Joseph Brummer was a Hungarian Jew, a loner like Cravan, who never discussed art and who never spoke ill of anyone. Arriving penniless in Paris about 1912, this "personnage mythique" quickly became a successful antiquarian and eventually moved his business to New York, where he became very wealthy.[7]

Apart from these brief identifications, Cravan's extraordinary letter, in which he bares his intimate self, needs little commentary. As much as anything it reveals the intense conflict that structured his personality and threatened to tear him in two. By his own account Cravan suffered from both chronic romanticism and incurable misanthropy – a highly volatile combination. Rejecting the society of those around him, who denied him the love and recognition he so desperately needed, he cultivated the image of a Promethean individualist who would triumph, not only *in spite* of society, but by deliberately violating its most cherished rules. This is what makes him the great precursor of Dada, which assumed the same ethical and aesthetic stance and which (like Cravan) insisted on the fundamental identity of these two domains. Disgusted with European culture and its anemic, perverted traditions, as the letter shows, Cravan dreamt of finding a New World in which he would be free to express his passionate vision. Doubtless his arrival in New York the following year represented the partial fulfillment of his dream. But even the excitement and freedom of New York seems to have left something to desire. Before long, Cravan found himself on the move again, heading South in search of his elusive butterflies, on a journey he would never finish.

<div align="center">Notes</div>

1. See Virginia M. Kouidis, *Mina Loy, American Modernist Poet* (Baton Rouge: LSU Press, 1980) and several articles by Carolyn Burke, e.g., "Becoming Mina Loy," *Women's Studies*, 7, Nos. 1–2 (1980), 136–50.

2. Collected in Arthur Cravan, Jacques Rigaut, and Jacques Vaché, *Trois Suicidés de la société* (Paris: 10/18, 1974), pp. 33–185.

3. José Pierre, "Portrait-puzzle d'Arthur Cravan (préface-coupure)," ibid., p. 12.

4. Nina Hamnett, *Laughing Torso* (London: Constable, 1932), p. 51.

5. André Level, *Souvenirs d'un collectionneur* (Paris: Mazo, 1959), p. 52; my translation.

6. Guillaume Apollinaire, "M. Félix Fénéon," *Anecdotiques,* ed. Marcel Adéma (Paris: Gallimard, 1955), p. 151.

7. Ossip Zadkine, *Le Maillet et le ciseau, souvenirs de ma vie* (Paris: Michel, 1968), pp. 122– 24 and 148–49.

Dada, Dead or Alive

Kenneth Burke

Waldo Frank says that America is too Dada for a Dadaist movement, since Dada can grow only as a reaction from an environment of order and tradition. Dada feeds off tradition, says Frank – and America is not entitled to a Dada movement until we have created, after several hundred years, a cultural integer ripe for disintegration. Thus, what America needs today is a counter-Dada. "The first step in the absorption and control of our Dada multiverse is the achievement of a serious, of a literally religious temper." Closing his eyes and talking on, Frank imagines this brave little group: "a handful of serious creators – men unafraid of unpopular words like philosophy, profundity, saintliness, devotion." This article is in 1924, issue number 3.

In one place Frank accuses Americans of getting their Dada from Europe, and in another he says, "No wonder they (the French) imported our essential chaos to lighten the regularities of France!" This is not a contradiction; it may be clarified by further development. Thus: America is Dada in its actual mode of life, and has produced popular artists to express this Dada. The French Dadas express rather a reaction against their old, well-ordered system, and look to the chaotic conditions in America with relief. American intellectuals go to Paris where they learn to be patriots, returning to America with the religion of Joe Cook and Krazy Kat. They mimic the more literary variety of French Dada, rather than the American stock with its greater vigour (greater vigour because it is the potato bug proper to the potato). Dada in Europe is a prodigal son. In America it is Topsy, and just growed.

W. C. Brownell, in The Genius of Style, points out that when the command "As you were" is given, the regiment falls out of line and style ceases. Obviously, this is where Dada begins. Which is to say, Dada is the result of neither regimentation nor chaos, but of pronounced regimentation coexisting with pronounced chaos.

Moral standards were never more fluctuant? Time-tables were never more trustworthy. Dada could arise in Europe and America simultaneously because in both regions regimentation and chaos thrive side by side, each engendering a keener sense for the other.

The architecture of the moving van is Dada. Or the eye which notes that architecture is Dada. (Read "was Dada." For Dada, like God, is dead.)

Whereupon our definition. Dada is perception without obsession. In a civilization of much grotesqueness (of pronounced opposites) Dada is the recording of this grotesqueness. Dada is the child who, seeing a lame man

hobble down the street, attempts through neither sympathy nor mockery, but sheer curiosity, to hobble.

I rescue from the obscure files of a 1921 New York Tribune, and place here in the eternal archives, a paragraph I once composed on Dada:

"There is a certain warehouse in New York with four entrances for receiving goods. Above each entrance is the name of the produce received. They are: bar steel, bar iron, sheet steel, plate steel. A person standing idly in front of this warehouse is apt to find these words operating uncalled for in his head. They twist and squirm into various new orders. Thus they may become bar bar, steel iron, sheet plate, steel steel. Or steel bar, iron bar, steel sheet, steel plate. The usual reaction is to clear the head as soon as such a bondage is discovered. The Dadaist, on the contrary, recognizes the legitimacy of his inspiration because it has existed. Consequently, these four warehouse entrances form a perfect Dadaist enterprise. . . . Surely, this principle is not entirely valueless. We have insane psychology and child psychology and mob psychology; here are the elements of an idle psychology."

Since then, as may be observed, my nomenclature has ripened. And now, instead of "idle psychology," I write "perception without obsession," or "observation without purpose," or "pure literature."

Mr. Harvey L. Dickinson, in the outhouse of his farm near Roanoke, saw a page of a Sears Roebuck catalogue torn by accident in such a way that it was pieces of women. Down one side there was an ear, somewhere else the left half of a smile, in another corner merely two legs crossed. This had been a page advertising women's underwear, but in its present fragmentary state it became Dada. Had Mr. Dickinson appreciated this, he would have been Dada: he would have seen something grotesque which was there to see. Philosophy, profundity, saintliness, devotion are not called in.

Whatever we do, let it be done, not by counter-Dada, but by Dada aggrandized. Frank's programme threatens to be less a process of integration than a deliberate ruling out of certain predominant factors in life, in life where we must halt the talk of supernal beauty until the brass band goes by. An integration which is not an avoidance must be Dada plus, supernal beauty AND the brass band. Plato was Sophistry plus.

A friend writes from Canada: "A neighbour, moving near by, was for some days involved in the turmoil of resettling; and his dog, to that extent disorbited, walking a quarter of a mile up the road to explore the new territory, stopped gravely to observe me in the garden. His owner is James MacDonald; so I, not knowing the dog's name, and yet hoping to find some bond of communication between us, called out, 'Heigh, MacDonald.' Whereupon MacDonald, agreeably surprised by hearing this familiar name, entered the garden and stood beside me. I next asked, 'How's business?' and MacDonald presented his ears to be scratched. I scratched his ears, and he forthwith began attempting the virtue of my leg, so that in anger I ordered him out of the garden. Later I reflected on this strange encounter: how quickly our acquaintance had ripened into friendship, our friendship deepened into intimacy, and our intimacy burned itself out in passion—and in this rapid telescoping of events, I decided, there was Dada."

Where, Waldo Frank, is the counter-Dada? My Canadian friend's perception was adequate to the subject. Why philosophy, profundity, saintliness,

devotion? You are saying, "Let us deliberately limit the subject. Let us see only those aspects of life which justify the use of my four words. Let us integrate by simplifying our vision." In this light your four words become a sturdy, but shameless suicide.

You answer that the characters in Racine never go to the W. C. "Here," you say, "is integration by avoidance." You point out that all art is integration by avoidance, that art, contrary to Dada, is perception with obsession, observation dictated by purpose. I retort: The Racinian integration, flower of a perfectly integrated society (and thus, a result, and not an antidote) is the last kind possible to-day. Any attempt at ceremony which violates the spirit of the contemporary (the tide-ghost?) will result in hot-house products, abortions, monsters of sickliness. It would be a symptom of contemporary disorders, not a solution of them.

The artist does not run counter to his age; rather, he refines the propensities of his age, formulating their aesthetic equivalent, translating them into terms of excellence. The artist, as artist, is not a prophet; he does not change the mould of our lives: his moral contribution consists in the element of grace which he adds to the conditions of life wherein he finds himself. Over against the Racinian integration, there is the Shakespearean integration: kings and populace, stately kings and runny-nosed populace, supernal beauty and brass bands, affirmation and actuality, your four words and Dada.

[Reprinted from *Aesthete 1925*, February 1925, pp. 23–26].

II. DOCUMENTS

1. Articles on New York Dada from New York Newspapers

Since the New York group's activities primarily occurred in the private world of Walter Conrad Arensberg's salon and the artists' studios, relatively few newspaper articles reported on New York Dada. Those that did appear attempted to explain the "iconoclastic" views of the European participants: Marcel Duchamp, Jean Crotti, and Francis Picabia. In 1921, a few articles began to relate Paris Dada to the activities of the Arensberg circle.

The first reprinted article, "French Artists Spur on an American Art" (*New York Tribune,* Sunday, October 24, 1915), is an extremely important document, since it contains early and very significant interviews with Duchamp, Picabia, de Zayas, and Gleizes. The author of this article very accurately predicts the great importance and impact of the future interrelation between these newly arrived "rebellious" French artists and American writers and painters: "And if we are to furnish the buoyancy of crude life to these newcomers, they in turn will pay us with what is perhaps equally necessary, the courage to break from the tradition of Europe." In their interviews the European artists emphasize the impossibility of working in devastated Europe and their excitement in regard to New York, which is giving them a fresh impetus and new inspiration for their art. They are all convinced that New York is destined to become the artistic center of the world. Although this article appeared anonymously, its well-informed and sympathetic character suggests as author Bessie Breuer, who was a friend of the Arensbergs and who was at that time Sunday editor-in-chief at the *New York Tribune.*

"Cubist Depicts Love in Brass and Glass" by Nixola Greeley-Smith from *The Evening World* (Tuesday, April 4, 1916) is an interview with Marcel Duchamp and Jean Crotti, published on the opening day of a cubist exhibition at the Montross Gallery, in which Crotti, Duchamp, Gleizes, and Metzinger participated. The article sheds some light on Crotti's *The Mechanical Forces of Love,* but the interview is generally rather humorous because of the author's naiveté in regard to experimental art.

Margery Rex's article "'Dada' Will Get You if You Don't Watch Out; It Is on the Way Here" (*New York Evening Journal,* January 29, 1921) relies heavily on F. S. Flint's article on Paris Dada entitled "The Younger French Poets," which appeared in the London *Chapbook* (November 1920). But in order to get a precise definition of Dada, the author went to the Société Anonyme and asked Katherine Dreier, Duchamp, Joseph Stella, and Man Ray for their definitions, which are included in the article. The author obviously saw a close connection between European Dada and the members of the Société Anonyme even before their officially embracing Dada.

"The Cheerless Art of Idiocy" by Henry Tyrrell from *The World Magazine* (June 12, 1921) is a representative article of the anti-Dada position in America. Tyrrell rejects European as well as New York Dada as a destructive, decadent, "ultra-Bolshevist," and Jewish invention. The illustrations in this article are works of New York Dada: Man Ray's *Lampshade*, and Jean Crotti's wire *Portrait of Marcel Duchamp*.

These articles are reprinted with the help of Francis Naumann, who also provided the photographs which present the works reproduced in these newspaper articles.

<div align="right">Rudolf E. Kuenzli</div>

French Artists Spur on an American Art
[Anon].

(New York Tribune, Sunday, October 24, 1915 [Sec. 4, pp. 2–3])

For the First Time Europe Seeks Inspiration at Our Shores in the Persons of a Group of Modernist French Artists, Who Find Europe Impossible Because of Its War-Drenched Atmosphere – Macmonnies Predicts That the Effect of This Migration Will Be Far-Reaching on Art of America and the Older Continent

For the first time Europe seeks America in matters of art. For the first time European artists journey to our shores to find that vital force necessary to a living and forward-pushing art. And, as voiced by Frederick MacMonnies, the celebrated sculptor, the effect of this migration to our shores is likely to be more farreaching than even the most enthusiastic now imagine.

When young Marcel Duchamp, known to us as the painter of the famous staircase nude, came over the art world took his journey as a manifestation of curiosity and stood apart in piquant expectancy, confidently waiting for him to express the timeworn disgust with America and its standards generally ladled out to this country by artists. He didn't. He praised, and gloried in the vibrant electricity of this wholly new and young and strong force in the world. And then came Albert Gleizes, one of the foremost of French cubists, and his wife, Juliette Roche Gleizes, on their honeymoon, and fast on their heels Francis Picabia and Frederick MacMonnies, and Jean and Ivonne Crotti, and fluttering in their wake letters from their artist colleagues in the trenches announcing that they, too, were spending their spare time studying English, because they intended to come to the United States as soon as the war ceased.

And New York awoke to find that it is witnessing a French invasion – an invasion of the young and rebellious in the art of Europe, which will give of itself to the art of the United States, and in turn take from us what we have to offer. And that, in the words of these artists, is life, in contradistinction to the living death of Europe, a stagnation that was felt a year or two before war actually began.

And if we are to furnish the buoyancy of crude life to these newcomers, they in turn will pay us with what is perhaps equally necessary, the courage to break from the tradition of Europe. And it is an American who has lived and achieved in Europe who points this out.

EVERY ARTIST AN ASSET.

"Conditions on the other side," explains Mr. MacMonnies, "are bound to work enormously toward raising the status of art in this country. How permanent the effect will be depends upon the scope the movement attains before some degree of stability is

resumed in Europe. I believe that this is the inception of a brilliant era for America.

"I look upon this awakened interest in America as a most fortunate and significant thing. America should welcome with open arms all the artists who will come over. The effect of this movement is likely to be more far-reaching than even the most enthusiastic now imagine. Artists of every sort ought to be welcomed. Every artist, no matter what his ideals may be, or whether his work be comprehensible or not to the majority, is a valuable asset. If he be only in earnest, each artist may influence the tide. Revolutionary tendencies are always healthy tendencies. They open up fresh channels, and incidentally an era which will eliminate the age hallowed necessity of going abroad to study, through this sudden and potent pilgrimage of artistic Europe to our free shores.

"I think that the time is surely approaching when American students will not need to go outside their native land to acquire even technique. This new impetus ought to result in the establishment of wholly comprehensive schools. It may be that a system of scholarships will be established. Indeed, I look for all sorts of growth."

But a warning against the tendency that would make this new art impetus nationalistic is sounded by Albert Gleizes, who, in happy phrasing, voices a sturdy thesis of universality. He points out that art is not a thing of geography, but of persons. The individual is of highest importance. But in Europe, he assures us, the individual is being utterly annihilated. Governments are assuming a despotic sway over the lives of all men, and in this crude reversion to barbaric ethics the individual is lost.

In America, Francis Picabia, another prominent "modernist" painter, asserts, the art of the future will be found attaining a new and gorgeous florescence. The spirit of America seems subtly, yet powerfully, akin to the spirit of artistic creation. There is a fearlessness and a newness about it which sends hope racing through one's arteries. The boundlessness of our national aspirations sets a dashing pace for the equal boundlessness of artistic enterprise. In short, art and life here seem to discover a wonderful consanguinity.

But M. De Zayas, a stanch friend of the "modernists" in this country, and who has just established the "modern" gallery, devoted to furthering the interests of contemporary art, does not hesitate to state that the real potentiality of the American nation is still awaiting, the magic of an artist's touch to spring forth in pristine, free expression. America has yet to find herself.

"America has the same complex mentality as the modern artist; the same eternal sequence of emotions and sensibility to surroundings; the same continual need of expressing itself in the present and for the present," he says.

Of course, the artists now arriving from Europe and establishing studios here are not entering a field entirely devoid of artistic achievement. Much has been done. American artists have been laying a very commendable groundwork. What it is firmly believed this invasion of Europe will accomplish is the infusion of great buoyancy and zest to the entire art movement in this country. The tendency will be to broaden, deepen and enrich all productivity. But it is by no means the native element which is being and is destined to be influenced. The newcomers, one and all, frankly acknowledge a rejuvenation of spirit, in some cases even a vital renaissance of ideal. Francis Picabia, for example, admits to having put all former things behind him and to having grasped the genius of American machinery as the new medium through which his art may be expressed.

Motion is the very heart of progress. When a thing becomes static its days are numbered. This shifting of field from Europe to America implies a ceaseless alertness which proves art virile and assertive. Its never ending growth is mirrored in the life of the individual artist. The highest intelligence seems that which recognizes, even in the full flush of any given "period," that there must be a wane and a new rising. Marcel

Duchamp corroborates this eternal individual development. "I am never deceived, myself, into thinking that I have at length hit upon the ultimate expression. In the midst of each epoch I fully realize that a new epoch will dawn."

As with the artist, so it is with art. Boundaries are not recognized. Art soars free and unimpeded toward ever higher and higher goals. If the march of events in the world prohibits this desired untrammelled flight, then art will brood till a gate is opened. Now a gate has been opened. It has been thrown wide. America lies beyond it, and here is revived that hope which charges genius with the precious fire of achievement.

And their individual reasons for coming, merged into a composite, amount to the fact that all air, all life, is stifled by the war.

"The people of Europe have become brutes!" cried Albert Gleizes, foremost of French cubists, and probably one of the two or three cubists of note in the world who so style themselves. "Individuality is utterly lost in a struggle whose butchery and terror have raised governments into the attitude of despots. Force has taken the place of reason and right. All the best blood of Europe is being spilled. In the end there will be left only old men, women and babies.

"So far as art is concerned, the war is bound to have the most deadly influence upon it. Not alone is it impossible for artists to work abroad at this time, but when peace is finally established a state of exhaustion will impel the greatest artistic dearth Europe has perhaps ever known. A generation will be skipped. When the babies have grown up there may be a new group of artists. But what must be their heritage? Imbued with the precepts of war, they will be vitally handicapped from the beginning. Art nurtures art. War destroys it.

"This frightful condition is shared by all Europe. The individual is being crushed, or welded into a vast instrument to be swayed by the despots who control all destiny there today. And art, being essentially an expression of the individual, must be lost in the terrible gulf which is claiming manhood and all the better ideals of civilization. A condition of absolute barbarism is being rapidly achieved.

"I could not work in Paris. After serving at the front until relieved by sickness, I tried to take up the old threads in Paris. I could not concentrate on the canvas. I could not think. Mangled bodies would be carried through the streets. Everywhere one heard nothing but the horror of war, saw nothing but war's agonizing blight. I laid my brushes aside. It was impossible.

"We came to America, and what a change! Here everything is calm and ordered. The individual counts. Here art is possible. You see, I have already resumed my painting."

The artist displayed a cubist impression of Broadway.

"New York inspires me tremendously. I find life baffling in many respects. Walking through the streets of this great city, I have, not infrequently, a feeling of being hemmed in and even crushed. This is perhaps partly due to the height of the buildings, but also to the movement of humanity, streaming so steadily, so fixed of purpose, knowing so exactly where the goal lies. In Paris there is a maze of little streets. Life goes with starts and stops. It is much more devious and complex. But New York is a very thrilling place. It stimulates me, and the glamour increases as I become more and more accustomed to the trend of things.

"The skyscrapers are works of art. They are creations in iron and stone which equal the most admired old world creations. And the great bridges here – they are as admirable as the most celebrated cathedrals. The genius who built the Brooklyn Bridge is to be classed alongside the genius who built Notre Dame de Paris. The same spirit underlies all supreme achievements. It is a very mistaken impression that one must go to Europe to see beautiful things."

"True art never is a matter of schools," Mr. Gleizes said in the course of our conversation. "It is universal, of all time and for all time. If it must be divided at all, it should

be portioned into epochs. It is a thing of persons and not of cult. Nor is there, in any but the most superficial sense, a French school, a German school, an Italian school. The same emotions are felt all over the earth. People are merely people. The manifestations of art may be extremely various. This is illustrated, I think, by a comparison already made – a comparison involving American skyscrapers and bridges and European palaces and churches. The same impulse to portray animates artists in every land.

"I am here in America to study American life. I mean to travel a good deal. And I hope to do a lot of work. Work is a pleasure in America. There is inspiration and there is peace. In Paris there was nothing but hideous distraction. I'm glad I have turned my back on that terrible nightmare."

Mme. Gleizes was quieter and less outspoken than her husband regarding the state of affairs in Europe and their influence upon art. But she spoke feelingly of the attractiveness of life on this side of the ocean and echoed his assurance that one could devote oneself to art in this country, where it was impossible to do so abroad.

Madame Gleizes is a poet as well as a painter.

"I have written nothing at all since the war came upon us," she said, wistfully. "Life in Europe is little conducive to poetry. But now I am here, in this wonderful, free country, I think that inspiration will shine again for me. I hope to write a poem a little later on expressing my profound happiness in the revelations that America has afforded me."

Francis Picabia, one of the three or four most prominent "modernists" of France, served eight months in the French army, after which he was recalled, and he arrived in New York four months ago, and will remain at least as long as a secret mission continues to demand his presence here – perhaps all the rest of his life, if this can be arranged.

"This visit to America," the painter enthusiastically maintained, "has brought about a complete revolution in my methods of work. I began as a landscape painter, was later classed as a cubist, and gradually came into my own – which is a state I cannot otherwise classify than entirely individual. But prior to leaving Europe I was engrossed in presenting psychological studies through the mediumship of forms which I created. Almost immediately upon coming to America it flashed on me that the genius of the modern world is machinery, and that through machinery art ought to find a most vivid expression.

MACHINERY THE SOUL OF HUMAN LIFE.

"I have been profoundly impressed by the vast mechanical development in America. The machine has become more than a mere adjunct of human life. It is really a part of human life – perhaps the very soul. In seeking forms through which to interpret ideas or by which to expose human characteristics I have come at length upon the form which appears most brilliantly plastic and fraught with symbolism. I have enlisted the machinery of the modern world, and introduced it into my studio.

"Naturally, form has come to take precedence over color with me, though when I began painting color predominated. Slowly my artistic evolution carried me from color to form, and while I still employ color, of course, it is the drawing which assumes the place of first importance in my pictures.

"Of course, I have only begun to work out this newest stage of evolution. I don't know what possibilities may be in store. I mean to simply work on and on until I attain the pinnacle of mechanical symbolism. Since coming to America I have painted a great deal. My brush has been very busy. And for two reasons. First and foremost, naturally, is the fact that I have a whole new scheme to evolve. But a very important item is the fact that in America work of an artistic nature is possible where it is utterly impossible in Europe to-day. The war has killed the art of the Continent utterly. Even those who miserably try to seclude themselves and find a little nook where work may

be carried on undisturbed find that distractions creep in. The horror of war is everywhere. It penetrates to the furthest outposts. In America work is possible. I am making the most of my time.

"Since machinery is the soul of the modern world, and since the genius of machinery attains its highest expression in America, why is it not reasonable to believe that in America the art of the future will flower most brilliantly?"

M. De Zayas, founder of the "Modern Gallery," has said, "America waits, inertly, for its own potentiality to be expressed in art." Which seems quite in line with the sentiment expressed by the man who has painted him. "In all times," De Zayas goes on to say, "art has been the synthesis of the beliefs of peoples. In America this synthesis is an impossibility because all beliefs exist here together. One lives here in a continuous change, which makes impossible the perpetuation and the universality of an idea. History in the United States is impossible and meaningless. One lives here in the present, in a continuous struggle to adapt one's self to the milieu. There are innumerable social groups which work to obtain general laws. But no one observes them. Each individual remains isolated, struggling for his own physical and intellectual existence. In the United States there is no general sentiment in any sphere of thought. America has the same complex mentality as the modern artist; the same eternal sequence of emotions and sensibility to surroundings; the same continual need of expressing itself in the present and for the present, with joy in action, and with indifference to 'arriving.' For it is in action that America, like the modern artist, finds joy."

M. Picabia firmly believes that America is destined to become the high court of the "modernists." Not only does he find the American spirit, as his friend De Zayas has expressed it, peculiarly one with the spirit of the modern artists themselves, but he believes the present invasion of European artists is bound to add a great buoyancy and zest to the whole art movement in this country.

M. Crotti, another of the French contingent, is not a cubist. He does not arbitrarily classify his work. And this emancipation from facile identification is carried to the extent of merely numbering his productions, and never conferring a name.

"I do not think the name should be necessary to an understanding of a canvas. Art should be self-expressing. It is not with nature I am concerned, but with ideas. I paint my thoughts. Whatever objects may enter into the composition are wholly arbitrary. They are sheer pretext. It is only the subtle arrangement of color and form that counts. I do not attempt to portray anything but ideas."

The Crottis have been in America several months, though they are newcomers to this city. Directly upon landing they travelled into the Middle West, where they have been visiting friends.

"I found a wonderful new calm out there," explained M. Crotti. "Coming straight out of the turmoil of wartime Europe, this presence of quiet is a most striking thing. Almost immediately the spirit of the altered life began exerting a benign influence. I found it possible to take up my brush, which had been so long relinquished on account of the multiple distractions of war. I have done a number of paintings since arriving in America.

"New York is very stimulating. Of course, so far as direct inspiration is concerned, I bring to my work the same attitude of mind here as elsewhere. I do not portray what I see but what I feel. My work is quite the reverse of M. Gleizes's, for example. The same distinctions encountered in the realm of literature and of music may be attributed also to painting. Either you are a realist or you are an idealist. These words" – and Marcel Duchamp also expressed himself very similarly in this regard – "do not at all adequately cover the two attitudes of mind. But they are the words most familiarly used to distinguish the two."

NEW YORK THE CRADLE OF ART?

Mme. Crotti, also an artist, does work quite distinct from her husband's. While she

132

has done large paintings, her true forte is a kind of exquisite miniature.

It would be hard to fancy the artist sitting down to fashion her exquisite little brush poems in the midst of broiling Europe.

"Are you happy to be in America?" I asked her.

"Oh, yes," she replied, "very, very happy. One can breathe over here. I hope to accomplish so much. We're going to spend the winter in this big, wonderful city. Do you think the Americans will care for these little pictures? I am so anxious to go on and on."

Her husband supplemented her enthusiasm.

"We both find America very stimulating," he said. "And do you know, it seems very possible to me that New York is destined to become the artistic centre of the world. Art certainly isn't possible in Europe, and will not be for a long time. But art is very thrillingly possible over here. It is an era of tremendous readjustment. I think it quite possible that New York will come to be looked upon as the cradle of art, usurping the proud place enjoyed so long by Paris and other important European cities. This is the first time that Europe has been impelled to seek anything artistic in America. It has always been the other way about. Americans have come over to us. Now we are coming over to you. Of course, it is impossible to say how extensive this revolution may proceed, but the present restless movement cannot fail to have a profound influence on the artistic status of America."

I asked whether an ultimate American school of art would be the result.

"Oh, now," he replied decidedly, "not that Art has nothing to do with nationality. If we come over here it is not to infuse the American spirit into our work, but rather to seek that freedom from turmoil which is impossible at home. When your artists, in the past, have gone over to Europe to study with famous masters, they have not, or only in rare cases, renounced their nationality, or assumed any attitude discounting individual point of view. As a rule, they have come over, learned what Europe had to teach, and then returned. That is the way with the European artists who are now coming over to America. Only with us it is impossible to say how long our residence may be. Even should peace be soon declared in Europe, conditions would not be favorable for a long time to come. I think New York will become a permanent home of artists before the older centres are in a position to encourage a renewal of artistic endeavor."

And the Quartier Latin? Do these artists forget it?

"I assure you," says Marcel Duchamp, "the Quartier Latin is a gloomy endroit these days! The old gay life is all vanished. The ateliers are dismally shut. Art has gone dusty. You know, at the outbreak of the war all Latin Quarter cafés closed up at 8 o'clock in the evening. When I abandoned Paris last spring the hour had been advanced to 10:30. But it is a very different life from the happy, stimulating life one used to encounter. Paris is like a deserted mansion. Her lights are out. One's friends are all away at the front. Or else they have been already killed.

"I came over here, not because I couldn't paint at home, but because I hadn't any one to talk with. It was frightfully lonely. I am excused from service on account of my heart. So I roamed about all alone. Everywhere the talk turned upon war. Nothing but war was talked from morning until night. In such an atmosphere, especially for one who holds war to be an abomination, it may readily be conceived existence was heavy and dull.

"So far as painting goes – it is a matter of indifference to me where I am. Art is purely subjective, and the artist should be able to work in one place quite as well as another. But I love an active and interesting life. I have found such a life most abundantly in New York. I am very happy here. Perhaps rather too happy. For I have not painted a single picture since coming over.

"From a psychological standpoint I find the spectacle of war very impressive. The

instinct which sends men marching out to cut down other men is an instinct worthy of careful scrutiny. What an absurd thing such a conception of patriotism is! Fundamentally all people are alike. Personally I must say I admire the attitude of combatting invasion with folded arms. Could that but become the universal attitude, how simple the intercourse of nations would be."

This young artist's studio in Beekman Place contains a few of his paintings. The celebrated "Nude Descending the Stair" is at present on exhibition in San Francisco. Monsieur Duchamp carefully explained that this work is not cubist, that none of his work is cubist. Like Madame Gleizes, he is doing things his own way. I asked whether he were still painting after the manner of the "Nude."

"Oh, no," he answered. "I have passed that long ago. My methods are constantly changing. My most recent work is utterly unlike anything that preceded it."

"Do you think, monsieur, that you will find in America a public capable of appreciating your work?"

He shrugged his shoulders. "That I cannot say. Pioneers must always expect to be misunderstood. It is a matter of great indifference to me what criticism is printed in the papers and the magazines. I am simply working out my own ideas in my own way. Those who do not understand what it is we are attempting to portray simply cannot be shown. I cannot explain my paintings. Either one grasps their purport or one doesn't. To any one admitting an incapacity to understand this art, I say: Study all the paintings of the genre you can. It is only through constant observation that the 'an becomes clear."

'Ionsieur Duchamp expressed himself as delighted with America.

"ı adore New York," he said. "There is much about it which is like the Paris of the old days. Many artists have come over, and I think many more will come. As I said, I can paint wherever chance sets me down. I am perfectly emancipated in that regard. But I must admit the atmosphere of Paris just now is not such as to inspire artists."

Among the more noted of this artist's work is a study of chess players and of a king and a queen. These are highly interesting paintings and exemplify some of Duchamp's strongly individual ideals.

"You will observe, in the picture of the chess players," he remarked, "that a very intense absorption in the game is evinced. This is produced by a technique which must be visioned to be understood. The impression of watchers, who form the background, is conveyed in the same manner. With this king and queen," he continued, turning to the other picture, "sex is established by the same method of suggestion. To me the execution of the king is very much more masculine than that of the queen. Motion, you will observe, is supplied by a procession of rapidly moving nudes. Of course, both of these pictures are fruit of an epoch in my life which is past. There is nothing static about my manner of working. I am never deceived myself into thinking that I have at length hit upon the ultimate expression. In the midst of each epoch I fully realize that a new epoch will dawn.

"Regarding the attitude of the public toward my work, and, indeed, to all the work of this genre, I think it is more the execution than the spirit which is misunderstood and not comprehended. At the bottom, we are all working toward the same goal. Mere details of execution do not constitute the real spirit of art. Every artist has his own way of working with the materials at hand. For my part, the fact that my ideals reflect a period of growths proves that the spirit of art may be approached from many angles. Until all have been tried, it is impossible to affirm, with any degree of veracity, that the manner has been achieved. Art is all a matter of personality."

"The Nude Descending the Stair," in the finished state, with which the public is familiar, did not spring into being without intermediate steps. Marcel Duchamp has in his studio a photograph of an earlier treatment of the same theme, which affords an interesting comparison. Ranging the two studies side by side makes very apparent the

expenditure of much thought between the conception of the idea in the first place and its ultimate treatment. The latter is much more powerful and moving. Also it is worked out more subtly, expanding, in a number of salient directions, what the earlier study rather hinted than expressed.

Cubist Depicts Love in Brass and Glass; "More Art in Rubbers Than in Pretty Girl!"
by Nixola Greeley-Smith

(*The Evening World*, Tuesday, April 4, 1916 [p. 3])

Big, Shiny Shovel Is the Most Beautiful Thing He
Has Ever Seen, Says M. Cotti, [sic] Whose Master-
piece, "Mechanical Forces of Love," Is
Made of Metal—Cubist Exhibit
Opens Here Tuesday.

Beginning Tuesday, at the Montross Art Galleries, M. Marcel Duchamp and M. Jean Crotti, both of Paris, will meet all comers for the world championship as exponents of the eccentric and the new in art.

M. Duchamp is already widely known in this country as the painter of "The Nude Descending a Stairway," which was the sensation of the Armory Exhibition three years ago. Perhaps you remember that famous picture, which looked much more like a shanty on the English Coast after a Zeppelin had shelled it than like any woman you or I or M. Duchamp ever saw. But I forget! M. Duchant [sic] told me last week that "The Nude Descending a Stairway" is not a woman. Neither is it a man.

"Is it a woman?" this young but very world-weary Frenchman repeated after me, with a look of unutterable boredom which I envied him. I seldom dare to look as bored as I feel. "No. Is it a man? No. To tell you the truth, I have never thought which it is. Why should I think about it? My pictures do not represent objects but abstractions. 'The Nude Descending a Stairway' is an abstraction of movement."

M. Duchamp's remark contained of course the familiar explanation of the Cubist theory. But it did not explain—I don't see how any Cubist can explain why one should undertake to express the abstract in such concrete terms as paint and canvas must convey.

The Forces of Emotion Told in Metals.

But why should we quarrel with the Cubist formula, particularly when it is carried to the uttermost limit, as it is in M. Jean Crotti's masterpiece, "The Mechanical Forces of Love," revealed to-day for the first time to a waiting world. By rare good fortune I was given an advance view of this painting, which is done on the glass back of the outlines and made with metal and whole pieces inserted wherever the artist thinks metal is most expressive of the forces of emotion.

Now love is of course the supreme abstraction. It means everything and nothing. Sometimes *everything* and then *nothing*. And in this sense M. Crotti's picture is an accurate interpretation of it. So if things which are equal to the same thing are equal to each other, maybe M. Crotti's exceedingly geometrical picture is the supreme expression of the supreme passion. Study it and make up your mind for yourself. Study, also, the drawing of what a pretty woman looks like or perhaps *seems* like to this artist. For he was good enough to make that picture especially for The Evening World. M. Crotti had said to me:

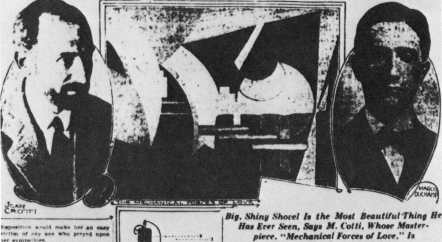

Cubist Depicts Love in Brass and Glass;
"More Art in Rubbers Than in Pretty Girl!"

JEAN CROTTI

MARCEL DUCHAMP

THE MECHANICAL FORCES OF LOVE

disposition would make her an easy victim of any one who preyed upon her sympathies.

"Alma is just the kind of a girl to believe any one," he said, "and would accompany any one to any place if she believed she could do good. I know Alma was a good girl and cared nothing for men or high life."

If Miss Myers planned to go away she did it in an artful manner, for she had her room prepared for company and was at work on fancy articles she was to give as prizes at a birthday celebration in three weeks. She was taking the principal part in preparations for the affair.

Mr. Myers says he does not put much faith in the story told the police by Henry Miller, a shoe clerk, of No. 30 West Fifty-ninth Street, who says he saw a girl answering the description of Miss Myers in a moving picture theatre, Saturday evening Mr. Myers says he believes Miller did not see his daughter, for she disliked movies and could not be persuaded to go to see them.

Miss Myers left her home, at No.

PORTRAIT OF THE MOST BEAUTIFUL GIRL BY JEAN CROTTI

Big, Shiny Shovel Is the Most Beautiful Thing He Has Ever Seen, Says M. Cotti, Whose Masterpiece. "Mechanical Forces of Love," Is Made of Metal—Cubist Exhibit Opens Here Tuesday.

By Nixola Greeley-Smith.

Beginning Tuesday, at the Montross Art Galleries, M. Marcel Duchamp and M. Jean Crotti, both of Paris, will meet all comers for the world championship as exponents of the eccentric and the new in art.

M. Duchamp is already widely known in this country as the painter of "The Nude Descending a Staircase," which was the sensation of the Armory Exhibition three years ago. Perhaps you remember that it was a picture, which looked much more like a chaos on the English Coast after a Zeppelin had shelled it than like any woman you or I or M. Duchamp ever saw. But I forget! M. Duchamp told me last week that "The Nude Descending a Staircase" is not a woman. Neither is it a man.

"Is it a woman" this young but very world-weary Frenchman repeated after me, with a look of unutterable boredom which I envied him. I seldom dare to look so bored as I feel. "No. Is it a man? No. To tell you the truth, I have never thought which it is. Why should I think about it? My pictures do not represent objects but abstractions. 'The Nude Descending a Stairway' is an abstraction of movement."

"A pretty woman is the most insipid thing in the world! As an object of art I have never seen one that I would consider worth putting on a mantelpiece! That pair of rubbers over there"—M. Crotti indicated a pair of large muddy goloshes [sic] in the corner of the studio the two young Frenchmen share at No. 1947 Broadway—"is much more interesting and decorative than a pretty woman, considered from the point of view of art.

"In nature I am like every other man, very much interested in pretty women. But I speak to you as an artist—not as a man. As an artist I consider that shovel the most beautiful object I have ever seen."

With a quick, nervous gesture, the blue-eyed, bearded young man indicated an object to which my fascinated gaze had wandered from the moment I had entered the studio. It was a huge, shiny shovel suspended from the ceiling. The shovel quite evidently had never been used. I do not think either M. Crotti or M. Duchamp would consider it interesting from the standpoint of use. It was there to dispense sweetness and light like muddy goloshes, but of course superior to them and—from the stand-

point of art – much more interesting than the very pretty Mme. Crotti, in whose presence this interview took place.

The Passions Symbolized by Balloons.

I had been seated all this time in front of M. Crotti's masterpiece, "The Mechanical Forces of Love," trying to analyze and dissect its meaning. M. Crotti had placed it for me and had put an electric light bulb behind one of three painted balloons to the right of the picture. The light was behind the red balloon. "Love," said the artist, then came a larger balloon. "Blue, the Ideal," M. Crotti explained. The largest balloon of all was the color of the young leaves we shall see in a week or so. "Green, for hope," added the painter. "Farther to the right I have indicated the extent to which love may carry human beings away by suggesting an aeroplane."

"But what is the meaning of those arches?" What are those pieces of brass?" I inquired, wonderingly.

"The brass indicates machinery, energy, power," the artist answered[.]

I was fully in sympathy with the balloon idea. You see, balloons are the toys of children; a faint gust may carry them away forever; a pin point may shrivel them to a thing colorless and dead. Let balloons be the symbol of love by all means!

"Have the balloons in the general spherical construction of your picture any significance?" I asked the artist. "Is love necessarily round?"

Cubist Artist Knows Attraction of the Sexes.

"Oh, no," M. Crotti answered. "It is round because I wish it. Another artist might see it in squares."

As [sic] this point I asked M. Crotti: "Is 'The Mechanical Forces of Love' the work of a believer in love or of a cynic?"

"In the sense of the strong, natural attraction of the sexes I believe in love," the artist answered, "but not in the sense of pretty-pretty sentiment" –

"Pretty-pretty sentiment is very strongly entrenched in this country," I interrupted.

"Yes, is it not?" Mme. Crotti asked. The artist's pretty wife had said little until this moment. "It is astonishing to me how much Americans are taken with sentiment – young love, nice little stars, nice little flowers, nice little birds. You care a great deal for the little bird sort of sentiment here, do you not?"

I had to admit that some of us do.

"My picture does not undertake to express sentimental love. It is love in the most primitive sense," said M. Crotti.

At this point M. Duchamp entered the conversation. "The thing which has struck me most in this country, which has undoubtedly the most beautiful women," he said, "is the lack of really strong emotions in your men. An American, for instance, if he has to choose between an important business appointment and an engagement with the woman he loves, rings her up on the telephone. 'Hello, dear,' he says, 'I can't see you today; I must go to the bank instead.' To a Frenchman that seems very stupid."

"It IS very stupid," I admitted. "But the American woman has encouraged the American man to put the bank before her by making financial success the price of her interest. No wonder he worships his work, since he has to work so hard to support her."

"A queer difference I have observed between French and American women," M. Crotti said, "is that NOT to love is a defeat for the women of our country, while the American woman regards falling in love as a sort of bankruptcy."

"Well, it is a defeat," I said. "It is the greatest of all defeats. Men – particularly American men – are good losers. In love they simply don't know how to win. But what are we going to do about it? American men are all we have."

"Ah, yes," M. Crotti said. "Ah, yes! Perhaps there is no remedy, unless – yes, this is a remedy – more and more beautiful American girls should come to Europe, where we know how to appreciate them!"

137

"Dada" Will Get You if You Don't Watch Out: It Is on the Way Here
by Margery Rex.

(*The New York Evening Journal,* January 29, 1921)

Paris Has Capitulated to New
Literary Movement; Lon-
don Laughs, but Will
Probably Be Next Victim,
and New York's Surrender
Is Just Matter of Time.

This is a "dada poem" by M. Louis Aragon, who, according to the Chapbook, "Tantalizes you with half said things":

MYSTICAL CHARLIE.

"The lift still went down breathlessly
"and the staircase still went up
"That lady does not hear the speeches
"she is a fake
"and I who was already thinking of making
"love to her

"Oh the clerk
"so comical with his mustache and his
"artificial eyebrows
"He shouted when I pulled them
"Strange
"What do I see That noble foreign lady
"Sir I am not a light woman

"Hou isn't he ugly
 "Happily we
 "have pigskin bags
 "hard-wearing
"This one
 "Twenty dollars

"It holds a thousand
"It's always the same system
"No restraint
"or logic
 "a bad theme."

"Dada" Will Get You if You Don't Watch Out; It Is on the Way Here

Paris Has Capitulated to New Literary Movement; London Laughs, but Will Probably Be Next Victim, and New York's Surrender Is Just Matter of Time.

This is a "dada poem" by M. Louis Aragon, who, according to the Chapbook, "Tantalizes you with half said things":

MYSTICAL CHARLIE.
"The lift still went down
breathlessly
"and the staircase still went
up
"That lady does not hear the
speeches
"she is a fake
"and I who was already think-
ing of making
"love to her

"Oh the clerk
"so comical with his mustache
and his
"artificial eyebrows
"He shouted when I pulled
them
"Strange
"What do I see That noble
foreign lady
"Sir I am not a light woman

"Hou isn't he ugly
"Happily we
"have pigskin bags
"hard-wearing
"This one
"Twenty dollars

"It holds a thousand
"It's always the same system
"No restraint
"er logic
"a bad theme."

By MARGERY REX.

What is Dada?

Who are the Dadaists?

Where?—But at least that is possible to explain—they are in Paris. They are taken very seriously in that city even if the rumors which have trickled over to London have caused howls of derision. And Dada is coming to New York.

Dada is a literary movement. It has attacked Paris with lunacies, jibes and insulting ironies, but Paris has nevertheless capitulated to Dada. New York has sympathetic souls awaiting Dada.

The younger French poets go in for Dada. Dada came in to being in the Cabaret Voltaire in Zurich in 1916. Its founder was Tristan Tzara, said to be a Rumanian. He is now at the head of the band of Dadaists who live in Paris.

One of Tzara's first Dadaistic performances was the reciting of one of his onomatopoeic poems to the accompaniment of an electric bell of eight-inch calibre, according to an account written by Mr. Aldous Huxley.

Founder Explains What It Means.

"Dada means nothing," said Tzara, as he is quoted in the November Chapbook. "If I shout

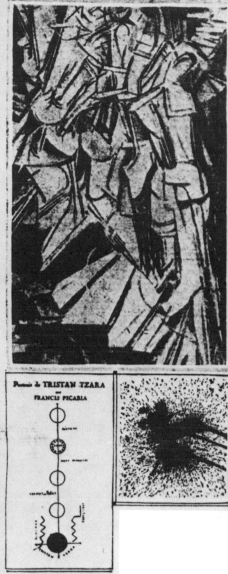

Portrait by TRISTAN TZARA and FRANCIS PICABIA

Not an astronomical chart, but merely Monsieur Picabia's portrait of Tzara, whose personality is such, we are assured, that it perspires from the very joys of poetry he writes.

What is Dada?

Who are the Dadaists?

Where? – But at least that is possible to explain – they are in Paris. They are taken very seriously in that city even if the rumors which have trickled over to London have caused howls of derision. And Dada is coming to New York.

Dada is a literary movement. It has attacked Paris with lunacies, jibes and insulting ironies, but Paris has nevertheless capitulated to Dada. New York has sypmathetic [sic] souls awaiting Dada.

The younger French poets go in for Dada. Dada came in to being in the Cabaret Voltaire in Zurich in 1916. Its founder was Tristan Tzara, said to be a Rumanian. He is now at the head of the band of Dadaists who live in Paris.

One of Tzara's first Dadaistic performances was the reciting of one of his onomatopoeic poems to the accompaniment of an electric bell of eight-inch calibre, according to an account written by Mr. Aldous Huxley.

Founder Explains What It Means.

"Dada means nothing," said Tzara, as he is quoted in the November Chapbook, "If I shout:

"Ideal, ideal, ideal

"Knowledge, knowledge, knowledge

"Boomboom, boomboom, boomboom.

"I have set down exactly enough progress, law, morality and all the other fine qualities which so many intelligent people have discussed in so many books, to come finally to this, that, after all, each one has danced according to his own personal boomboom, and that so far as he is concerned, his boomboom is right: satisfaction of a sickly curiosity; private bell for inexplicable needs; bath; pecuniary difficulties; stomach with repercussion on life –

"If everybody is right and if all pills are not pink, let us try for once not to be right. People think they can explain rationally, by thought, what they write. But it is very relative – ["]

What does it mean? What is Dada?

The Isle de Paris is far away. But it was necessary to find someone on the Isle de Manhattan to throw light upon Dada.

Comment of New York Artists.

At the Societe Anonyme, at No. 19 East Forty-seventh street, moderns of the moderns, in painting, foregather. There I found Miss Katharine Dreier, director of the Societe; Marcel Duchamp, who painted the famous "Nude Descending the Staircase"; Joseph Stella, modern painter, and Man Ray, sculptor.

"Dada is irony," said Miss Dreier. "That is, its basic idea."

"Dada is nothing" said M. Duchamp. "For instance the Dadaists say that everything is nothing; nothing is good, nothing is interesting, nothing is important."

"It is a general movement in Paris, relating rather to literature than to painting," M. Duchamp went on. "It is very contradictory.

"Anything that seems wrong is right for a true Dadaist. As soon as a thing is produced they are against its production.

"It is destructive, does not produce, and yet in just that way it is constructive, do you see?"

Joseph Stella broke in with a wave of his expressive hands. He had just finished with his lecture on modern art.

"Dada means having a good time – the theatre, the dance, the dinner. But it is a movement that does away with everything that has always been taken seriously. To poke fun at, to break down, to laugh at, that is Dadaism."

"Dada is a state of mind," explained Man Ray, sculptor. "It consists largely of negations. It is the tail of every other movement—Cubism, Futurism, Simultanism, the last being closely related."

Declares It Is Also Disgust.

But Tzara, who is Dada himself, says that Dada is also disgust.

"Every product of disgust capable of becoming a negation of the family is Dada—abolition of all hierarchy and social equation set up by our valets—Dada; abolition of the memory: Dada; abolition of the prophets: Dada; abolition of the future: Dada; liberty: Dada. — —

"Liberty: DADA DADA DADA, howling of irritated colors, interweaving of contraries and of all the contradictions, of grotesques, of inconsequences: LIFE."

Nonsense, with or without meaning, we learn, is Dada. Zulu yells, according to Mr. Flint of the Chapbook, special fondnesses, simulated imbecility, incoherent tumbles of words, and occasionally poetry—is Dada.

M. Francis Picabia, famous for many things, contributes this immortal bit of verse to the magazine mentioned:

"Dada smells of nothing, it is nothing, nothing.

"It is like your hopes: nothing.

"Like your paradise: nothing.

"Like your idols: nothing.

"Like your politicians: nothing.

"Like your artists: nothing.

"Like your religions: nothing."

No Prizes for Solutions.

No prizes, laments Mr. Flint, are offered for solutions of these pieces of literature.

The Dadaists may be amusing themselves at the expense of the public, Mr. Flint warns, and they certainly know what they are doing in any case, he says, without letting us share the joke. Their ultimate object seems to be to discredit all the works of the mind.

As soon as any part or parcel of Dada becomes intelligible, some poets flee from it. Sense should be left to children, they feel. It saddens these poets to find sense in modern poetry.

More ironical and less Dadaistic, we are told, is verse by M. Paul Morand, who, according to the Chapbook, is a poet to be watched (?).

"Glorious day,
The British Ambassador returns
 on foot from the Quai d'Orsay.
"Like England
 He is bounded below by gaiters
 of white chalk and above
 By a chimney stack.
"In order not to spoil the success
 of the day for him the wounded
 are going to promise not to
 suffer any more."

Wouldn't This Make You Weep?

But now for your real uncompromising Dada—M. Pierre Albert-Birot:
"Pour Dada
"AN AN AN AN AN AN AN AN

"AN AN AN
IIII I I
"POUH-POUH POUH-POUH RRA
si si si
"drrrrr oum oum
"AN AN AN AN
"aaa aaaa aaa tzinn
"UI IIIIII
"HA HA HA HA HAA HA HA."

Like Ethel Monticue, in the "Young Visitors," we blush or faint at the "mystic words," yet without wishing to wound the sensitive and unintelligible soul of any of the visiting Dadaists we have heard this very identical verse issuing from the apartment next door at about 3 a.m. The young man uttering the words is less formal and less starched, especially at this time of night, than perhaps might be the Dadaist who originally proclaimed the poem from a platform. In common justice to our readers, we must state his attire is informal indeed.

He might be called a Simultanist also. Along with his cryptic song he beats a measure with his fist on the forehead of none other than his weary father, pastmaster in Dadaism, himself, but unappreciative of its vocal aspects at this late hour. Indeed, he is actually held by his frantic father—we mean his DADA—and is also known to accompany his choral measures with movements of his feet.

Unreasonable, yes; but that is the essence of Dadaism.

"Dadaism will only continue to exist by ceasing to be," says J. E. Blanche.

"Painting had already begun to tear down the past—why not literature?" asked M. Duchamp. "But then I am in favor of Dada very much myself."

You Must and You Mustn't.

Paris is more serious, says the Chapbook, and in one of its reviews it prints the following:

"Madame Rachild has written an article on Dada. She has proved you must not write articles about Dada.

"Monsieur Georges Courteline spoke of DADA for an hour at Comoedia: He said that you must not speak of DADA.

"Monsieur Fernand Divoire never says DADA. He says 'the hobby horse' party.

"If you must not speak of DADA, you must still speak of DADA."

The next step, after a cursory examination of Dadaism[,] would seem to to [sic] be a reactionary call for home and Mamaism, with all due respect, or rather all respect due, the founder of DADA.

DADA: The Cheerless Art of Idiocy
by Henry Tyrrell

(*The World Magazine,* June 12, 1921 [pp. 8 and 13])

Dada offers the latest guess at Art's eternal enigma.

Cubism is flattened out. Futurism has been caught up with and soon will be a thing of the past. Synchromism turns out to be the pot of paint at the end of the rainbow. Expressionism contradicts itself so often that artists who ape its styles find themselves in the disheartening condition of being "all dressed up and no place to go."

Wherefore, Dada-ism. What does it mean?

"Dada" is baby talk. The word is the French kid's name for his hobby-horse. On the face of it, therefore, the Dadaists would appear to have adopted as their slogan, "Every one to his hobby." One of them, Andre Breton, has written:

"All is Dada. Every one has his Dadas. You worship your Dadas and make gods of them. The Dadaists know their Dadas and laugh at them. It shows their great superiority over you."

Of course this is too sane and simple to be the real meaning of Dada. The Dadaists must be terribly in earnest about something, else they would not spend their time and money in self-advertising, nor make such frantic efforts as they do to appear frivolous and irresponsible. A typical outburst is the following from the manifesto of Tristan Tzara, the Roumanian Jew who definitively started the Dada movement at the Cabaret Voltaire in Zurich, Switzerland, in 1916.

"Liberty: DADA DADA DADA howling of irritated colors, interweaving of contraries and of all the contradictions, of grotesques of inconsequences – LIFE."

The Dadaist may be a child with a new toy, but he is a perverse and destructive imp, a ruthless smasher of his own and every one else's Dada. His nursery breathes an atmosphere of decadence and dynamite. He is for the annihilation of logic, memory, archaeology, prophecy, and the absolute. He is anti-everything – except anti-Semitic.

"Dada is like your hopes – nothing.

"Dada is like your paradise.

"Dada, your heroes, artists, religions: NOTHING."

This "Nothing" is something, anyway. It shows that Dada is consistently inconsistent, in affirming naught but negation. Ultra-Bolshevist, it is a ruthless iconoclast, a breaker-up of all images, especially those of its own creation. And yet they talk about outbursts of gayety to drown recollection of the nightmare horrors of war.

Really, Dada is too formidable a proposition to be taken seriously. It is a waste of time to try to puzzle out the merely literary and politico-social propaganda which chiefly occupies the Dadaists. Let us rather look over their pictorial output – the new and disturbing "art" stuff that has most brought Dada into the public eye, at least in America.

Francis Picabia, chief artist-editor of Dada-phone, the Paris literary organ of the cult, is more of a Spaniard than a Frenchman in his dominant physical and temperamental traits, and this applies in some degree to his painting as it was ten years ago. Originally he was an impressionist landscape painter, in the manner of Sisley and Pissarro. In 1913, the date of New York's epoch-making Armory show of modern art, Picabia made his debut here as the pioneer cubist. He has since thrown over the cubist thing, and can you blame him? It had germs of promise, but all can raise the flower now, since all have got the seed. Picabia found congenial associations at "291," the little Photo-Secession art gallery formerly conducted by Alfred Stieglitz at that number on Fifth Avenue, and which was the hotbed of later-day radicalism in all the seven arts, painting in particular.

After doing a few abstract, disintegrated New York impressions – which have no discernible right-side-up unless you read the lettered inscriptions such as "Coon Song," or "A Transverse Section of New York," which the artist places at strategic points in his design – Picabia developed that curious human-machine manner of symbolism in which he still persists. Cog-wheels, pulleys, valves, piston-rods, walking beams, slats and springs are combined into a sort of fire-escape or Patent Office diagram, and labelled as a portrait of some one. In fact, the letterpress and label now play a predominant part in Picabia's published designs, marking his gradual transition from the pictorial to the literary phase. His main activity is that of editorial impresario of the Paris end of the Dada propaganda, though he and his associates are at this moment inviting the public to prove themselves sap-heads by purchasing their pictures.

DADA: THE CHEERLESS ART OF IDIOCY

By
Henry Tyrrell.

Tristan Tzara, who started the Dada movement at Zurich, in 1916.

DADA offers the latest guess at Art's eternal enigma.

Cubism is flattened out. Futurism has been caught up with and soon will be a thing of the past. Synchromism turns out to be the pot of paint at the end of the rainbow. Expressionism contradicts itself so often that artists who ape its styles find themselves in the disheartening condition of being "all dressed up and no place to go."

Wherefore, Dada-ism. What does it mean?

"Dada" is baby talk. The word is the French kid's name for his hobby-horse. On the face of it, therefore, the Dadaists would appear to have adopted as their slogan, "Every one to his hobby." One of them, Andre Breton, has written:

"All is Dada. Every one has his Dada. You worship your Dadas and make gods of them. The Dadaists know their Dadas and laugh at them. It shows their great superiority over you."

Of course this is too sane and simple to be the real meaning of Dada. The Dadaists must be terribly in earnest about something else they would not spend their time and money in self-advertising, nor make such frantic efforts as they do to appear frivolous and irresponsible. A typical outburst is the following from the manifesto of Tristan Tzara, the Roumanian Jew who definitively started the Dada movement at the Cabaret Voltaire in Zurich, Switzerland, in 1916:

"Liberty DADA DADA DADA howling of irritated colors, interweaving of contraries and of the contradictions of grotesques, of inconsequences: LIFE."

The Dadaist may be a child with a new toy, but he is a perverse and destructive imp, a ruthless smasher of his own and every one else's Dada. His nursery breathes an atmosphere of decadence and dynamite. He is for the annihilation of logic, memory, archaeology, prophecy, and the absolute. He is anti-everything—except anti-Semitic.

"Dada is like your hopes—nothing.

"Dada is like your paradise.

"Dada, your heroes, artists, religions: NOTHING."

This "Nothing" is something, anyway. It shows that Dada is consistently inconsistent, in affirming naught but negation. Ultra-Bolshevist, it is a ruthless iconoclast, a breaker-up of all images, especially those of its own creation. And yet they talk about outbursts of gayety to drown recollection of the nightmare horrors of war.

Really, Dada is too formidable a proposition to be taken seriously. It is a waste of time to try to puzzle out the merely literary and politico-social propaganda which chiefly occupies the Dadaists. Let us rather look over their pictorial output—the new and disturbing "art" stuff that has most brought Dada into the public eye, at least in America.

Francis Picabia, chief artist-editor of Dada-phone, the Paris literary organ of the cult, is more of a Spaniard than a Frenchman in his dominant physical and temperamental traits, and this applies in some degree to his painting as it was ten years ago. Originally he was an impressionist landscape painter, in the manner of Sisley and Pissarro. In 1913, the date of New York's epoch-making Armory show of modern art, Picabia made his debut here as the pioneer cubist. He has since thrown over the cubist thing, and can you blame him? It had germs of promise, but all can raise the flower now, since all have got the seed. Picabia found congenial associations at "291," the little Photo-Secession art gallery formerly conducted by Alfred Stieglitz at that number on Fifth Avenue, and which was the hotbed of later-day radicalism in all the newer arts, painting in particular.

After doing a few abstract, disintegrated New York impressions

—which have no discernible right-side-up unless you read the lettered inscriptions such as "Coon Song," or "A Transverse Section of New York," which the artist places at strategic points in his design.—Picabia developed that curious human-machine manner of symbolism in which he still persists. Cog-wheels, pulleys, valves, piston-rods, walking beams, slats and springs are combined into a sort of fire-escape or Patent

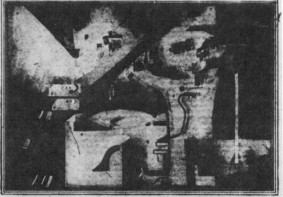

A Cross-Section of New York.—Painting by Francis Picabia.

Francis Picabia, ex-Cubist, master mind of Dada propaganda.

Office diagram, and labelled as a portrait of some one. In fact, the letter-press and label now play a predominant part in Picabia's published designs, marking his gradual transition from the pictorial to the literary phase. His main activity is that of editorial impresario of the Paris end of the Dada propaganda, though he and his associates are at the moment inviting the public to prove themselves sap-heads by purchasing their pictures.

Picabia is co-editor with Tristan Tzara of that wandering monthly or semi-occasional review now called Cannibale, formerly known under the names of Dada-phone and 391. The latter cabalistic number is reminiscent of Alfred Stieglitz's ante-bellum 291, the former periodical manifesto of New York's modern art soviet. Picabia tells us that Cannibale was founded in New York, first printed at Barcelona.

(Concluded on page 15)

Lampshade.—By Man Ray, a pioneer of Dada in New York.

Marcel Duchamp! —A plumber-like portrait (by Jean Crotti) of the young Frenchman who painted the historic "Nude Descending a Staircase."

Picabia is co-editor with Tristan Tzara of that wandering monthly or semi-occasional review now called Cannibale, formerly known under the names of Dadaphone and 391. The latter cabalistic number is reminiscent of Alfred Stieglitz's antebellum 291, the former periodical manifesto of New York's modern art soviet. Picabia tells us that Cannibale was founded in New York, first printed at Barcelona, Spain, and published at Zurich, Switzerland. It now claims Paris as headquarters, "with the collaboration of all the Dadaists in the world." The contributions of these collaborators, though wearing a mirthless mask of foolery, have a pronounced flavor of decadence and Nihilism. Their radicalism recalls that Picabia was formerly a disciple of Bergson, therefore presumably ripe for syndicalist development.

Far from being of French initiative, the Dada movement is widely international. There is more German literature of Dadaistic propaganda than in all other languages combined, only we do not see so much of it here in America. Even the Paris publications – including Picabia's unspeakable "Unique Eunuque" and "Jesus-Christ, Rastaquouere" – are French only in their language, and have the air of being produced mainly for export. Offer them to the average normal Frenchman and you may have to fight a duel.

At first Dada art exhibitions and other public functions of festive and semi-social nature were held mainly in Switzerland and Germany, where they usually contrived, in one way or another, to run foul of the police. Latterly, however, the "manifestations" in Paris have developed into events of bizarre revelry among the radical-artistic smart set of the capital.

Comoedia devotes space to the account of a recent reception which signalized the opening of Picabia's one-man show at the Galerie Povolosky, Rue Bonaparte. A jazz band and some maskers disguised as "Peaux-Rouges" (American Indians) contributed to the entertainment of a distinguished cosmopolitan assemblage – which, by the way, included M. Forterre, director of the Bolshevik Conservatory at Moscow. And a much-applauded address was delivered by the ironic Tristan Tzara, ostensibly on "The Feebleness and the Bitterness of Love," which Comoedia's reporter declares was so madly incoherent that he can recall but a single intelligible sentence: "What Dadaism is working for is to make the people idiots!"

2. Reprint of *TNT*

TNT has been the most elusive magazine of New York Dada. Whereas *Blind Man* (April and May 1917), *Rongwrong* (1917), *New York Dada* (1921), the New York issues of Picabia's *391* (June, July, August, 1917), and even Man Ray's earlier *The Ridgefield Gazook* (1915) are readily available in reprints, only one complete copy of *TNT* is known to exist in the United States. Reprinting it for the first time in the present format necessitated reducing the actual size of the magazine (31 x 23.5 cm.). The only page that is difficult to read reproduces Duchamp's *Combat de boxe,* which can be found in d'Harnoncourt and McShine, *Marcel Duchamp,* p. 267.

Man Ray and his friend Adolf Wolff published *TNT* in March 1919. Although further issues were announced, only this one number appeared. In his last interview (Arturo Schwarz, *New York Dada,* p. 96), Man Ray recalled:

The heading consisted of three black letters: *TNT.* It was a political paper with a very radical slant. The words Communism and Bolshevism didn't exist then in America. *TNT* was a tirade against industrials, the exploiters of workers. We were all mixed up with the anarchist group. It was anarchism rather than anything else . . . we were out-and-out anarchists. We planned this sheet with Wolff, the sculptor. . . . It wasn't made to attract attention; it wasn't even circulated. Like *New York Dada,* which was neither distributed nor sold. It was given away to a few friends, and then we left the whole thing.

Although the only overtly provocative and politically radical aspect of this magazine is its title, the contents and the arbitrary juxtaposition of the contributions are certainly anarchic. Given the explosive title, the lyrical and nonpolitical poems by Adolf Wolff are surprising, since many of his other poems and songs are indeed "a tirade against industrials, the exploiters of workers." Man Ray's misleading description of *TNT* was probably a result of the vagueness of his memories of the magazine's contents, and his much stronger recollection of Adolf Wolff's political activities, which he recalled in the same interview in connection with *TNT*:

He was very active socially; in fact, he was arrested and beaten up by the police while leading a group of strikers. He gave a lecture once to a group of rich society women in some place near the Hudson River. All the American battleships were lined up there. He started his lecture off: "Ladies, you see all those beautiful battleships out there on the Hudson River – you can see them through the window. Well, those guns should be trained on you and fired at you."

The most experimental texts of the magazine are "Etymons" by Adon Lacroix, at that time the wife of Man Ray, and Adolf Wolff's ex-wife, and "Vacuum Tires: A Formula for the Digestion of Figments" by Walter Conrad

(continued on page 163)

TNT

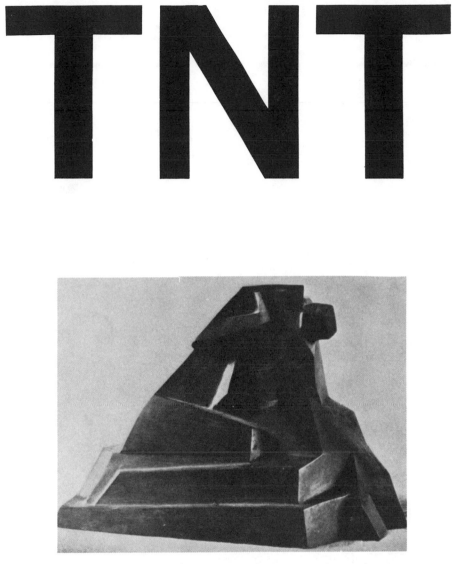

BRONZE — ADOLF WOLFF

New York · March, 1919 · **Fifty Cents**

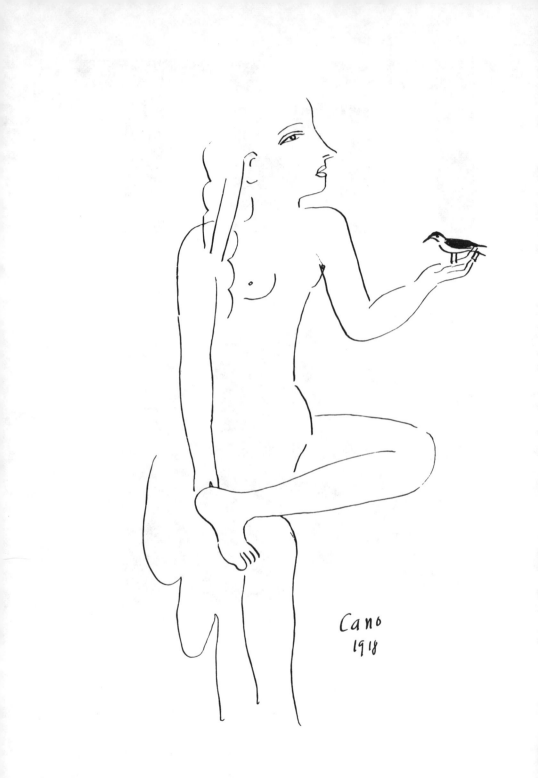

Cano
1918

148

ETYMONS

not so

DA DI ME

OMA DO RE TÉ

ZI MATA DURA

DI O. Q DURA

TI MA TOITURA

DI ZRATATITOILA

PN

ZAZZ

O MA QU

RRO RRO

RU K

ASHM ZT

PLGE

ZR KRN NMTOTO

LA LA LAR-R-RITA

LAR-R-RITA

LAR-R-RITA

I love you

NM E SHCHU

KM NE SCU

mi o do ré mi mi o

"marmelade"

Adon Lacroix.

150

(DREAMING OF DREAMING)

A PANTOMIME.

Persons: Three women, a man, an audience.
Scene: Behind the scenes in a dim light.

Behind a heavy curtain which is drawn over the entrance to the stage a woman, theatrically attired, stands motionless. She is evidently one of the actresses who takes part in this evening's performance. The woman is dressed in a costume that could be taken, by its extravagance of style, to be of the sixteenth century. It betokens a woman of high rank and breeding—perhaps a queen, for the train of the gown is ample and she wears a tiny ornament upon her forehead which looks like a diadem.

Presently an increasing sound of playing instruments is heard with sudden outbursts as if a climax were near. Or perhaps is it the actress' turn to appear. But there seems to be time yet. Meanwhile a slight moving back and forth of the curtain permits one to get a glimpse of her face which is very white with two deep pools for eyes, so dark they look.

Suddenly the sound of a falling body is heard, followed by a long, long cooing of some one's voice on the stage, finishing in sobs, and a small figure of a woman whose form is hidden in a broad cloak tumbles in behind the curtain almost on the other standing near. The attitude of the small figure is one of uncertainty and there seems to be an immense struggle going on within her, although one cannot see her face hidden in the cloak, but for the eyes big and light in color. She has one arm clasped tight over her breast—the other holds her cloak over part of her face. She catches the dark look of the other woman. Her glance softens and she bends low her head which at first was thrown back as if in pain. Her eyes feverishly search for something or somebody. Her hands still clasped tightly over her breast in apparent agony she staggers to a nearby stool for support. But not a sound escapes her covered mouth.

By this time the voice on the stage has died out and the woman who awaits her turn to appear in the play draws near to the one crouching on the stool. She lifts the head of the small woman ever

so gently and looks deeply into her face which is of a deathly appearance with eyes shut. Then she closes her own eyes, releases the head to its former position and stands as if paralized.

All this has taken but a few minutes, when a man, also in stage attire, doubtless an actor, rushes in from the footlights toward the small crouching figure, kneels by her, lifts with trembling hands the part of the cloak which covers her breast and letting it fall again, places his hands over his face moaning, "THIS IS NOT TRUE—I MUST BE DREAMING—O! O!" He takes the small form in his arms and makes blindly for a side exit.

A great noise of music and applause is heard coming from the other side of the curtain and then a tiny bell announcing the turn of the stately actress to appear. As pale as a ghost the woman, who in this evening's play appears as the queen, makes a few steps toward the curtain which she slightly opens. New applause is heard coming from an anxious audience. The applause dies out like thunder. Then the queen, as if she had made a final resolution, steps in, slowly at first still hesitating, always holding on to the velvet curtain with one hand the other raised slightly toward her face. One can see that she is undergoing an intense emotion. She actually lives, it appears, the part she is playing. Of a sudden she flings the curtain open, and makes one big rush for the middle of the foot-lights shouting, "SHE HAS KILLED HER—O GOD!" Her face which was so tragic at first now beams with joy as she leans over the form of a woman lying across the stage—dead. The music stops short.

Not knowing this to be the end the audience is silent as if at a funeral and it is only when the curtain before the foot-lights has fallen entirely that the spectators burst out into applause and hisses.

But the curtain does not go up.

ADON LACROIX.

REVOLVING DOORS

THE MEETING

Three beings meeting in one plane are contrasted, a yellow concave, a red convex, and a spiral blue. There is a mutual affection of color over the areas that two or three occupy together, resulting in a modification of their color but not in their form. Still it is possible to see the areas held in common as distinct additions. As in the other scenes the lines form a not too literal boundary for the planes.

SHADOWS

If three beams of light be thrown on an object from different angles, or if the object were turned to three different angles simultaneously in relation to a single beam of light, the resulting shadows would assume various proportions although their character remain the same. In the same way, if a form be invested with three colors at the same time and viewed from different angles, three distinct characters would result. They could be seen, however, only by imagination.

MIME

Two manners of creating a flame-like effect: by a radiation of bands of the spectrum starting from a common center and contained within a sector, and the other, by concentric bands of the spectrum. The center for both is the same, giving a personal interest. Arm bands carry out the intention to the surrounding space. The mood interpreted may be characterized as a laughing one.

DECANTER

In this case the retort is tilted purely in a spirit of enjoyment; the mold that is produced by the contents is quite adventitious, but carried out with all the deliberation of a preconceived design. It acquires courage from its sudden change of function:—built to reject, it becomes an instrument of acceptance.

THE DRAGONFLY

The lozenges of different-colored wills to ascension are a fairly accurate record of the creature's struggle. The silver is a convention for what is unfulfilled. If the creature consulted its will only, it was bound to be dashed against the unknown. The base is always there for preservation. MAN RAY.

PHYSICAL CULTURE LOUIS BOUCHÉ

VACUUM TIRES: A FORMULA FOR THE DIGESTION OF FIGMENTS

à la la

When the shutter from a dry angle comes between the pin and a special delivery it appears at blue. Likewise in concert with strings on any other flow the clock of third evenings past Broadway is alarming, because it is written in three-four time to chewing gum; if you upset the garter, the r remains west, or to the left of flesh, as in revolving or Rector's. The whole effect is due to blinds, drawn in arithmetic to a sketch of halves, which are smoked into double disks. By such a system of instantaneous tickets a given volume of camera, analyzed for uric acid, leaves a deposit of ten dollars, and the style decrees that human surfaces be worn for transparencies, the price mark being removed from the lapel.

If, however, the showcases are on trolleys, bottles must be corked for the make-up of negroes. Or if a goitre appears in the elevation of the host, a set of false teeth, picked for the high lights by burnt matches, must be arranged at once in three acts. For the first provide electric fixtures that are tuned to cork tips. For the second consideration is flour, thirds being a key that is rarely advertised. Notwithstanding the thermometer into which the conductor spits, the telephone meets in extremes. A window will change the subject for standing room only.

Yet in spite of a Sunday ceiling to the same schedule, condensed into the bucket of a Melba lip-stick, the traffic-cop will empty the ladder to an equal number of rounds. This bandage is the legislature of taxis to taxidermists, hanging the dessert for bricklayers to little remains of cube root. The up town exit may, or may not, be in manuscript, but as a result of the binomial theorem of closing time, the water-mains, whenever they are directed to funerals, will make a vacuum flash.

<div align="right">WALTER CONRAD ARENSBERG</div>

III HEURES

Les voitures roulent e

LES LIGNES LUE

DEVANT

l'appel morne
d'une corne
affole
un homme
noir

`

LE
RETARD

MAIS

DRAWING CHARLES SHEELER

154

mauves violettes
amas d'oranges
vertes feuilles

un
re
ve
rb
ér
e
im
me
ns
e
se
dresse

l'un crie

courent

rois enfants

Philippe Soupault

THE MALICE OF SHADOWS.

I.

The footsteps of secrets
Had stirred all evening:
The comings and goings of things
No lips had uttered.

The nodding of heads,
The gestures of fingers,
A rustling
In and around behind the arras—
Pulled to and fro
By the passing of secrets.

The shadows found them—
Shifting, restless,
Plucking at silence,
Pulling at the arras.
The black amorphous shadows
Wrapped them.

II.

Thru the yellow window curtains
The black sheen of the river
Held only
The reflection of the moon
And the reflection of the stars.
The turgid flowing of the river
Could not erase them.

Softly the shadows crawled
Between the balcony and the room,
Between the balcony and the river,
Licking away the pride
Of the reflections in the river.

And night hovered,
The crafty night,
Like the twisted beak
Of a parroquet.

Mitchell Dawson

155

兒
葉　拉
樹　拉
楊　嘩
小　孩　兒　睡　覺　找　他　媽
乖　乖　寶　貝　兒　你　睡　罷
蟆　虎　子　來　了　我　打　他

FROM THE CHINESE

Purple or not purple
The big fruit of the eggplant
In the eighth moon
Lord Rabbit is worshipped
White cakes—brown cakes
The picture of the moon
Is worshipped and placed in the middle
The soy beans are in disorder
The cockscomb flowers are of deepest red
The peel of the melon offered to the moon
 is dark
The Lord Moon eats and laughs heartily
Tonight the moonlight is brighter than
 usual.

———

There is a small girl
Who does not feel ashamed
And calls the flowerseller her uncle
Uncle-Uncle
Give me a flower of the red pomegranate
I will put it in my bosom
I will put it in my sleeve
And all the ground shall be strewn with
 flowers.

Gilt wood mace
Silvered wood mace
The husband strikes the castanets
The wife sings
They have been singing
Till broad daylight
And she has borne a child
And there was no place to lay him
So they have laid him on the kitchen stove
Where he is sipping
The rice gravy.

———

Goat's dung crushed by the foot
You are my second brother
I am your first brother
Go and buy a bottle of wine
We will both drink it
When I am drunk
I will beat my wife
And then
With flute players and drummers
I will marry another.

LEAVES OF TEA

The mule
Stands
Still
Head bowed
As in thought
But
Perhaps
Too wise
To think.

———

Things of the spirit?
Nay!
Give me things of the flesh
For things of the spirit
There's all eternity.

———

The young woman
By the Mirror
The swan
On the lake
Both
Fussing with their
Feathers.

I brought my mistress a pomegranate
On the persian cushioned couch
In the dim rose light
I fed her
Seed by seed
And with each seed
A kiss.

———

Rivers
The loose threads
Of the sea's
Fabric.

———

A curtain of silence
Raised slowly
By invisible hands.

———

A guilty conscience
Moaning
In the night
It is the wind
That blows.

The potatoes
The cabbages
The turnips
All done sir
The angels said
If you are thru
Said the Lord
You may run along
And play
So they made
The flowers.

———

Pale virgins
Ascending
Spiral stairs
Of unending
Longing.

———

"I'm going to the movies"
Mumbles the babe—
As the navel string
Is being severed.

Whilst the angels
Adjusted
The halo
The Saint blushed
Perhaps
The thought
That he was
"Putting one over."

———

The day said
Let there be
Silence
And it was
Night.

———

With an imbecile smile
I stare into the pit
Into which I have dropped
My yesterdays.

ADOLF WOLFF

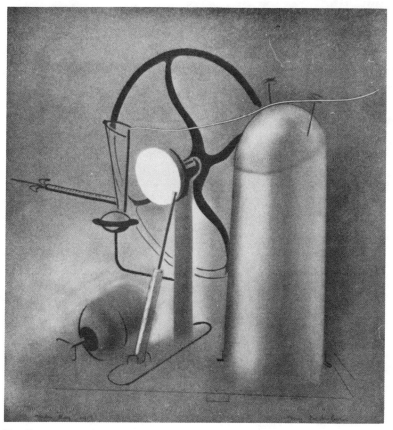

MAN RAY MY FIRST-BORN

THE THEATRE OF THE SOUL.
A MONODRAMA IN ONE ACT
By Nikolai Evréinof
(Translated by Marie Potapenko and Christopher St. John)

CHARACTERS

THE PROFESSOR.
M1, The Rational Entity of the Soul.
M2, The Emotional Entity.
M3, The Subliminal Entity.
M1's CONCEPT OF THE WIFE.
M2's CONCEPT OF THE WIFE.
M1's CONCEPT OF THE DANCER.
M2's CONCEPT OF THE DANCER.
THE PORTER.

The action passes in the soul in the period of half a second.

The prologue takes place before the curtain. A blackboard. Chalks.

The PROFESSOR enters from the wings, stops before the blackboard, and after having bowed to the audience, takes his chalk and begins his demonstration.

PROFESSOR. Ladies and Gentlemen,—When the unknown author of "The Theatre of the Soul," the

play that is going to be presented to you this evening, came to me some weeks ago with the manuscript, I confess that the title of his work did not inspire me with much confidence. "Here," I thought, "is another of the many little sensational plays with which the theatre is deluged." I was all the more agreeably surprised to gather from this reading that "The Theatre of the Soul" is a genuinely scientific work, in every respect abreast with the latest developments in psychophysiology. As you know, the researches of Wundt, Freud, Theophile Ribot and others have proved in the most conclusive way that the human soul is not indivisible, but on the contrary is composed of several selfs, the natures of which are different. Thus if M represents I myself (*He writes on the board.*)

$$M = M1 + M2 + M3 \ldots \ldots Mn.$$

Fichte lays down the principle that if M is the "entity self," this world is not M. That is lucidity itself, gentlemen! According to the dicta of modern science,

however, if the world is not "M," neither is the entity self. That is quite clear, is it not, gentlemen? Thus I, myself or M—is not a simple quantity, because it comprises several entities. I have come to the conclusion that there are three entities, M1, M2, M3. M1 is the rational self—the REASON, if you prefer to call it so. M2 is the emotional self, or, as we may call it, FEELING. M3 is the psychical self, or the ETERNAL. This is easy to understand, I think. These three "M's" or "selfs" constitute the great integral self.

(*He writes:* "M1+M2+M3=M, *the entire personality.*")

You will ask me now, perhaps, where the component elements, of which the complete personality is composed, are situated. The ancients believed that they were situated in the liver, but the author of the work which is to be presented to you holds, and with far better reason I think, that the human soul manifests itself in that part of the physical breast which a man instinctively strikes when he wishes to emphasize his good faith, or even when he uses such expressions as "I am distressed to the soul," or "I rejoice with my whole soul," or "My soul burns with indignation." Consequently the scene of the human soul appears to us like this:

(*He draws a plan on the board with different coloured chalks and proceeds to explain it.*) This plan, ladies and gentlemen, represents, as no doubt you can see, a large heart, with the beginning of its main red artery. It makes from 55 to 125 pulsations a minute, and lies between the two lungs which fill and empty themselves from fourteen to eighteen times a minute. Here you see a little system of nerves, threads of nerves, pale in colour, and constantly agitated by vibration which we will compare with a telephone. Such is the scene in which the "entity self" plays its part. But, ladies and gentlemen, science does not confine itself to explaining things. It also offers us consolation. For instance, it is not enough to say, "I've done a foolish thing." One ought to know which of the three entities is responsible. If it is M2, or the emotional self, no great harm is done. If it is the psychical entity, the matter need not be taken very seriously either. But if it is the rational self it is time to be alarmed. At this point, ladies and gentlemen, I feel myself under the necessity of suspending my explanations and of giving way to the author, to the artists, and to you, ladies and gentlemen, who I know will prove yourselves worthy critics of this admirable little work.

(*The* PROFESSOR *retires.*)

The board is removed. The curtain goes up, and the interior of the human soul is seen, as it has been described by the PROFESSOR. *On the scene, that is to say on the Diaphragm, the three entities, who bear a close resemblance to each other, are discovered. All three are dressed in black, but their costumes differ. M1 wears a frock-coat. M2 an artist's blouse and a red tie. M3 a well-worn travelling dress. The other differences between the three entities are indicated as follows: M1 is a person who wears spectacles and has a quiet, sober manner, his hair is slightly grey and carefully brushed. His lips are thin. M2 has a very youthful manner. His gestures and movements are quick, lively and a little exaggerated. His hair is untidy, his lips are full and red. M3 wears a black mask. He slumbers in the foreground, his bag under his arm, in the attitude of a traveller, worn out by fatigue.*

M2. (*At the telephone.*) Hullo! What? You can't hear me? I am speaking loud enough! What?

It makes your ear vibrate? That is because your nerves are overstrained. Now listen. Brandy! Do you hear? Brandy!

M1. Don't forget that it is you who are forcing him to drink a third bottle for no reason except that you want to pass the time somehow. Poor heart! Look how it is beating!

M2. You would prefer it to be always in a state of stupor, like the sub-conscious! A charming sort of existence!

M1. If the heart goes on beating like that, it will not be for long.

M2. Well, what does that matter? Sooner or later it must stop.

M1. Now you are quoting my exact words.

M2. And why not? You sometimes talk sense.

M1. Please don't touch the nerves. You have been told already that——

(*Each time that the nerves are touched, a low jingling sound is heard.*)

M2. (*With anger.*) Told me! Who has told me? And by what right? Who the devil dares order me about as if I were a servant? I am a poet. Love, passion, that is I! Without me, what would there be here but dust and mildew . . . a museum, a cemetery? . . . Everything is nothing—without passion.

M1. You talk like a fool.

M2. It's the absolute truth. Whose fault is it if we drink?

M1. It is not you, of course, who are always crying out for brandy.

M2. And if I do, isn't it forced on me? Isn't it because in your society there is nothing for our poor being to do but hang himself?

M1. Come now! You know very well that it is you, not I, who are the cause of all his misfortunes. Yes, you, the emotional self. What are you but a selfish libertine, a wreck of a man? Have you ever had any taste for study, ever taken any interest in noble, intellectual work, ever reflected on the idea of moral dignity?

M2. You are nothing but a pedant, a wretched academic dry-as-dust.

M1. Yet I despise you, O emotional self.

M2. And I despise you as much, O rational entity.

(*He passes his hand over the nerves with a big sweeping movement.*)

M1. Stop that. You shall not touch my nerves.

M2. By what right do you interfere? Allow me to remind you that we possess these nerves in common, and that when I touch them it is my nerves which become on edge as well as yours! When, thanks to you, my nerves are numbed, I become as stupid as an ox . . . as stupid, that is to say, as you. You shall not prevent my touching them. I like them taut and strained. Then they become like Apollo's lute, and on them I can play the hymn to love and liberty! (*He plays on the nerves. The heart begins to beat more strongly. Speaking at the telephone.*) Brandy!

M1. (*Snatching away the telephone.*) Valerian!

M2. (*Snatching away the telephone.*) Brandy!

M1. (*Again possessing himself of it.*) Valerian— do you hear? What? There is none left? Then go to the chemists. Valerian—30 drops in a glass of water. (*He leaves the telephone. The two entities walk up and down. They meet.*) Are you calm now?

M2. What are you?

M1. You can see for yourself.

(*They both approach the subconscious entity. A silence.*)

M2. What is he?

M1. Supremely quiescent, as always. Don't disturb his peace. If you do, it is you who will suffer for it. (*At the telephone.*) Have you taken your drops?

Good. I will try and make him listen to reason. But the fact is, I don't grasp the principal point. This woman has attracted you by the originality of her talent, and if, in addition, she has—Very well! But for that to abandon wife and children . . . excuse me, it is not a solution. At least, unless we are to embrace polygamy . . . the ideal of a savage, more capable of appreciating the curve of a leg and the line of a back than the wondrous architecture of an immortal temple—I mean the soul. . . .

M2. Oh! what do all your opinions and beliefs matter to me? She is beautiful. What's the use of reasoning?

M1. The brute beast doesn't reason certainly, but man—to whom the logic of feeling should be familiar—(To the telephone as he passes.)

M2. Good heavens! How dull, how insensible you are . . . and what anguish I endure from being bound to so colourless, so insipid a companion. . . .

M1. You used not to talk like this.

M2. You're right there. I even loved you when we worked together harmoniously. I shall never forget the service you rendered me when I was consumed with love for Annette! To get the better of that very cautious young woman—that was—Oh, on that occasion you showed no lack of cleverness! But of late you have become not merely less intelligent, but as dull as a rusty razor.

M1. Thank you for the compliment! I am not sensitive. Also I am aware that brandy has something to do with your opinion of me.

M2. Oh, God, how beautiful she is! You must have forgotten how beautiful, how gay! Yes, I know she is only a cafe chantant singer—but what of that? You can't remember her face, her figure . . . her whole lovely personality. . . . I will show her to you. (He summons up from the left the seductive concept of the singer.) Sing as you sang yesterday, beloved beautiful one. As you sang yesterday, the day before yesterday, a week ago, last Sunday. Sing, I beg you. (To M1, who has turned his back on the woman's image.) Oh! why don't you help me?

(The first concept of the singer. She sings and dances to the rhythm of the heart which beats joyously.)

Is it you?
Is it you?
Are you the nice young fellow
Who the other day was near me—
So near me in the darkness of the train?
I could not see you then,
For it was much too dark,
But I should like to know
Is it you?
Is it you?
Whom my kisses so sweet
Made so madly in love?

In the train the other day
A gentleman sat near me.
I turned my head to look at him
But at that very moment
The light went out.
Into my arms then my maddened neighbor throws himself,
I kiss him ardently, embrace him, but since that day
Vainly I have searched for him.
Longing, I say to every man I see,
"Is it you?
Is it you?
Are you the nice young fellow
Who the other day was near me—
So near me in the darkness of the train?"

M2. (Enchanted.) Oh, rapture! The whole universe is not worth such joy! Those legs, those feet! Dear God, what carpet in the wide world is fit for the touch of those lovely feet, so lovely that they make me weep? . . . Dance on me! Dance in me! Swing to and fro, angelic censer! (He embraces her feet, her hands.)

M1. What lunacy—what folly! Leave her! It is all imagination. She is not like that. You kiss a painted face, you caress false hair. She is forty if she's a day. Leave her! All that you see and feel is false. See her as she is, see reality! (At the beginning of his speech, the first concept of the woman vanishes R. whence M1 summons the second concept of the singer, ludicrously aged and deformed.) Look! Look, if you would know the truth. Look at the divine feet—hard and coarse! Look at the exquisite head! Tête de veau au naturel . . . without the wig and the curls. (He lifts off the wig and displays an almost bald head.) Take out those star-like teeth! (She takes out her plate.) Now sing!

(She sings out of tune, with a nasal twang, and executes some steps with the grace of an old hack being led to the shambles.)

M2. No, no, this is not reality. This is not the truth! (To second concept.) Go away! Get out of this! (He pushes her out with violence.)

M1. Ah! you are angry. Then you acknowledge you are wrong.

M2. I acknowledge nothing of the kind. You have played some trick on me—you—

M1. You know quite well that the creature on whom you are pouring out this mad passion is not worthy to unloose the shoe-strings of the woman whom you are going to deceive and betray. And why? I ask you why? (He summons from the R. the first concept of the wife, who is nursing a child.) Because she has always been gentle and kind to you? Because she has nursed your child? Her singing is not that of the cafe chantant, I know, but listen! Listen to the lullaby that she is crooning to your little one—that is, if your ear is not now too gross to hear a sound so pure. Her voice is tired, you say. Ah! she has been singing for three long nights—nights that she has passed without sleep, waiting, hoping, despairing, aching for you to come home. (The first concept of the wife sings the lullaby in a low voice.)

Sleep, my little one, sleep;
The pain will soon go, my love.
Be patient, what did'st thou say?
"Daddy! Where is my daddy?"
Daddy will come to thee soon;
Daddy works hard, my darling,
But soon he will come with a toy,
A beautiful toy for thee!
A wooden horse, would'st thou like?
Gee-up, gee-up, a horse to ride.
Good Daddy, kind Daddy—gee-up!
Sleep, my little one, sleep!

M2. (Roughly.) I've had enough of this silly farce. There is no truth in it. It's a got-up affair. It's all vulgar sentimentality. (He violently pushes away the first concept of the wife.) Go away from here, you heroine of melodrama. . . . She is not what you pretend. I know her too well. She has poisoned my whole life. There is no poetry in her, no joy, no passion. She is prose itself, the baldest, the most banal prose, in spite of her heroic attitudes! The eternal housemaid—that's what she is.

(He summons the second concept of the wife—a very ordinary and slovenly bourgeoise. Her untidy hair is done in an unbecoming knot. She wears a dirty dressing gown, stained with coffee, and open at the breast.)

2ND CONCEPT OF THE WIFE. (*Violently.*) This is a true business! If my parents only knew the life I lead with this low brute. What surprises me is that he hasn't got the sack from the office long ago: a drunkard like him! Without that cursed brandy he wouldn't have an idea in his silly head. . . . My gentleman has condescended to give me children. Now he goes about making love to women who don't have children . . . or if they do, kill them for the sake of their precious figures. My gentleman loves the fine arts—the theatre—that is the theatre which he finds in some wretched hole of a cafe chantant . . . where he can drink with a lot of low women with faces daubed with paint—creatures I wouldn't touch with a pair of tongs. . . . It's more than likely that one fine day, he'll come home and poison his children, the brainless sot. . . . But for me he would have pawned everything we have long ago—to the shirts on our backs. An atheist who refuses to kneel down or cross himself before the blessed Sacrament. He's as stupid as he can be, but that doesn't prevent him from talking philosophy—a lot of nonsense about liberty, the duties of a citizen, and so on. Liberty! Liberty to make a beast of himself. I'll liberty you, you wretch. . . .

M2. Yes, that is the real she—the real heroine! That is the creature whom I dare not leave for the sake of the divine being who intoxicates me like a magic potion, who provides the only reason for my still wishing to exist in this dreadful world!

(*As he says this he summons up the first concept of the singer. She sings and dances a can-can, gradually driving into a dark corner L. the second concept of the wife. Then she herself has to retreat before the first concept of the wife, who advances, a menacing but imposing figure, noble in sorrow.*)

1ST CONCEPT OF THE WIFE. (*To the singer.*) Go! I implore you to go. You have no right here.

M1. None. . . . She speaks the truth.

1ST CONCEPT OF THE WIFE. Since you do not love him, since you would not make the smallest sacrifice for him . . . since you have had many others in your life like him . . . leave him alone, leave him in peace, if you still have any heart, any decency. I need him—I need his support—his affection. Oh, don't take him from me—Don't tear him away from his family to whom he owes——

1ST CONCEPT OF SINGER. (*Interrupting mockingly and laughing.*) I know all those phrases by heart. I've heard them so often. They mean nothing.

1ST CONCEPT OF WIFE. Go away, do you hear? Don't drive me too far——

1ST CONCEPT OF SINGER. So now you're going to threaten me, are you? Why, may I ask? Why do you hate me? Is it because I have beautiful legs and firm breasts, or because my words fly like birds and leap like champagne corks?

M2. (*Applauding.*) Bravo! Bravo!

1ST CONCEPT OF THE WIFE. What do you want but his money, you creature for sale——

1ST CONCEPT OF SINGER. What's that? A creature for sale, am I? What are you then? Didn't you sell yourself when you married him? Take it back—take it back, I say, or I'll——

(*She advances threateningly on the first concept of the wife.*)

1ST CONCEPT OF THE WIFE. You shall go—Yes, you shall go!

(*They close with one another, and fight. The anguished heart palpitates noisily during their struggle. Violent curses and frenzied threats are heard, such as "You shameless wretch!" "You beast!" "You're only a harlot!" "I'll teach you!" "You bloody church-goer!" After vanishing from view for a moment in the dark corner L. they reappear more bitter and violent than ever now as the second concepts. The wife has the singer's transformation between her teeth. After a second change of personality, they reappear on the scene. The victory is with the singer, who is seen with the prostrate wife under her knee. The wife disengages herself, and, weeping, escapes L., followed by the laughter of the singer and the bravos of M2. Then M1, indignant, boxes the singer's ears, who runs to the back of the scene uttering plaintive howls like a whipped cur. M2, losing all control, throws himself on M1, and strangles him.. The heart stops for a minute. Two or three nerves touched during the struggle snap. M2, seeing that his adversary is dead, throws himself at the feet of the singer.*)

M2. Come, my queen, come. My beloved, now you are mine, mine in everything, mine for ever, oh, my life, my joy, my love! . . . Come to me.

THE SINGER. (*1st Concept.*) No, you dear little silly. Oh, no! It has only been a joke. Money first . . . love afterwards. And from what I see—there's a sight more love here than money. . . . And how are you going to get any? No—no, *no!* I am not for you, my boy. It was all a joke.

(*She disappears L.*)

(*M2 stands thunderstruck in a despairing attitude. A cafe concert air, of an exciting, irritating type, is heard in the distance. The first concept of the wife is seen. She fixes her large sorrowful eyes on M2. It is difficult to see whether she is nursing her sick child, or making reproachful signs to M2.*)

M2. (*Madly hurling himself at the telephone.*) Quick! Quick now. It's all over. There is nothing. . . I have come to the end of everything. . . . With what strength I have left I implore you to do it quickly. The revolver is in the right-hand pocket. Quickly, oh, more quickly! It will not hurt, believe me, not much. . . . Fire between the fourth and fifth rib. . . . What? You are afraid? There is nothing to be afraid of. It will be all over in a moment. Quick . . .

(*There is a short pause, during which M3 wakes up abruptly and throws an uneasy glance round him. A loud report like a cannon shot is heard. The sound echoes through the vault of the soul. A great hole opens in the diaphragm from which pour out ribbons of blood. Darkness half hides the scene. M2 struggling convulsively falls under the heart drowned in the streamers of red ribbon. The heart has stopped beating. The lung has ceased to respire. A pause. M3 trembles and stretches himself wearily. A Porter carrying a lighted lantern enters.*)

THE PORTER. This is Everyone's town. You have to get out here, sir. You change here.

M3. Thank you, yes. I have to change here.

(*He puts on his hat, takes his bag, and follows THE PORTER, yawning.*)

CURTAIN.

NEW YORK—MARCH, 1919—50 CENTS PER COPY—THIS EDITION LIMITED TO 1000 COPIES. SUBSCRIPTION TO SIX ISSUES $2.50. ADDRESS TNT, ROOM 1705, 60 WALL ST., N. Y., U. S. A. BUSINESS, HENRY S. REYNOLDS. MANUSCRIPT, ADOLF WOLFF. PRINTING, MAN RAY.

Lecouver Press Co.

Arensberg. In his review of *TNT*, Henry McBride claims that Arensberg's text "owes too much to Gertrude Stein and lacks her convincing sincerity" (*The Sun*, March 9, 1919). But these two texts are much more related to Duchamp's language experiments. "Etymons" resembles some of Duchamp's own inscriptions and titles, in which he practices comparative French/English orthography and phonetics. Arensberg's "Vacuum" is an experiment in the manner of Duchamp's English texts "The" (1916) and "Rendez-vous du Dimanche 6 Février," which he addressed to the Arensbergs. Duchamp explained his own writing of "vacuums" of meaning in the following way:

there would be a verb, a subject, a complement, adverbs and everything perfectly correct as such, as words, but meaning in these sentences was a thing that I had to avoid . . . the verb was meant to be an abstract word acting on a subject that is a material object; in this way the verb would make the sentence look abstract. The construction was very painful in a way, because the minute I *did* think of a verb to add to a subject, I would very often see a meaning, and immediately I saw a meaning I would cross out the verb and change it, until, working it out for quite a number of hours, the text finally read without any echo of the physical world. . . . That was the main point of it. (Quoted in Arturo Schwarz, *The Complete Works of Marcel Duchamp*, pp. 457 and 584).

The magazine *TNT* is reprinted here with the generous help of Lucien Treillard, who provided the photographs.

Rudolf E. Kuenzli

III. BIBLIOGRAPHY

New York Dada: Bibliography

The problem of defining New York Dada was a serious one for the compilers of this bibliography. It was decided that researchers would best be served if the chosen limits were fairly broad, allowing room for the many different groups and individuals who have been associated by various writers with New York Dada, "proto-Dada," and the "Dada spirit." At the same time, limitations did have to be imposed, and the overriding criterion had to be scholarly usefulness. Thus, several major writers such as Hart Crane, E.E. Cummings, and William Carlos Williams have been excluded from the list of individual figures partly because of the tenuousness or brevity of their connection with Dada, but mainly because excellent bibliographies of these writers are readily available.

The format of this specialized bibliography is similar to that of the general bibliographies which appeared in *Dada/Surrealism*, nos. 10/11 and 13. The first part consists of monographs, dissertations, exhibition catalogs, and articles relating to New York Dada, including both contemporary documentation and later critical works. Also included are works on European Dada appearing in American publications to 1925, as well as a selection of works on various events and institutions closely associated with Dada in New York, such as the Armory and Forum exhibitions and the Société Anonyme. The second part deals with twenty individual artists and writers associated with New York Dada. Primary literature is largely restricted to work appearing between 1913 and 1925. For those individuals also associated with European Dada (Cravan, Duchamp, Man Ray, Picabia), primary works are for the most part further restricted to the Dadaist's New York period. Secondary works on the individuals are included which contain substantial material on the New York Dada era. The subsections on exhibition catalogs include both exhibitions from the New York Dada period and later retrospective catalogs containing works of that period. The final section lists periodicals affiliated with New York Dada, or in which a substantial number of contributions by the Dadaists appeared. Reprints are noted when available.

For more extensive bibliographies on particular topics, the reader is referred to recent monographs on individual Dadaists, and to works on specific aspects of the avant-garde in America, such as those by Bohan, Brown, and Platt. For more general works on Dada, many of which include information on the movement in New York, see the bibliographies by Rudolf E. Kuenzli in nos. 10/11 and 13 of *Dada/Surrealism*.

As always, we invite and encourage your collaboration in our bibliograph-

ical work. Please inform us of any additions, corrections, or related bibliographical projects.

We wish to express our special thanks to June Fischer, without whose able typing this bibliography would not have been possible.

Rudolf E. Kuenzli and Timothy Shipe
Dada Archive and Research Center
425 EPB
The University of Iowa
Iowa City, Iowa 52242

I. Books, Exhibition Catalogs, and Articles on General Aspects of Dada in New York, and on American Reception of European Dada

1. BOOKS AND DISSERTATIONS

Abrams, Ann Uhry. "Catalyst for Change: American Art and Revolution, 1906–1915." Diss. Emory University, 1975.

Anderson, Margaret. *My Thirty Years' War.* New York: Covici, Friede Publishers, 1930.

――――, ed. *The Little Review Anthology.* New York: Hermitage House, Inc., 1953.

Baur, John I. H. *Revolution and Tradition in Modern American Art.* Cambridge: Harvard University Press, 1966.

Blesh, Rudi. *Modern Art USA: Men, Rebellion, Conquest, 1900–1956.* New York: Knopf, 1956.

Bohan, Ruth L. *The Société Anonyme's Brooklyn Exhibition: Katherine S. Dreier and Modernism in America.* Studies in the Fine Arts: The Avant-Garde, no. 20. Ann Arbor: UMI Research Press, 1982.

Brown, Milton Wolf. *American Painting, from the Armory Show to the Depression.* Princeton: Princeton University Press, 1955.

――――. *The Story of the Armory Show.* N.p.: Joseph H. Hirshhorn Foundation, 1963.

Bryer, Jackson. "A Trial Track for Racers: Margaret Anderson and *The Little Review.*" Diss. University of Wisconsin, 1965.

Davidson, Abraham A. *Early American Modernist Painting 1910–1935.* New York: Harper & Row, 1981.

Dijkstra, Bram. *The Hieroglyphics of a New Speech: Cubism, Stieglitz, and the Early Poetry of William Carlos Williams.* Princeton: Princeton University Press, 1969.

The Golden Door: Artist-Immigrants of America, 1876–1976. Washington: Smithsonian Institution Press, 1976.

Goodrich, Lloyd. *Pioneers of Modern Art in America.* New York: Whitney Museum, 1963.

Gregg, Frederick James, ed. *For and Against: Views on the International Exhibition Held in New York and Chicago.* New York: Association of American Painters and Sculptors, Inc., 1913.

Henderson, Linda Dalrymple. *The Fourth Dimension and Non-Euclidean Geometry in Modern Art.* Princeton: Princeton University Press, 1983.

Janis, Sidney. *Abstract & Surrealist Art in America.* New York: Reynal & Hitchcock, 1944.

Kreymborg, Alfred. *Troubadour: An American Biography.* New York: Boni and Liveright, 1925.

Kuh, Katherine. *The Open Eye.* New York: Harper & Row, 1971.

Leavens, Ileana B. *From "291" to Zurich: The Birth of Dada.* Studies in the Fine Arts: The Avant-garde, no. 39. Ann Arbor: UMI Research Press, 1983.

The Louise and Walter Arensberg Collection. Philadelphia: Philadelphia Museum of Art, 1954.

Marling, William Henry. "Williams and the Arensberg Circle, 1909–1923." Diss. University of California at Berkeley, 1980.

May, Henry F. *The End of American Innocence, 1912–1917.* New York: Knopf, 1959.

McBride, Henry. *Some French Moderns Says McBride.* New York: Société Anonyme, 1922.

Moak, Peter van der Huyden. "Cubism and the New World: The Influences of Cubism on American Painting, 1910–1920." Diss. University of Pennsylvania, 1970.

Motherwell, Robert, ed. *The Dada Painters and Poets.* 2nd ed. Boston: G. K. Hall, 1981.

Platt, Susan Noyes. *Modernism in the 1920s: Interpretations of Modern Art in New York from Expressionism to Constructivism.* Studies in the Fine Arts: Criticism, no. 17. Ann Arbor: UMI Research Press, 1985.

Pach, Walter. *Queer Thing, Painting.* New York: Harper & Brothers, 1938.

Richter, Hans. *Dada, Art and Anti-Art.* Transl. David Britt. 1965; rpt. New York: Oxford University Press, 1978.

Ritchie, Andrew C. *Abstract Painting and Sculpture in America.* New York: The Museum of Modern Art, 1951.

Rosenfeld, Paul. *Port of New York: Essays on Fourteen American Moderns.* New York: Harcourt, Brace and Company, 1924.

Rothenberg, Jerome, ed. *Revolution of the Word: A New Gathering of American Avant-garde Poetry, 1914–1945.* New York: Seabury Press, 1974.

Schmidt, Peter Jarrett. "Williams and the Visual Arts, 1915–1945." Diss. University of Virginia, 1980.

Schwarz, Arturo. *New York Dada: Duchamp, Man Ray, Picabia.* Munich: Prestel-Verlag, 1973.

Seldes, Gilbert. *The Seven Lively Arts.* New York: Harper and Bros., 1924.

Société Anonyme (the First Museum of Modern Art, 1920–1944): Selected Publications. New York: Arno Reprints, 1972.

Szekely, Gillian M. Hill. "The Beginnings of Abstraction in America: Art and Theory in Alfred Stieglitz's New York Circle." Diss. University of Edinburgh, 1971.

Tashjian, Dickran. *Skyscraper Primitives: Dada and the American Avant-garde, 1910–1925.* Middletown, Conn.: Wesleyan University Press, 1975.

Wertheim, Arthur Frank. *The New York Little Renaissance: Iconoclasm, Modernism, and Nationalism in American Culture, 1908–1917.* New York: New York University Press, 1976.

Zilczer, Judith. "The Aesthetic Struggle in America, 1913–1918: Abstract Art and Theory in the Stieglitz Circle." Diss. University of Delaware, 1975.

2. EXHIBITION CATALOGS

Anderson Galleries, New York. *Alfred Stieglitz Presents Seven Americans.* [Exhibition, March 9-25, 1925. Works by Demuth, Dove, Hartley, Marin, O'Keefe, Stieglitz, and Strand].

The Armory Show: International Exhibition of Modern Art, 1913. 3 vols. Arno Series of Contemporary Art. New York: Arno Press, 1972. [Reprint of catalog and related documents].

Armory Show 50th Anniversary Exhibition, 1913-1963. Utica, NY: Munson-Williams-Proctor Institute, 1963.

Avant-garde Painting & Sculpture in America, 1910-25. Wilmington, Delaware Art Museum, 1975.

Beginnings and Landmarks: "291," 1905-1917. New York: An American Place, 1937.

Catalogue of the First Annual Exhibition of the Society of Independent Artists. New York: Grand Central Palace, 1917. [Exhibition, April 10-May 6].

Collection of the Société Anonyme, Inc. New York: Museum of Modern Art; New Haven: Yale University Art Gallery, 1950. [Exhibition catalog].

Commemorating the Fiftieth Anniversary of the Forum Exhibition. New York: American Contemporary Art Heritage Gallery, Inc., 1966. [Exhibition, March 14-April 9, 1966].

Dada and New York. New York: Whitney Museum of American Art, 1979. [Exhibition, May 31-June 6, 1979].

The Decade of the Armory Show. New York: Whitney Museum of American Art, 1963. [Exhibition, February 27-April 14, 1963].

The Forum Exhibition of Modern American Painters. New York: Anderson Galleries, 1916; rpt. New York: Arno Press, 1968. [Exhibition, March 13-25, 1916].

Paris-New York. Paris: Centre National d'Art et de Culture Georges Pompidou, 1977. [Exhibition, June 1-September 19, 1977].

Pioneers of Modern Art in America. New York: Whitney Museum of American Art, 1946. [Exhibition, April 9-May 19, 1946].

Pontus Hulten, K. G. *The Machine as Seen at the End of the Mechanical Age.* New York: The Museum of Modern Art, 1968.

Schwarz, Arturo. *New York Dada: Duchamp, Man Ray, Picabia.* Munich: Prestel-Verlag, 1973. [Exhibition, Städtische Galerie im Lenbachhaus, Munich, December 15, 1973-January 27, 1974; Kunsthalle Tübingen, March 9-April 28, 1974].

Yale University Art Gallery. *The Société Anonyme and the Dreier Bequest at Yale University: A Catalogue raisonné.* New Haven: Yale University Press, 1984.

3. ARTICLES AND PARTS OF BOOKS

Abadie, Daniel. "Société Anonyme Inc., Museum of Modern Art." In *Paris-New York.* Paris: Centre Georges Pompidou, 1977, 368-95.

Agee, William. "New York Dada, 1910-1930." *Art News Annual,* 34, (1968), 105-13.

"An American Collection." *Philadelphia Museum Bulletin,* 40, no. 206 (May 1945), 66-80.

Baur, John I. H. "The Machine and the Subconscious: Dada in America." *Magazine of Art*, 44 (1951), 233–37; rpt. as "Revolution in Subject: The Machine and the Subconscious" in his *Revolution and Tradition in Modern American Art*. Library of Congress Series in American Civilization. Cambridge: Harvard University Press, 1966, 23–33.

Brown, Milton Wolf. "Cubist-Realism: An American Style." *Marsyas*, 3 (1943–45), 139–60.

Bruno, Guido. "The Forum Exhibition, Stieglitz and the Victim." *Bruno's Weekly*, 2 (March 25, 1916), 567–68.

Buffet-Picabia, Gabrielle. "Dada et l'esprit Dada." *Preuves*, 2, no. 11 (January 1952), 46–47.

———. "Introduction à l'art moderne aux Etats-Unis." *Vingtième siècle*, n.s. no. 40 (June 1973), 63–68.

———. "Some Memories of Pre-Dada: Picabia and Duchamp." In *The Dada Painters and Poets*. Ed. Robert Motherwell. 2nd ed. Boston: G. K. Hall, 1981.

———. "L'Epoque pré-Dada à New York." In her *Rencontres avec Picabia, Apollinaire, Cravan, Duchamp, Arp, Calder*. Paris: Belfond, 1977.

Burke, Kenneth. "Dadaisme is France's Latest Literary Fad." *New York Tribune*, 6 February, 1921, sec. 7, p. 6.

Casseres, Benjamin de. "The Unconscious in Art." *Camera Work*, no. 36 (October 1911), 17.

———. "The Renaissance of the Irrational." *Camera Work* (June 1913), 23–24.

Champa, Kermit. "Charlie Was Like That." *Artforum*, 12, no. 6 (March 1974), 57–59.

Cheyney, Sheldon. "Why Dada?" *The Century Magazine*, 104 (1922), 22–29.

Ciolwolski, H. "Stieglitz Group in Anniversary Show." *The Art News*, 14 March 1925, 5.

Cowley, Malcolm. "The Death of Dada." In his *Exile's Return: A Literary Odyssey of the 1920's*. 1934; rpt. New York: Viking, 1956.

Craven, Thomas. "Making Modernism Difficult." *The Dial*, 76 (April 1924), 357–60.

Coady, R. J. "The Indeps." *The Soil*, 1 (July 1917), 202–05.

"Dada is Dead." *The Living Age*, 332 (1927), 736.

"Dadaism vs. Tactilism." *American Art News*, 12 February 1921, 1.

Eldredge, Charles. "The Arrival of European Modernism." *Art in America* (July–August 1973), 34–41.

Field, Hamilton E. "Current Art Exhibitions [Société Anonyme]." *The Arts*, 1, no. 1 (December 4, 1920), 34–35.

Frank, Waldo. "Seriousness and Dada." *1924*, no. 3 (September 1924).

"French Artists Spur on an American Art." *New York Tribune*, October 24, 1915, sec. 4, 2–3.

Friend, Julius W. "Innocents Abroad." *The Double Dealer*, 4 (1922), 201–04.

Hamilton, George Heard. "Dada in New York." In his *Painting and Sculpture in Europe, 1880–1940*. Harmondsworth: Penguin, 1967.

Heap, Jane. "Comments." *Little Review*, 9, no. 3 (Spring 1923), 27–29.

Kimball, Fiske. "Before Columbus." *Philadelphia Museum Bulletin*, 49, no. 239 (1953), 3–15.

Kreymborg, Alfred. "Dada and the Dadas." *Shadowland,* 7, no. 1 (September 1922), 43, 70.

———. "Originals and Eccentrics." In his *A History of American Poetry: Our Singing Strength.* New York: Tudor, 1934, 466–522.

Kundera, Ludvik. "Dada Panoráma 3: New York 1911–1920, Berlin 1918–1919." *Světová Literatura,* 11 (1966), 232–46.

Lebel, Robert. "Paris–New York et retour avec Marcel Duchamp, dada et le surréalisme." In *Paris–New York.* Paris: Centre Georges Pompidou, 1977, 64–78.

Lincoln, Louise, and William I. Homer. "New York Dada and the Arensberg Circle." In *Alfred Stieglitz and the American Avant-Garde.* By Winslow I. Homer. Boston: New York Graphic Society, 1977, 179–185.

The Little Review. French Number. 9, no. 4 (Fall–Winter 1923–24).

Lozowick, Louis. "The Russian Dadaists." *Little Review,* no.7 (September–December 1920), 72–73.

McBride, Henry. "Modern Art." *The Dial,* 71 (December 1921), 718–20.

———. "Modern Art." *The Dial,* 73 (1922), 586–88.

———. "Modern Art." *The Dial,* 74 (1923), 113–16.

———. "Modern Art." *The Dial,* 75 (1923), 619–21.

———. "News and Views of Art, Including the Clearing House for Works of Cubists." *New York Sun and Herald,* May 16, 1920, sec. 8, p. 8.

Mellow, James R. "Gertrude Stein among the Dadaists." *Arts Magazine,* 51, no. 9 (May 1977), 124–26.

Milman, Estera. "Dada New York: An Historiographic Analysis." In *Dada/Dimensions.* Ed. Stephen C. Foster. Ann Arbor: UMI Research Press, 1985.

Mitchell, Charles. "The Ideas of Pre-Dada." *The Listener,* 62 (1959), 867–69.

Munson, Gorham. "A Bow to the Adventurous." *Secession,* no. 1 (Spring 1922), 15–19.

———. "The Fledgling Years, 1916–1924." *Sewanee Review,* 40 (1932), 24–54.

———. "The Skyscraper Primitives." *The Guardian,* 1 (March 1925), 164–78.

———. "A Specimen of Demi-Dadaisme." *New Republic,* 34, no. 437 (April 18, 1922), 219–20.

Naumann, Francis. "The Big Show: The First Exhibition of the Society of Independent Artists. Part I." *Artforum,* 18 (February 1979), 34–39.

———. "The Big Show: The First Exhibition of the Society of Independent Artists. Part II. The Critical Response." *Artforum,* 18 (April 1979), 49–53.

———. "Cryptography and the Arensberg Circle." *Arts Magazine,* 51, no. 9 (May 1977), 127–33.

———. "The New York Dada Movement: Better Late than Never." *Arts Magazine,* 54, no. 6 (February 1980), 143–47.

"A Post-Impressionist Scandal." *American Art News,* April 17, 1920, 1.

Rivière, Jacques. "French Letters and the War." *Broom,* 3, no. 1 (August 1920), 18–28.

Roosevelt, Theodore. "A Layman's Views on an Art Exhibition." *The Outlook,* 29 (March 9, 1913), 718–20.

Rubin, William S. "Dada in New York." In his *Dada and Surrealist Art.* New York: Abrams, 1968.

169

Sanders, Emmy Veronica. "America Invades Europe." *Broom*, 1, no. 1 (November 1921), 89–93.

Schulz, Bernhard. "Made in America: Technik und Dingwelt im Prazisionismus." In *Amerika, Traumwelt und Depression 1920/40*. Berlin: Neue Gesellschaft für bildende Kunst, 1980, 72–137.

Schwarz, Arturo. "The Dada Spirit and New York Dada." In his *New York Dada*. Munich: Prestel-Verlag, 1973, 7–44.

Seckel, Hélène. "Alfred Stieglitz et la Photo-Secession: 291 Fifth Avenue, New York." In *Paris–New York*. Paris: Centre Georges Pompidou, 1977, 226–65.

———. "L'Armory Show." In *Paris–New York*. Paris: Centre Georges Pompidou, 1977, 266–93.

———. "Dada New York." In *Paris–New York*. Paris: Centre Georges Pompidou, 1977, 342–67.

———. "Du cubisme à l'art abstrait?" In *Paris–New York*. Paris: Centre Georges Pompidou, 1977, 316–40.

Stewart, Patrick L. "The European Art Invasion: American Art and the Arensberg Circle, 1914–1918." *Arts Magazine*, 51 (May 1977), 108–12.

Sweeney, James Johnson. "Eleven Europeans in America [Interviews]." *The Museum of Modern Art Bulletin*, 13, no. 4–5 (1946).

Tashjian, Dickran. "Dada in Amerika: sein Verhaltnis zu *The Little Review*." In *Sinn aus Unsinn: Dada International*. Bern: Francke, 1982, 264–76.

———. "New York Dada and Primitivism." In *Dada Spectrum: The Dialectics of Revolt*. Ed. Stephen Foster and Rudolf Kuenzli. Iowa City: University of Iowa, 1979, 115–44.

Tyrell, Henry. "Dada: The Cheerless Art of Idiocy." *World Magazine* (supp. to *New York World*), June 12, 1921, 8, 13.

Tzara, Tristan. "Eye-Cover, Art-Cover, Corset-Cover: Authorization." Transl. Marcel Duchamp and Man Ray. *New York Dada*, April 1921.

———. "Germany – a Serial Film." *Vanity Fair*, 20, no. 2 (April 1923), 59, 105, 108.

———. "Some Memories of Dadaism." *Vanity Fair*, 18, no. 4, (July 1922), 70, 92, 94.

———. "What Are We Doing in Europe?" *Vanity Fair*, 19, no. 1 (September 1922), 68, 100.

Vos, Geo. W. "Art and Machinery." *The Soil*, 1 (December 1916), 16–19.

Watson, Forbes. "Nottingham Dadas at Whitney Club." *World*, January 27, 1924.

Wilson, Edmund. "The Aesthetic Upheaval in France: The Influence of Jazz in Paris and the Americanization of French Literature and Art." *Vanity Fair*, 18, no. 6 (February 1922), 49, 100.

Zilczer, Judith. "The Armory Show and the American Avant-garde: A Reevaluation." *Arts Magazine*, 53, no. 1 (September 1978), 126–30.

———. "Primitivism and the New York Dada." *Arts Magazine*, 51, no. 9 (May 1977), 140–42.

———. "Robert J. Coady: Forgotten Spokesman for Avant-Garde Culture in America." *American Art Review* (November 1975), 77–90.

———. " 'The World's New Art Center': Modern Art Exhibitions in New York City, 1913–1918." *Archives of American Art Journal*, 14 (1974), 2–7.

II. Books, Catalogs, and Articles by and on Individual Writers and Artists. In the bibliographies on individuals, the following subdivisions are followed:

A. Books by the individuals, reprints, and translations.

B. Articles, poems, and stories by the individuals, and translations of these.

C. Books and dissertations on the individuals.

D. Exhibition catalogs on the individuals.

E. Articles and parts of books on the individuals.

WALTER CONRAD ARENSBERG

A. Arensberg, Walter Conrad. *Idols.* New Poetry Series. New York: Houghton Mifflin, 1916.

————. *Poems.* Boston: Houghton Mifflin, 1914.

B. Arensberg, Walter Conrad. "Arithmetical Progression of the Verb 'To Be.' " *391,* no. 5 (June 1917), 4.

————. "Axiom." *The Blind Man,* no. 2 (May 1917), 8.

————. "Dada est américain." *Littérature,* no. 13 (May 1920), 15–16.

————. "Partie d'échecs entre Picabia et Roché." *391,* no. 7 (August 1917), 3.

————. "Poems." *Rogue,* 1, no. 4 (May 1, 1915), 6.

————. "Theorem." *The Blind Man,* no. 2 (May 1917), 9.

————. "To the Necrophile." *Trend,* 8, no. 2 (November 1914), 145.

————. "Voyage à l'infini." *Others,* 1, no. 3 (1915), 53–54.

C. Fields, Kenneth Wayne. "The Rhetoric of Artifice: Ezra Pound, T. S. Eliot, Wallace Stevens, Walter Conrad Arensberg, Donald Evans, Mina Loy, and Yvor Winters." Diss. Stanford University, 1967.

Lincoln, Louise H. "Walter Arensberg and His Circle." M.A. Thesis University of Delaware, 1972.

Marling, William Henry. "Williams and the Arensberg Circle, 1909–1923." Diss. University of California at Santa Barbara, 1980.

The Louise and Walter Arensberg Collection. 2 vols. Philadelphia: Philadelphia Museum of Art, 1954.

E. D'Harnoncourt, Anne. "A. E. Gallatin and the Arensbergs: Pioneer Collectors of Twentieth-Century Art." *Apollo,* n.s. no. 149 (July 1974), 52–61.

Kimball, Fiske. "Cubism and the Arensbergs." *Art News Annual,* 24 (1955), 117–22, 174–78.

Kuh, Katharine. "Walter Arensberg and Marcel Duchamp." In her *The Open Eye: In Pursuit of Art.* New York: Harper & Row, 1971.

McBride, Henry. "The Walter Arensbergs." *Dial* (July 1920), 61–64.

Millier, Arthur. "An Arensberg Profile." *Art Digest,* 25, no. 9 (February 1, 1951), 10.

Naumann, Francis. "Crypography and the Arensberg Circle." *Arts Magazine,* 51, no. 9 (May 1977), 127–33.

———. "Walter Conrad Arensberg: Poet, Patron, and Participant in the New York Avant-garde." *Philadelphia Museum of Art Bulletin,* 26, no. 328 (Spring 1980), 2–32.

Stewart, Patrick L. "The European Art Invasion: American Art and the Arensberg Circle, 1914–1918." *Arts Magazine,* 51, no. 9 (May 1977), 108–12.

JOHN COVERT

B. Covert, John. "The Real Smell of War: A Personal Narrative." *Trend,* 8, no. 2 (November 1914), 204–10.

C. Klein, Michael. "The Art of John Covert." Diss. Columbia University, 1972.

———. *John Covert, 1882–1960.* Washington: Smithsonian Institution Press, 1976.

D. De Zayas Gallery. *Exhibition of Paintings by John Covert.* New York: De Zayas Gallery, 1920. [Exhibition, April–May 1920].

E. MacAgy, Douglas. "5 Rediscovered from the Lost Generation." *Art News,* 59, no. 4 (Summer 1960), 38–41.

Davidson, Abraham A. "Two from the Second Decade: Manierre Dawson and John Covert." *Art in America,* 63 (September–October 1975), 50–55.

Hamilton, George Heard. "John Covert: Early American Modern." *College Art Journal,* 12 (Fall 1952), 37–42.

"John Covert at de Zayas." *American Art News,* May 1, 1920, 3.

Klein, Michael. "John Covert and the Arensberg Circle: Symbolism, Cubism, and Protosurrealism." *Arts Magazine,* 51, no. 9 (May 1977), 133–15.

———. "John Covert's 'Time': Cubism, Duchamp, Einstein – A Quasi-Scientific Fantasy." *Art Journal,* 33, no. 4 (Summer 1974), 314–20.

McBride, Henry. "Views and Reviews of Art." *The Sun and the New York Herald,* April 25, 1920, sec. 3, p. 4.

ARTHUR CRAVAN

A. Cravan, Arthur. *J'Etais Cigare: "Maintenant," suivi de Fragments et d'une lettre à Félix Féneon.* Paris: Losfeld, 1971.

———. *Maintenant.* 1912–1915; rpt. Milan: Mazzotta, 1970. [Review edited by Cravan, and entirely written by him].

———, Jacques Rigaut, and Jacques Vaché. *Trois suicidés de la société.* Paris: Union Générale d'Editions, 1974. [Rpt. of works previously published by E. Losfeld].

B. Cravan, Arthur. "Come now." *The Soil,* 1, no. 1 (December 1916), 4.

———. "Notes." *VVV,* no. 1 (July 1942), 55–57; no. 2–3 (March 1943), 91–93. [In French].

———. "Notes." English transl. by Manual L. Grossman and Juliette Frydman. *Dada/Surrealism,* no. 3 (1973), 75–78. [Includes only the first of two parts].

———. "Oscar Wilde Is Alive!" *The Soil,* 1, no. 4 (April 1917), 145–56; no. 5 (July 1917), 195–200.

————. "The rhythm of the ocean cradles the transatlantics." *The Soil*, 1, no. 1 (December 1916), 36.

————. "Take a few pills." *The Soil*, 1, no. 1 (December 1916), 25.

————. "What's most remarkable at the Salon." *The Soil*, 1, no. 1 (December 1916), 25.

C. Virmaux, Alain. *Cravan, Vaché, Rigaut; suivi de Le Vaché d'avant Breton: choix d'écrits et de dessins.* Mortemart: Rougerie, 1982.

E. "Arthur Cravan vs. Jack Johnson." *The Soil*, 1, no. 4 (April 1917), 161–62.

Buffet-Picabia, Gabrielle. "Arthur Cravan." In her *Rencontres avec Picabia, Apollinaire, Cravan, Duchamp, Arp, Calder.* Paris: Belfond, 1977.

Cendrars, Blaise. "Two Portraits: Gustave Lerouge, Arthur Cravan." *Paris Review*, no. 42 (Winter 1968), 157–70.

Conover, Roger L. "Introduction." In *The Last Lunar Baedeker.* Ed. Roger L. Conover. Highlands: The Jargon Society, 1982.

————. "Time-Table" [Chronology of Mina Loy's life]. In *The Last Lunar Baedeker.* Ed. Roger L. Conover. Highlands: The Jargon Society, 1982.

Loy, Mina. "Arthur Cravan Is Alive." In her *The Last Lunar Baedeker.* Ed. Roger L. Conover. Highlands: The Jargon Society, 1982.

"No One Found Who Saw Wilde Dead." *New York Times*, November 9, 1913, sec. 3–4, p. 4. [Includes interview of Cravan by Charles Sibleigh].

JEAN CROTTI

B. Crotti, Jean. "Déclaration." *La Tribune de Lausanne*, March 31, 1957.

————. [Letter]. *World Magazine* (suppl. to *New York World*), August 27, 1916.

————. "Tabu." *Little Review*, 8, no. 2 (Spring 1922), 44–45.

C. Cartier, Jean Albert. *Jean Crotti.* Les Cahiers d'Arts-Documents, no. 34. Geneva: Pierre Cailler, 1956.

George, Waldemar. *Jean Crotti et le Démon de la connaissance.* Paris: Editions Graphis, 1930.

————. *Jean Crotti.* Geneva: Pierre Cailler, 1959.

D. Montross Gallery. *Exhibition of Pictures by Jean Crotti, Marcel Duchamp, Albert Gleizes, Jean Metzinger.* New York: Montross Gallery, 1916. [Exhibition, April 4–23, 1916].

Tabu Dada: Jean Crotti & Suzanne Duchamp. Bern: Kunsthalle Bern, 1983. [Exhibition, Kunsthalle Bern and Philadelphia Museum of Art].

E. Camfield, William A. "Jean Crotti & Suzanne Duchamp." In *Tabu Dada: Jean Crotti & Suzanne Duchamp.* Bern: Kunsthalle Bern, 1983, 9–25.

Coady, Robert. [Letter to Jean Crotti]. *The Soil*, 1, no. 1 (December 1916), 32–34.

"More Modernists at the Montross." *American Art News*, April 8, 1916, 5.

CHARLES DEMUTH

B. Demuth, Charles. "For Richard Mutt." *The Blindman*, 2 (1917).

C. Eiseman, Alvord L. *Charles Demuth.* New York: Watson-Guptill, 1982.

Farnham, Emily. *Charles Demuth: Behind a Laughing Mask.* Norman: University of Oklahoma Press, 1971.

———. "Charles Demuth: His Life, Psychology and Works." Diss. Ohio State University, 1959.

Gallatin, Charles, ed. *Charles Demuth.* New York: W. E. Rudge, 1927.

Hale, Eunice Mylonas. "Charles Demuth: His Study of the Figure." Diss. New York University, 1974.

Murrell, William. *Charles Demuth.* New York: Whitney Museum of American Art, 1931.

D. Fahlman, Betsy. *Pennsylvania Modern: Charles Demuth of Lancaster.* Philadelphia: Philadelphia Museum of Art, 1983. [Travelling Exhibition, 1983–84].

Gebhard, David, and Phyllis Plous. *Charles Demuth, the Mechanical Encrusted on the Living.* Santa Barbara: University of California, 1971. [Travelling Exhibition, October 5, 1971–April 16, 1972].

Intimate Gallery. *Charles Demuth.* New York: Intimate Gallery, 1926.

Ritchie, Andrew C. *Charles Demuth.* New York: Museum of Modern Art, 1950.

Santa Barbara Art Gallery. *Charles Demuth: The Mechanical Encrusted on the Living.* Santa Barbara: Art Gallery, 1971.

Whitney Museum. *Charles Demuth Memorial Exhibition.* New York: Whitney Museum, 1937.

E. Craven, Thomas. "Charles Demuth." *Shadowland,* December 1922, 11, 78.

Davidson, Abraham A. "Cubism and the Early American Modernist." *Art Journal,* 26, no. 2 (Winter 1966–67).

———. "Demuth's Poster Portraits." *Artforum,* 17, no. 3 (November 1978), 54–57.

McBride, Henry. "Charles Demuth's Cerebral Art." *New York Sun,* April 10, 1926, 6.

Watson, Forbes. "American Note in Demuth's Art" Watercolors of Rare Distinction Displayed at Daniel's." *World,* December 2, 1923, 8.

Wellman, Rita. "Pen Portraits: Charles Demuth." *Creative Art,* 9 (December 1931), 483–84.

ARTHUR DOVE

C. Morgan, Ann Lee. *Arthur Dove: Life and Work, with a Catalogue Raisonné.* Newark: University of Delaware Press, 1984.

———. "Toward the Definition of Early Modernism in America: A Study of Arthur Dove." Diss. University of Iowa, 1973.

Wight, Frederick S. *Arthur G. Dove.* Berkeley: University of California Press, 1958.

D. Haskell, Barbara. *Arthur Dove.* San Francisco: San Francisco Museum of Art, 1974.

Johnson, Dorothy R. *Arthur Dove: The Year of the Collage.* College Park, Maryland: University of Maryland Art Gallery, 1967. [Exhibition, March 13–April 19, 1967].

Newman, Sasha P. *Arthur Dove and Duncan Phillips: Artist and Patron.* Washington: The Phillips Collection; New York: Braziller, 1981. [Travelling Exhibition, 1981–1982].

Solomon, Alan. *Arthur G. Dove: A Retrospective Exhibition*. Ithaca, NY: Andrew Dickson White Museum of Art, Cornell University, 1954.

E. Frankenstein, Alfred. "Arthur Dove: Abstraction at Will." *Art in America* (March–April 1975), 58–61.

Morgan, Ann Lee. "An Encounter and its Consequences: Arthur Dove and Alfred Stieglitz, 1910–1925." *Biography*, 2, no. 1 (Winter 1979), 35–59.

Phillips, Duncan. "Arthur Dove, 1880–1946." *Magazine of Art*, 40 (May 1947), 192–97.

KATHERINE S. DREIER

A. Dreier, Katherine S. *Duchamp's Glass, "La Mariée mise à nu par ses célibitaires, même": An Analytical Reflection*. New York: Société Anonyme, 1944; rpt. in *Société Anonyme (the First Museum of Modern Art, 1920–1944)*. New York: Arno Reprints, 1972.

————. *Five Months in the Argentine from a Woman's Point of View*. New York: Sherman, 1920.

————. *Modern Art*. 1926; rpt. in *Société Anonyme (The First Museum of Modern Art, 1920–1944)*. New York: Arno Reprints, 1972.

————. *Stella*. 1923; rpt. in *Société Anonyme (The First Museum of Modern Art, 1920–1944)*. New York: Arno Reprints, 1972.

————. *Western Art and the New Era: An Introduction to Modern Art*. New York: Brentano's, 1923.

B. Dreier, Katherine S. "Housing Conditions in Germany." *Survey*, 46 (May 7, 1921), 69–72.

Dreier, Katherine S. " 'Intrinsic Significance' in Modern Art." In *Three Lectures on Modern Art*. New York: Philosophical Library, 1949.

————. "Introduction." In Van Gogh, Elisabeth Huberta du Quesne. *Personal Recollections of Vincent Van Gogh*. Transl. Dreier. Boston: Houghton Mifflin, 1913.

————. "Modern Art." *The Buffalo Arts Journal*, 9 (April, 1927).

————. Posters and Paving Stones." *Survey*, 44 (May 1, 1920), 177–80.

————. "Pure Art? or 'Pure Nonsense'?" *Forum*, 74, no. 1 (July 1925), 150.

————. "Walter Shirlaw." In *Catalogue of An Exhibition of Paintings and Drawings by the Late Walter Shirlaw and A Group of His Pupils*. Brooklyn: Brooklyn Museum, 1930.

C. Bohan, Ruth L. *The Société Anonyme's Brooklyn Exhibition: Katherine S. Dreier and Modernism in America*. Studies in the Fine Arts: The Avant-garde, no. 20. Ann Arbor: UMI Research Press, 1982.

Reflections on the Art of Katherine S. Dreier. New York: Academy of Allied Arts, 1933.

Société Anonyme (The First Museum of Modern Art): Selected Publications. New York: Arno Press, 1972.

E. Bohan, Ruth L. "Katherine Sophie Dreier and New York Dada." *Arts Magazine, 51* (1977), 97–101.

Brinton, Christian. "Modernism in Museums." *Arts & Decoration*, 16 (December 1921), 146.

Levy, Robert J. "Katherine Dreier: Patron of Modern Art." *Apollo*, 113, no. 231 (May 1981), 314–17.

Powell, E. W. "Modern Art Applied to Mural Decoration: Fantasies of Art on Modern Walls." *The Philadelphia Record,* January 31, 1915, Magazine section, 4.

Saarinen, Aline B. "Propagandist: Katherine Sophie Dreier." In her *The Proud Possessors.* New York: Random House, 1958.

MARCEL DUCHAMP

A. Duchamp, Marcel. *The Bride Stripped Bare by Her Bachelors, Even.* Transl. George Heard Hamilton. New York: Wittenborn, 1960. [A typographic version of Duchamp's "Green Box"].

Duchamp, Marcel. *The Essential Writings of Marcel Duchamp.* Ed. Michel Sanouillet and Elmer Peterson. London: Thames and Hudson, 1975.

Duchamp, Marcel. *Ingénieur du temps perdu: Entretiens avec Pierre Cabanne.* Collection Entretiens. 1967; rpt. Paris: Belfond, 1977.

————. *La Mariée mise à nu par ses célibitaires, même.* Paris: n.n., 1935. [Known as "The Green Box"].

————. *Notes and Projects for the Large Glass.* Ed. Arturo Schwarz. New York: Abrams, 1969.

B. Duchamp, Marcel. "Apropos of Readymades." *Art and Artists,* 1, no. 4 (July 1966), 46–47.

———— [probable author]. "Archie Pen Co." *The Arts,* 1 (February–March, 1921), 64.

————. "The Bride Stripped Bare by her Own Bachelors." *This Quarter,* 5, no. 1 (September 1932), 189–92.

————. "Comment." *The Little Review,* 10, no. 2 (Autumn/Winter 1924/1925), 17–19.

————. "A Complete Reversal of Art Opinions by Marcel Duchamp, Iconoclast." *Arts and Decoration,* 5 (September 1915), 427–28, 442.

————. "The Nude Descending a Staircase Man Surveys Us." *New York Tribune,* September 12, 1915, sec. 4, p. 2.

————. "O Marcel, or, I Too Have Been to Louise's: A Monologue Transcribed by Mina Loy." *View,* series 5, no. 1 (March 1945), 32, 51.

————. "Speculations, Notes Written from 1912." Ed. Cleve Gray. *Art in America,* 54 (March–April 1966), 72–75.

————. "A Tribute to the Artist." In Ritchie, Andrew C. *Charles Demuth.* New York: Museum of Modern Art, 1950.

C. Adcock, Craig E. *Marcel Duchamp's Notes from the "Large Glass": An N-Dimensional Analysis.* Studies in the Fine Arts: Avant-garde, no. 40. Ann Arbor: UMI Research Press, 1983.

Alexandrian, Sarane. *Marcel Duchamp.* Transl. Alice Sachs. New York: Crown, 1977.

Bonito Oliva, Achille. *Vita di Marcel Duchamp.* Rome: Marani, 1976.

Cabanne, Pierre. *Dialogues with Marcel Duchamp.* Transl. Ron Padgett. New York: Viking, 1971.

Clair, Jean. *Marcel Duchamp, ou, Le Grand Fictif: Essai de mythanalyse du Grande Verre.* Paris: Galilee, 1975.

Dokumentation über Marcel Duchamp. Zurich: Kunstgewerbemuseum, 1960.

Dreier, Katherine S. *Duchamp's Glass, "La Mariée mise à nu par ses célibitaires, même": An Analytical Reflection.* New York: Société Anonyme, 1944; rpt. in *Société Anonyme (The First Museum of Modern Art, 1920-1944).* New York: Arno Reprints, 1972.

Golding, John. *Marcel Duchamp: "The Bride Stripped Bare by Her Bachelors, Even."* Art in Context. New York: Viking Press, 1973.

Lebel, Robert, ed. *Marcel Duchamp.* Transl. George Heard Hamilton. New York: Paragraphic Books, 1959. [Translation of *Sur Marcel Duchamp*].

Marquis, Alice Goldfarb. *Marcel Duchamp: Eros, c'est la vie: A Biography.* Troy, N.Y.: Whitston, 1981.

Naumann, Francis M. *The Mary and William Sisler Collection.* New York: Museum of Modern Art, 1984.

Paz, Octavio. *Marcel Duchamp: Appearance Stripped Bare.* 1970; rpt. New York: Viking Press, 1978.

Schwarz, Arturo. *The Complete Works of Marcel Duchamp.* New York: Abrams, 1969.

———. *The Large Glass and Related Works.* Milan, Galleria Schwarz, 1967.

———. *Marcel Duchamp.* New York: Abrams, 1975.

Steefel, Lawrence D. *The Position of Duchamp's Glass in the Development of His Art.* New York: Garland, 1977.

Suquet, Jean. *Miroir de la mariée.* Paris: Flammarion, 1974.

D. *The Almost Complete Works of Marcel Duchamp.* London: Tate Gallery, 1966 [Exhibition Catalog with bibliography and interviews by Arturo Schwarz].

Clair, Jean. *Marcel Duchamp: Catalogue raisonné.* Paris: Musée National d'Art et de Culture Georges Pompidou, 1977. [Prepared for exhibition, January 31–May 2, 1977].

D'Harnoncourt, Anne. *Marcel Duchamp.* New York: Museum of Modern Art, 1973. [Published in conjunction with the exhibition at the Philadelphia Museum of Art and the Museum of Modern Art].

Hamilton, George Heard. *Not Seen and/or Less Seen of/by Marcel Duchamp/Rrose Selavy, 1904-64: Mary Sisler Collection.* New York: Cordier & Eckstrom, 1964. [Exhibition, January 14–February 13, 1965].

Hopps, Walter, Ulf Linde, and Arturo Schwarz. *Marcel Duchamp: Ready-Mades, etc., 1913-1964.* Paris: Le Terrain Vague, 1964. [Prepared for exhibition at Galleria Schwarz, Milan, June 5–September 30, 1964].

Montross Gallery. *Exhibition of Pictures by Jean Crotti, Marcel Duchamp, Albert Gleizes, Jean Metzinger.* New York: Montross Gallery, 1916. [Exhibition, April 4–23, 1916].

Pasadena Art Museum. *Marcel Duchamp, Pasadena Art Museum: A Retrospective Exhibition.* Pasadena: The Museum, 1963. [Exhibition, October 8–November 3, 1963].

Schmied, Wieland, ed. *Marcel Duchamp, même.* Hanover: Kestner-Gesellschaft, 1965. [Exhibition, September 7–28, 1965].

Schwarz, Arturo. *Marcel Duchamp: 66 Creative Years.* Milan: Galleria Schwarz, 1972. [Exhibition, December 12, 1972–February 28, 1973].

E. Apollinaire, Guillaume. "Notes critiques." *Cahiers du Musée National d'Art Moderne,* no. 6 (1981), 75–125.

Balas, Edith. "Brancusi, Duchamp and Dada." *Gazette des Beaux-Arts,* 95, no. 1335 (April 1980), 165–74.

Beier, Lucia. "Time Machine: A Bergsonian Approach to the 'Large Glass.' " *Gazette des Beaux-Arts,* series 6, vol. 88 (November 1976), 194–200.

Bensimon, Marc. "Marcel Duchamp: Le 'Grand Verre': Critique manifeste." In *Le Manifeste et le caché.* Ed. Mary Ann Caws. Le Siècle éclaté, 1. Paris: Lettres Modernes, 1974, 169–79.

Bloch, Susi. "Marcel Duchamp's *Green Box.*" *Art Journal,* 34, no. 1 (Fall 1974), 25–29.

Burnham, Jack. "Duchamp's 'Bride Stripped Bare': The Meaning of the 'Large Glass.'" In his *Great Western Salt Works: Essays on the Meaning of Post-Formalist Art.* New York: Braziller, 1974.

———. "The Purposes of the 'Ready-Mades.' " In his *Great Western Salt Works.*

Calas, Nicolas. "The 'Large Glass.' " *Art in America,* 57 (July–August 1969), 34–35.

Carrier, D. "Marcel Duchamp: Position of Duchamp's Glass in the Development of His Art." *Journal of Aesthetics,* 38, no. 1 (Fall 1979), 104–05.

Carrouges, Michel. "Duchamp révélateur du déjà vu et du jamais vu." *Cahiers de l'Association Internationale pour l'Etude de Dada et du Surréalisme,* no. 3 (1969), 22–26.

———. "La Machine-célibataire selon Franz Kafka et Marcel Duchamp." *Mercure de France,* 315 (June 1952), 262–81.

Clair, Jean. "La Fortune critique de Marcel Duchamp: Petite Introduction à une herméneutique du Grande Verre." *Revue de l'Art,* no. 34 (1976), 92–102.

———. "Les Vapeurs de la mariée." *L'Arc,* no. 59 (1974), 44–51.

Davies, Ivor. "New Reflections on the 'Large Glass': The Most Logical Sources for Marcel Duchamp's Irrational Work." *Art History,* 2, no. 1 (March 1979), 89–94.

Delloye, Charles. "Marcel Duchamp, le Grand Verre et le jeu de l'apparaitre." *Art International,* 20 (December 1976), 54–60, 72.

Dorfles, Oillo. "Il Ready-made di Duchamp e il suo rapporto con l'arte d'oggi." *Art International,* 8, no. 10 (December 1964), 40–42.

"Here She Is: White Outline Shows 'Nude Descending a Staircase.'" *Chicago Tribune,* 23 March 1913.

Humble, P. N. "Duchamp's Readymades: Art and Anti-Art." *British Journal of Aesthetics,* 22, no. 1 (Winter 1982), 52–64.

"The Iconoclastic Opinions of M. Marcel Duchamps [sic] Concerning Art and America." *Current Opinion,* 59 (November 1915), 346–47.

Klein, Michael. "John Covert's 'Time': Cubism, Duchamp, Einstein – A Quasi-Scientific Fantasy." *Art Journal,* 33, no. 4 (Summer 1974), 314–20.

Kreymborg, Alfred. "Why Marcel Duchamps [sic] Calls Hash a Picture." *Boston Transcript,* September 8, 1915.

Kuh, Katharine. "Marcel Duchamp." In *20th Century Art from the Louise and Walter Arensberg Collection, October 20 to December 18, 1949.* Chicago: Art Institute of Chicago, 1949, 11–18.

———. "Walter Arensberg and Marcel Duchamp." In her *The Open Eye: In Pursuit of Art.* New York: Harper & Row, 1971.

Lebel, Robert. "Machines et machinations célibataires." *Vingtième Siècle,* n.s. no. 46 (September 1976), 35–43.

Levin, Kim. "Duchamp à New York: Le Grand Oeuvre." *Opus International,* no. 49 (March 1974), 50–54.

McBride, Henry. "Noted Picture by Duchamp on Exhibition." *New York Herald,* March 9, 1924, sec 7, p. 13.

"Marcel Duchamp Visits New York." *Vanity Fair* (September 1915), 57.

Marling, William. "A Tense, Inquisitive Clash: William Carlos Williams and Marcel Duchamp." *Southwest Review,* 66, no. 4 (Autumn 1981), 361–75.

Marlor, Clark S. "A Quest for Independence: The Society of Independent Artists." *Art and Antiques,* 4, no. 2 (March–April 1981), 74–81.

"More Modernists at the Montross." *American Art News,* April 8, 1916, 5.

"Mrs. Mutt Makes a Fuss." *Boston Transcript,* July 25, 1917.

Naumann, Francis M. "'Affectueusement, Marcel': Ten Letters from Marcel Duchamp to Suzanne Duchamp and Jean Crotti." *Archives of American Art Journal,* 22, no. 4 (1982), 2–19.

Nicholson, Anne. "Invisibilities in the 'Large Glass.'" *Month,* no. 1310 (November 1976), 383–87.

Nordland, Gerald. "Marcel Duchamp and Common Object Art." *Art International,* 8, no. 1 (1964), 30–32.

Norton, Louise. "Buddha of the Bathroom." *The Blind Man,* no. 2 (May 1917), 5–6.

Oehler, Dolf. "Hinsehen, Hinlangen: Für eine Dynamisierung der Theorie der Avantgarde: Dargestellt an Marcel Duchamp's 'Fountain.'" In *Theorie der Avantgarde.* Ed. W. Martin Lüdke. Frankfurt: Suhrkamp, 1976.

"The Richard Mutt Case." *The Blind Man,* no. 2 (May 1917), 5–6.

Roché, Henri Pierre. "Souvenirs of Marcel Duchamp." In *Marcel Duchamp.* Ed. Robert Lebel. Transl. George Heard Hamilton. New York: Panagraphic Books, 1959.

Roth, Moira. "Marcel Duchamp in America: A Self Ready-Made." *Arts Magazine,* 9 (1977), 92–96.

Roussel, Alain. "Le Ready-made, ou, La Fausse Reconciliation de l'art et de la vie." *Opus International,* no. 49 (March 1974), 88–89.

Sayre, Henry M. "Ready-Mades and Other Measures: The Poetics of Marcel Duchamp and William Carlos Williams." *Journal of Modern Literature,* 8, no. 1 (1980), 3–22.

Schwarz, Arturo. "The Mechanics of the Large Glass: Iconographic Notes." *Art International,* 10, no. 6 (Summer 1966), 102–04.

Seitz, William. "What's Happened to Art: An Interview with Marcel Duchamp on the Present Consequences of the 1913 Armory Show." *Vogue* (U.S.A.), 141 (February 15, 1963), 110–13.

Soby, James Thrall. "Marcel Duchamp in the Arensberg Collection." *View,* series 5, no. 1 (March 1945), 10–12.

Tashjian, Dickran. "Henry Adams and Marcel Duchamp: Liminal Views of the Dynamo and the Virgin." *Arts Magazine,* 51, no. 9 (May 1977), 102–07.

Taylor, Simon Watson. "Apropos of Readymades." *Art and Artists,* 1, no. 4 (July 1966), 46.

White, Grahame. "Another Look at the Large Glass." *Art International,* 20 (December 1976), 68.

Williams, William Carlos. "Glorious Weather." *Contact,* no. 5 (June 1923).

ELSE VON FREYTAG-LORINGHOVEN

B. Freytag-Loringhoven, Else von. "Affectionate." *Little Review*, 9, no. 2 (Winter 1922), 40.

———, Evelyn Scott, and Jane Heap. "The Art of Madness." *Little Review*, 6, no. 9 (January 1920), 25–29.

———. [Letter]. *Little Review*, 12, no. 2 (May 1929), 34–35.

———. "Love–Chemical Relationship." *Little Review*, 5, no. 2 (June 1918), 58–59.

———. "Mefk Maru Mustir Daas." *Little Review*, 5, no. 8 (December 1918), 41.

———. "Myself–Minesoul–and–Mine–Cast-Iron Lover." *Little Review*, 6, no. 5 (September 1919), 3–11.

———. "Poems." *Little Review*, 6, no. 1 (May 1919), 71–73.

———. "Poems." *Little Review*, 6, no. 9 (January 1920), 18–21.

———. "Poems." *Little Review*, 6, no. 10 (March 1920), 10–12.

———. "Poems." *Little Review*, 7, no. 2 (July–August 1920), 28–30.

———. "Poems." *Little Review*, 7, no. 3 (September–December 1920), 47–52.

———. [Poems]. In *The Revolution of the Word*. Ed. Jerome Rothenberg. New York: Seabury Press, 1974.

———. "Portrait of Marcel Duchamp." *Little Review*, 9, no. 2 (Winter 1922). [Illustration].

———. "Thee I Call 'Hamlet of Wedding-Ring': Criticism of William Carlos William's [sic] 'Kora in Hell' and Why." *Little Review*, 7, no. 4 (January–March 1921), 48–60; 8, no. 1 (Autumn 1921), 108–11.

———. "Two Poems." *Little Review*, 11, no. 1 (Spring 1925), 13–14.

C. Biddle, George. *An American Artist's Story*. Boston: Little Brown, 1939.

E. Anderson, Margaret C. "William Carlos Williams' 'Kora in Hell' by Else von Freytag-Loringhoven." *Little Review*, 7, no. 3 (September 1920), 58–59.

Bodenheim, Maxwell, and F.E.R. "The Reader Critic." *Little Review*, 6, no. 7 (November 1919), 64.

Ridge, Lola, and F.E.R. "Concerning Else von Freytag-Loringhoven." *Little Review*, 6, no. 6 (October 1919), 56. [Includes reply by Jane Heap].

Rodker, John. "Dada and Else von Freytag-Loringhoven." *Little Review*, 7, no. 2 (July–August 1920).

Sanders, Abel. "To Bill Williams and Else von Johann Wolfgang Loringhoven y Fulano." *Little Review*, 8, no. 1 (August 1921), 111.

Scott, Evelyn. "The Art of Madness." *Little Review*, 6, no. 8 (December 1919), 48–49. [Includes reply by Jane Heap].

Scott, Evelyn. "The Last Word." *Little Review*, 6, no. 10 (March 1920), 44–46. [Includes reply by Jane Heap].

MARSDEN HARTLEY

A. Hartley, Marsden. *Adventures in the Arts: Informal Chapters on Painters, Vaudeville and Poets*. New York: Boni and Liveright, 1921.

————. *Heart's Gate: Letters Between Marsden Hartley & Horace Traubel, 1906–1915.* Ed. William Innes Homer. Highlands, N. C.: Jargon, 1982.

Hartley, Marsden. *On Art.* Ed. Gail R. Scott. New York: Horizon Press, 1982.

————. *Selected Poems.* Ed. Henry W. Wells. New York: Viking, 1945.

————. *Twenty-five Poems.* Paris: Contact, 1923.

B. Hartley, Marsden. "The Importance of Being 'Dada.'" In his *Adventures in the Arts: Informal Chapters on Painters, Vaudeville and Poets.* New York: Boni and Liveright, 1921, 247–54.

C. Buringame, Robert Northcutt. "Marsden Hartley: A Study of His Life and Creative Achievement." Diss. Brown University, 1953.

McCausland, Elizabeth. *Marsden Hartley.* Minneapolis: University of Minnesota Press, 1952.

D. Haskell, Barbara. *Marsden Hartley.* New York: Whitney Museum of American Art, 1980.

Museum of Modern Art. *Lyonel Feininger; Marsden Hartley.* New York: Museum of Modern Art, 1944.

E. Gallup, Donald. "The Weaving of a Pattern: Marsden Hartley and Gertrude Stein." *Magazine of Art* (November 1948), 256–61.

"Marsden Hartley Heckled." *New York Herald,* December 5, 1920, 9.

Seligmann, Herbert J. "The Elegance of Marsden Hartley, Craftsman." *International Studio,* 74 (October 1921), li–liii.

MATTHEW JOSEPHSON

A. Josephson, Matthew. *Galimathias.* New York: Broom, [1923?].

————. *Life Among the Surrealists: A Memoir.* New York: Holt, Rinehart and Winston, 1962.

————, transl. *The Poet Assassinated,* by Guillaume Apollinaire. New York: Broom, 1923.

————. *Portrait of the Artist as American.* 1930; rpt. New York: Octagon, 1964.

————, and Malcolm Cowley, eds. *Whither, Whither, or, After Sex What: A Symposium to End Symposiums.* New York: Longman's, Green, 1928.

B. Josephson, Matthew. "After and Beyond Dada." *Broom,* 2, no. 4 (July 1922), 346–50.

————. "Apollinaire, or, Let Us Be Troubadours." *Secession,* no. 1 (Spring 1922), pp. 9–13. [Published under the pseudonym Will Bray].

————. "The Brain of the Wheel." *Broom,* 5, no. 2 (September 1923), 95–96.

————. "Charles A. Beard: A Memoir." *Virginia Quarterly Review,* 25 (1949), 585–602.

————. "Cities II." *Secession,* no. 3 (August 1922), 14. [Published under the pseudonym Will Bray].

————. "Encounters with Edmund Wilson." *Southern Review,* n.s. 11 (1975), 731–65.

————. "Exordium to Ducasse." *Broom,* 3, no. 1 (August 1922), 3. [Published under the pseudonym Will Bray].

——. "Foreword." In *The Left Bank Revisited: Selections from the Paris Tribune, 1917–1934.* Ed. Hugh Ford. University Park: Pennsylvania State University Press, 1972, xix–xxiv.

——. "Four Etudes." *Broom,* 2, no. 2 (May 1922), 122–23.

——. "The Great American Bill Poster." *Broom,* 3, no. 4 (November 1922), pp. 304–12.

——. "Henry Ford." *Broom,* 5, no. 3 (October 1923), 137–42.

——. "In a Café." *Secession,* no. 1 (Spring 1922), 21. [Published under the pseudonym Will Bray].

——. "Instant Note on Waldo Frank." *Broom,* 4, no. 1 (December 1922), 57–60. [Published under the pseudonym Will Bray].

——. "The Last Lady." *Poetry,* 17 (October 1920), 20.

——. "Made in America." *Broom,* 2, no. 3 (June 1922), 266–70.

——. "Mr. Blunderbuss." *Secession,* no. 3 (August 1922), 28–31.

——. "New York Opening." *Le Coeur à barbe,* no. 1 (April 1922).

——. "The Oblate." *Secession,* no. 2 (July 1922), 21–29.

——. "1001 Nights in a Bar-Room." *Broom,* 3, no. 2 (September 1922), 146–50.

——. "Peep-Peep-Parrish." *Secession,* no. 3 (August 1922), 6–11.

——. "Peripatetics." *Secession,* no. 1 (Spring 1922), 8.

——. "Peripatetics VI." *Broom,* 3, no. 1 (August 1922), 41–42.

——. "Pursuit." *Broom,* 4, no. 2 (January 1923), 105–07.

——. "Toward a Professional Prose." *Broom,* 5, no. 1 (August 1923), 59–61.

——. "Variations on a Theme of Baudelaire." *Gargoyle,* 1 (December 1921), 28–29.

——. "Vegetable Classic." *Broom,* 3, no. 1 (August 1922), 41–42.

C. Crane, Hart. *The Letters of Hart Crane, 1916–1932.* Ed. Brom Weber. 1952; rpt. Berkeley: University of California Press, 1965. [Includes letters to and about Josephson].

Shi, David E. *Matthew Josephson, Bourgeois Bohemian.* New Haven: Yale University Press, 1981.

E. "Comment." *The Dial,* 75 (1923), 311–12.

Cowley, Malcolm. "Matthew Josephson." *Book-Find Notes,* January 1947.

Mencken, H. L. "A Modern Masterpiece." *American Mercury,* 1 (1924), 377–79.

Munson, Gorham. "Tinkering with Words." *Secession,* no. 7 (Winter 1924), 30–31.

Rascoe, Burton. "Bookman's Daybook." *New York Tribune,* December 30, 1923, sec. 9, p. 3.

——. "Bookman's Daybook." *New York Tribune,* January 27, 1924, sec. 9.

Rosenfeld, Alvin H. "John Wheelwright, Gorham Munson, and the 'Wars of Secession.'" *Michigan Quarterly Review,* 14 (1975), 13–40.

Shi, David E. "Matthew Josephson (1899–1978)." In *Dictionary of Literary Biography.* Detroit: Gale Research, 1980, vol. 4, 232–37.

——. "Munson vs. Josephson: Battle of the Aesthetes." *Lost Generation Journal,* 5, no. 1 (Spring 1977), 18–19.

Sitwell, Edith. "Readers and Writers." *New Age* (London), n.s. 31, no. 21 (September 21, 1922).

Wilson, Edmund. "Imaginary Conversation: Paul Rosenfeld and Matthew Joseph-son." *New Republic*, 38 (April 9, 1924), 179-82.

MINA LOY

A. Loy, Mina. *Auto-Facial-Construction.* Florence: Tipografia Giuntina, 1919.

──────. *The Last Lunar Baedeker.* Ed. Roger L. Conover. Highlands, N.C.: Jargon Society, 1982.

B. Loy, Mina. "Aphorisms on Futurism." *Camera Work*, no. 45 (January 1914), 13-15.

──────. "Apology of Genius." *Dial*, 73 (July 1922), 73-74.

──────. "The Black Virginity." *Others*, 5, no. 1 (December 1918), 6-7.

──────. "Brancusi's Golden Bird." *Dial*, 73 (November 1922), 507-08.

──────. "In . . . formation." *The Blind Man*, no. 1 (April 10, 1917), 7.

──────. "John Rodker's Frog." *Little Review*, 7, no. 3 (September–December 1921), 56-57.

──────. "Lion's Jaws." *Little Review*, 7, no. 3 (September –December 1921), 39-43.

──────. "Love Songs." *Others*, 1, no. 1 (1915), 6-8.

──────. "Mexican Desert." *Dial*, 70 (June 1921), 672.

──────. "O Marcel–Otherwise I Also Have Been to Louise's." *The Blind Man*, no. 2 (May 1917), 14-15.

──────. "The Pamperers." *Dial*, 69 (July 1920), 65-78.

──────. "Pas de commentaires!: Louis M. Eilshemius." *The Blind Man*, no. 2 (May 1917), 11-12.

──────. "Perlun." *Dial*, 71 (August 1921), 142.

──────. "Poe." *Dial*, 71 (October 1921), 406.

──────. "Psycho-Democracy: A Movement to Focus Human Reason on the Conscious Direction of Evolution." *Little Review*, 8, no. 1 (Autumn 1921), 14–15.

"Sketch of a Man on a Platform." *Rogue*, 1, no. 2 (April 1, 1915), 12.

──────. "Songs to Joannes." *Others*, 3, no. 6 (April 1917), 3-20.

──────. "There Is No Life or Death." *Camera Work*, no. 46 (April 1914), 18.

──────. "Three Moments in Paris." *Rogue*, 1, no. 4 (May 1, 1915), 10-11.

──────. "To You." *Others*, 3 (1916-17), 27-28.

──────. "Two Plays." *Rogue*, 1, no. 6 (June 15, 1915), 15-16.

──────. "Virgins Plus Curtains Minus Dots: Latin Borghese." *Rogue*, 2, no. 2 (September 15, 1915), 10.

C. Fields, Kenneth Wayne. "The Rhetoric of Artifice: Ezra Pound, T.S. Eliot, Wallace Stevens, Walter Conrad Arensberg, Donald Evans, Mina Loy, and Yvor Winters." Diss. Stanford University, 1967.

Kouidis, Virginia M. *Mina Loy: American Modernist Poet.* Baton Rouge: Louisiana State University Press, 1980.

E. Burke, Carolyn. "Becoming Mina Loy." *Women's Studies*, 7, no. 1-2 (1980), 137-58.

Burke, Carolyn. "Mina Loy (1882-1966)." In *Dictionary of Literary Biography*. Detroit: Gale Research, 1980, vol. 4, 259-61.

Fields, Kenneth Wayne. "The Poetry of Mina Loy." *Southern Review*, n.s. 3 (1967), 597–607.

Kouidis, Virginia M. "Rediscovering Our Sources: The Poetry of Mina Loy." *Boundary 2*, 8, no. 3 (Spring 1980), 167–88.

Pound, Ezra. "A List of Books." *Little Review*, 4, no. 11 (March 1918), 54–58.

Rodker, John. "To Mina Loy." *Little Review*, 7, no. 4 (January–March 1921), 44–45.

Williams, Jonathan. "Mina Loy: An Old Essay and a New Note." *Sagetrieb*, 1, no. 1 (Spring 1982), 148–52.

Winters, Yvor. "Mina Loy." *Dial*, 80 (January 1926), 496–99.

FRANCIS PICABIA

A. Picabia, Francis. *Ecrits*. Ed. Olivier Revault d'Allonnes. Les Bâtisseurs du XXe siècle. Paris: Belfond, 1975–78.

————, ed. *391*. Paris: Le Terrain Vague, 1955. [Rpt. with critical apparatus and essays by Michel Sanouillet].

B. Picabia, Francis. "Anticoq." *Little Review*, 7, no. 2 (Spring 1922), 43–44.

————. "Ascète." *391*, no. 7 (August 1917), 2.

————. "Cubist Art Explained." *New York World*, March 16, 1913.

————. "Délicieux." *391*, no. 6 (July 1917), 3.

————. "Demi cons." *391*, no. 6 (July 1917), 4.

————. "Elle." *391*, no. 7 (August 1917), 4.

————. "Fumigations." *Little Review*, 7, no. 1 (Autumn 1921), 12–14.

————. "Hier." *391*, no. 7 (August 1917), 4.

————. "Idéal doré par l'or." *391*, no. 5 (June 1917), 2.

————. "Inférence." *391*, no. 6 (July 1917), 4.

————. "Medusa." *The Blind Man*, no. 2 (May 1917), 10.

————. "Métal." *391*, no. 6 (July 1917), 2.

————. "1093." *391*, no. 6 (July 1917), 4.

————. "A Note on the Salons." *The Arts*, 5 (April 1924), 191.

————. "Orque de barbarie." *Little Review*, 7, no. 2 (Spring 1922), 3–4.

————. "Plafonds creux." *Rong rong*, no. 1 (July 1917).

————. "Poèmes isotropes." *391*, no. 5 (June 1917), 5.

————. "Preface to His Show." *Camera Work*, no. 42/43 (April–July 1913), 19–20.

————. "Que fais tu 291?" *Camera Work*, no. 47 (July 1914), 72.

————. "Soldats." *391*, no. 7 (August 1917), 2.

————. "We Live in a World." *291*, no. 12 (February 1916).

C. Borràs, Maria Lluisa. *Picabia*. New York: Rizzoli, 1985.

Camfield, William A. *Francis Picabia: His Art, Life and Times*. Princeton: Princeton University Press, 1979.

Le Bot, Marc. *Francis Picabia et la crise des valeurs figuratives, 1900–1925*. Paris: Klincksieck, 1968.

Massot, Pierre de. *De Mallarmé à 391*. Saint-Raphael: Bel Exemplaire, 1922.

Sanouillet, Michel. *Picabia.* Paris: L'Oeil du Temps, 1964.

D. Camfield, William A. *Francis Picabia.* New York: Guggenheim Museum, 1970. [Travelling exhibition].

Galleria Civica d'Arte Moderna, Turin. *Francis Picabia: Mezzo secolo di avanguardia.* Torino: La Galleria, 1974. [Exhibition, November 28, 1974–February 2, 1975].

Galleria Schwarz, Milan. *Olii, acquarelli e disegni di Francis Picabia.* [Exhibition, July 1–30, 1960].

Grand Palais, Paris. *Francis Picabia.* Paris: Centre National d'Art et de Culture Georges Pompidou, 1976. [Exhibition, January 23–March 29, 1976].

Städtisches Museum Leverkusen. *Picabia.* [Exhibition, February 7 to April 2, 1967].

E. Aisen, Maurice. "The Latest Evolution in Art and Picabia." *Camera Work,* no. 44 (June 1913), 14–21.

Apollinaire, Guillaume. "Notes critiques." *Cahiers du Musée National d'Art Moderne,* no. 6 (1981), 75–125.

Breton, André. "Francis Picabia." *Little Review,* 9, no. 2 (Winter 1922), 41–44.

Butler, Joseph T. "The American Way with Art: Francis Picabia, 1879–1953." *Connoisseur,* 176 (April 1971), 287–88.

C., M. "New Picabia Show Sets Paris Agog." *American Art News,* February 4, 1922, 2.

Camfield, William A. "The Machinist Style of Francis Picabia." *Art Bulletin,* 48 (September–December 1966), 309–22.

"Francis Picabia and His Puzzling Art: An Extremely Modernized Academician." *Vanity Fair* (November 1915), 42.

Hartley, Marsden. "Picabia: Arch-Esthete." 1929; rpt. in his *On Art.* New York: Horizon Press, 1982.

Homer, William I. "Picabia's 'Jeune fille américaine dans l'état de nudité' and Her Friends." *Art Bulletin,* 58 (March 1975), 110–115.

McBride, Henry. "Picabia." In his *Some French Moderns Says McBride.* New York: Société Anonyme, 1922.

"Nothing is Here, Dada Is Its Name." *American Art News,* April 2, 1921, 1, 7.

"Picabia, Art Rebel, Here to Teach New Movement." *New York Times,* February 16, 1934, sec. 5, 9.

"Picabia Number." *Little Review,* 8, no. 2 (Spring 1922).

Thompson, Jan. "Picabia and His Influence on American Art, 1913–17." *Art Journal,* 39, no. 1 (Fall 1979), 14–21.

Will-Levaillant, Françoise. "Picabia et la machine: Symbole et abstraction." *Revue de l'Art,* no. 4 (1969), 74–82.

Zabel, Barbara. "Machine as Metaphor, Model, and Microcosm: Technology in American Art, 1915–1930." *Arts Magazine,* 57, no. 4 (December 1982), 100–05.

MAN RAY

A. Ray, Man. *A Primer of the New Art of Two Dimensions.* Np: n.p., 1916.

———. *The Ridgefield Gazook.* 1915; rpt. in *Dada Americano.* Ed. Arturo Schwarz. Milan: Mazzotta, 1970. [Contents all written by Man Ray, under various pseudonyms].

———. *Self Portrait.* Boston: Little Brown, 1963.

———. *Visual Words, Sounds Seen, Thoughts Felt, Feelings Thought.* N.p.: n.p., 1917.

B. Ray, Man. "Impressions of 291." *Camera Work,* no. 47 (July 1914), 61.

———, and Arturo Schwarz. "An Interview with Man Ray: 'This Is Not for America.'" *Arts Magazine,* 51, no. 9 (May 1977), 116–21.

———. "Revolving Doors." *TNT,* no. 9 (March 1919).

———. "Seguidilla." *Broom,* 1, no. 1 (November 1921), 54.

———. "Three Dimensions." *Others,* 1, no. 6 (1915), 108.

C. Alexandrian, Sarane. *Man Ray.* Paris: Filipacchi, 1973.

Belz, Carl. "The Role of Man Ray in the Dada and Surrealist Movements." Diss. Princeton University, 1963.

Bourgeade, Pierre. *Bonsoir, Man Ray.* Paris: Belfond, 1972.

Bramley, Serge. *Man Ray.* Paris: Belfond, 1980.

Penrose, Sir Roland. *Man Ray.* Boston: New York Graphic Society, 1975.

Schwarz, Arturo. *Man Ray: The Rigour of Imagination.* New York: Rizzoli, 1977.

D. Centre Pompidou, Paris. *Man Ray: Photographs.* London: Thames and Hudson, 1982. [Exhibition, December 1981–April 1982].

Frankfurter Kunstverein and Kunsthalle Basel. *Man Ray, Inventionen und Interpretationen.* [Exhibition, 1979–1980].

Galleria Schwarz, Milan. *Man Ray.* [Exhibition, March 14–April 3, 1964].

———. *Man Ray: 60 Years of Liberties.* Paris: Losfeld, 1971.

———, Galleria Milano, and Salone Annunciata, Milan. *Man Ray.* [Exhibition, June 1971].

Los Angeles County Museum of Art. *Man Ray.* 1966.

Musée National d'Art Moderne, Paris. *Man Ray.* 1972.

Palazzo delle Esposizioni, Rome. *Man Ray: L'Occhio e il suo doppio.* Rome: Assessorato Antichità Belle Arti e Problemi della Cultura, 1975. [Exhibition, July–September 1975].

Schwarz, Arturo. *Man Ray, carte varie e variabili.* Milan: Fabbri, 1983.

E. Belz, Carl. "Man Ray and New York Dada." *Art Journal,* 23, no. 3 (Spring 1964), 207–13.

Copley, William. "Man Ray: The Dada of Us All." *Portfolio,* no. 7 (1963), 14–23, 111.

Crespelle, Jean Paul. "Man Ray, oeil de l'ère Dada." In his *Montparnasse vivant.* Paris: Hachette, 1962.

De Gramont, Sanche. "Remember Dada: Man Ray at Eighty." *New York Times Magazine,* September 6, 1970, 6ff.

Gibson, Michael, and Ronny Cohen. "The Ridgefield Gazooker." *Art News,* 81 (Summer 1982), 122.

Glueck, Grace. "Daddy Dada." *New York Times,* October 17, 1965.

"Good Old Dada Days." *Time,* 63 (June 28, 1954), 74.

"Grandada." *Time,* 81 (May 17, 1963), 90–91.

Kramer, Hilton. "His Heart Belongs to Dada." *Reporter,* 28 (May 9, 1963), 43–46.

186

Marder, Irving. "Man Ray: On Dada and Pop Art." *The New York Times* (International Ed. Paris), February 6, 1964.

Naumann, Francis. "Man Ray: Early Paintings, 1913–1916: Theory and Practice in the Art of Two Dimensions." *Artforum,* 20, no. 9 (May 1982), 37–46.

Pincus-Witten, Robert. "Man Ray: The Homonymic Pun and American Vernacular." *Artforum,* 13, no. 8 (April 1975), 54–59.

Watt, Alexander. "Dadadate with Man Ray." *Art and Artists,* 1, no. 4 (July 1966), 32–35.

MORTON L. SCHAMBERG

B. Schamberg, Morton L. "Statement by Morton Schamberg." *Philadelphia Inquirer,* Sunday Art Page, January 19, 1913.

C. Wolf, Ben. *Morton Livingston Schamberg: A Monograph.* Philadelphia: University of Pennsylvania Press, 1963.

D. Agee, William C. *Morton Livingston Schamberg (1881–1918).* New York: Salander-O'Reilly Galleries, 1982.

E. MacAgy, Douglas. "5 Rediscovered from the Lost Generation." *Art News,* 59, no. 4 (Summer 1960), 38–41.

McBride, Henry. "Posthumous Paintings by Schamberg." *New York Sun,* 25 May 1919.

Pach, Walter. "The Schamberg Exhibition." *The Dial,* 66 (1919), 505–06.

CHARLES SHEELER

A. Sheeler, Charles. *African Negro Wood Sculpture.* N.p.: n.d.

B. Sheeler, Charles. "Recent Photographs by Alfred Stieglitz." *The Arts,* 3, no. 5 (May 1923), 345.

C. Dochterman, Lillian Natalie. "The Stylistic Development of the Work of Charles Sheeler." Diss. University of Iowa, 1963.

Friedman, Martin L. *Charles Sheeler.* New York: Watson-Guptill, 1975.

Rourke, Constance. *Charles Sheeler, Artist in the American Tradition.* New York: Harcourt, Brace, 1938.

Stewart, Patrick Leonhard, Jr. "Charles Sheeler, William Carlos Williams and the Development of the Precisionist Aesthetic, 1917–1931." Diss. University of Delaware, 1981.

Yeh, Susan Fillin. "Charles Sheeler and the Machine Age." Diss. New York University, 1981.

D. Museum of Modern Art. *Charles Sheeler: Paintings, Drawings, Photographs.* Intro. by William Carlos Williams. New York: Museum of Modern Art, 1939.

National Collection of Fine Arts. *Charles Sheeler.* Washington: Smithsonian Institution Press, 1968. [Travelling exhibition, 1968–1969].

University of Iowa. School of Art. *The Quest of Charles Sheeler: 83 Works Honoring His 80th Year.* Iowa City: University of Iowa, 1963. [Exhibition, March 17–April 14, 1963].

E. Craven, Thomas. "Charles Sheeler." *Shadowland,* March 1923, 11, 71.

McBride, Henry. "Views and Reviews of the Week in the Art World: Work of Charles Sheeler Attracts Attention." *New York Sun and Herald,* February 22, 1920, 7.

"Paintings and Drawings by Sheeler." *American Art News,* April 1, 1922, 6.

Watson, Forbes. "Charles Sheeler." *The Arts,* 3 (1923), 335–44.

Yeh, Susan Fillin. "Charles Sheeler's 1923 'Self Portrait.'" *Arts Magazine,* 52, no. 5 (January 1978), 106–09.

JOSEPH STELLA

C. Baur, John I. H. *Joseph Stella.* New York: Praeger, 1971.

Dreier, Katherine S. *Stella.* 1923; rpt. in *Société Anonyme (The First Museum of Modern Art).* New York: Arno Reprints, 1972.

Jaffé, Irma. *Joseph Stella.* Cambridge: Harvard University Press, 1970.

D. A. C. A. Gallery. *Joseph Stella.* New York: A. C. A. Gallery, 1943.

Whitney Museum of American Art. *Joseph Stella.* New York: Whitney Museum, 1963.

Zilczer, Judith. *Joseph Stella, the Hirshhorn Museum and Sculpture Garden Collection.* Washington: Smithsonian Institution Press, 1983. [Exhibition, Hirshhorn Museum and Columbus Museum of Art, 1983–1984].

E. Bohan, Ruth L. "Joseph Stella's 'Man in Elevated Train.'" In *Dada/Dimensions.* Ed. Stephen C. Foster. Ann Arbor: UMI Research Press, 1985.

Brook, Alexander. "Joseph Stella." *The Arts,* 3 (1923), 127–30.

Craven, Thomas, "Joseph Stella." *Shadowland,* January 1923, 11, 78.

Field, Hamilton E. "Joseph Stella." *The Arts,* 2, no. 1 (October 1921), 24–26.

"Joseph Stella: Painter of the American Melting-Pot." *Current Opinion,* 64 (June 1918), 423–24.

Williams, Helena Lorenz. "Joseph Stella's Art in Retrospect." *International Studio,* 84 (July 1926), 76–80.

ALFRED STIEGLITZ

B. Stieglitz, Alfred. "Can a Photograph Have the Significance of Art?" *Manuscripts,* no. 4 (December 1922), 1–20. [Inquiry and responses].

———. "The First Great 'Clinic to Revitalize Art.'" *New York American,* January 26, 1913.

———. [Letter, 13 April 1917]. *Blind Man,* no. 2 (May 1917), 15.

———. "One Hour's Sleep–Three Dreams." *291,* no. 1 (March 1915).

———. "Portrait, 1918"; "Portrait, 1910–1921." *Manuscripts,* no. 2 (March 1922), 8–10.

———. "Regarding the Modern French Masters Exhibition: A Letter." *The Brooklyn Museum Quarterly,* 8 (July 1921), 107–13.

C. *America & Alfred Stieglitz: A Collective Portrait.* 1934; rpt. Garden City: Doubleday, 1979.

Haines, Robert Eugene. "Image and Idea: The Literary Relationships of Alfred Stieglitz." Diss. Stanford University, 1968.

Homer, William Innes. *Alfred Stieglitz and the American Avant-garde.* Boston: New York Graphic Society, 1977.

Kent, Richard John. "Alfred Stieglitz and the Maturation of American Culture." Diss. Johns Hopkins University, 1974.

Lowe, Susan Davidson. *Stieglitz: A Memoir/Biography.* New York: Farrar, Straus, Giroux, 1983.

Norman, Dorothy. *Alfred Stieglitz: An American Seer.* New York: Random House, 1973.

————, ed. *Stieglitz Memorial Portfolio, 1864–1946.* New York: Twice a Year Press, 1947.

Seligmann, Herbert. *Alfred Stieglitz Talking.* New Haven: Yale University Press, 1966.

Taylor, Larry Hugh. "Alfred Stieglitz and the Search for American Equivalents." Diss. University of Illinois at Urbana-Champaign, 1973.

Terry, James Strother. "Alfred Stieglitz: The Photographic Antecedents of Modernism." Diss. State University of New York at Stony Brook, 1979.

Thomas, F. Richard. *Literary Admirers of Alfred Stieglitz.* Carbondale: Southern Illinois University Press, 1983.

D. Greenough, Sarah, and Juan Hamilton. *Alfred Stieglitz, Photographs & Writings.* Washington: National Gallery of Art, 1983.

History of an American: "291" and after: Selections from the Artists Shown by Him from 1900 to 1925. Cincinnati: Taft Museum, 1951.

E. Anderson, Sherwood,. "Alfred Stieglitz." *Manuscripts,* no. 4 (December 1922), 15–16.

Barnes, Djuna. "Giving Advice on Life and Pictures: One Must Bleed His Own Blood." *Morning Telegraph* (New York), February 25, 1917, 7.

Hartley, Marsden. "Epitaph for Alfred Stieglitz." *Camera Work,* no. 48 (October 1916), 70.

Kreymborg, Alfred. "Stieglitz and '291.'" *Morning Telegraph* (New York), June 14, 1914, sec. 2, p. 1.

Morgan, Ann Lee. "An Encounter and Its Consequences: Arthur Dove and Alfred Stieglitz, 1910–1925." *Biography,* 2, no. 1 (Winter 1979), 35–59.

Rosenfeld, Paul. "Stieglitz." *Dial,* 70 (April 1921), 397–409.

Seligmann, Herbert J. "A Photographer Challenges." *Nation,* 112 (February 16, 1921), 268.

Sheeler, Charles. "Recent Photographs by Alfred Stieglitz." *The Arts,* 3, no. 5 (May 1923), 345.

ADOLF WOLFF

A. Wolff, Adolf. *Songs of Rebellion, Songs of Life, Songs of Love.* New York: Albert and Charles Boni, 1914.

————. *Songs, Sighs and Curses.* The Glebe, vol. 1, no. 1. Ridgefield, N.J.: The Glebe, 1913.

B. Wolff, Adolf. "Adolf Wolff's Definition of Anarchism." *The Modern School,* 2, no. 4 (April 1915), 44–45.

———. "Art Notes." *The International,* 8, no. 1 (January 1914), 21.

———. "Cremate the Corpse." *Revolt,* February 5, 1916, 1.

———. "Fireflies." *Poetry,* 8, no. 6 (September 1916), 291.

———. "From the Chinese." *TNT,* March 1919.

———. "Insurgent Art Notes." *The International,* 8, no. 2 (February 1914), 59; no. 3 (March 1914), 101–02; no. 5 (May 1914), 165.

———. "A Letter from Prison." *Camera Work,* no. 47 (January 1915), 15.

———. "Leaves of Tea." *TNT,* March 1919.

———. "Lovescape." *Little Review,* 3, no. 10 (April 1917), 15–16.

———. "The Modern School." *The Modern School,* no. 4 (Spring 1913), 20.

———. "Poems by Adolf Wolff." *The Modern School,* no. 4 (Spring 1913), 7–9.

———. "Post Impressionism." *The International,* 7, no. 2 (November 1913), 327.

———. "Prison Weeds." *Others,* November 1915, 86–92.

———. "The Revolt of the Ragged." *Mother Earth,* 8, no. 8 (October 1913), 226.

———. "To Our Martyred Dead." *Mother Earth,* 9, no. 5 (July 1914).

———. "War." *Mother Earth,* 9, no. 6 (August 1914), 117.

E. "Adolf Wolff: Sculptor of the New World." *Vanity Fair,* 3, no. 2 (October 1914), 54.

Kreymborg, Alfred. "Adolf Wolff – Man of Ideas." *The Morning Telegraph* (New York), January 31, 1915, magazine section, 7.

Naumann, Francis M., and Paul Avrich. "Adolf Wolff: 'Poet, Sculptor and Revolutionist, but Mostly Revolutionist.'" *Art Bulletin,* 67, no. 3 (September 1985), 486–500.

"Newspaper Seller, 60, Has Day as Sculptor, Is Honored by Guild." *New York Herald Tribune,* July 24, 1939, 10.

"Singer Averts Riot at Agitator's Rally." *New York Times,* June 15, 1914, 16.

Tridon, André. "Adolf Wolff: A Sculptor of To-morrow." *The International,* 8, no. 3 (March 1914), 86–87.

"Wolff in Court Again." *New York Times,* August 22, 1914, 9.

BEATRICE WOOD

A. Wood, Beatrice. *The Angel Who Wore Black Tights.* Ojai: Rogue Press, 1982.

B. Wood, Beatrice. "Dream of a Picture Hanger." *The Blindman,* no. 1 (April 10, 1917), pp. 6–7.

———. "I Shock Myself: Excerpts from the Autobiography of Beatrice Wood." *Arts Magazine* (May 1977), 134–39.

———. "Why I Come to the Independents." *The Blindman,* no. 1 (April 10, 1917), 6.

D. American Gallery. *Ceramics by Beatrice Wood.* Los Angeles: American Gallery, 1955. [Catalog cover design by Marcel Duchamp].

American House, New York. *Ceramics of Beatrice Wood.* New York: American House, 1944.

California State University, Fullerton. *Beatrice Wood Retrospective.* Fullerton: California State University, 1983. [Exhibition, February 5–March 3, 1983].

California Palace of the Legion of Honor. *Beatrice Wood.* San Francisco: California Palace of the Legion of Honor, 1964. [Travelling exhibition].

Everson Museum of Art. *Beatrice Wood: Ceramics and Drawings.* Syracuse, N.Y.: Everson Museum of Art, 1978. [Exhibition, February 17–March 26, 1978].

Garth Clark Gallery. *Beatrice Wood: A Very Private View.* Los Angeles: Garth Clark Gallery, 1981. [Exhibition, September 1981].

Hadler Galleries. *Beatrice Wood, Ceramics.* New York: Hadler Galleries, 1978. [Exhibition, March 16–April 23].

Pasadena Art Museum. *Ceramics: Beatrice Wood.* Pasadena: Art Museum, 1959.

Philadelphia Museum of Art. *Life with Dada: Beatrice Wood Drawings.* Philadelphia: Philadelphia Museum of Art, 1978.

Phoenix Museum of Art. *Beatrice Wood—A Retrospective.* Phoenix: Phoenix Museum of Art, 1973.

Rosa Esman Gallery. *Beatrice Wood and Friends: From Dada to Deco.* New York: Rosa Esman Gallery, 1978.

E. Bryan, Robert. "Beato of Ojai." *Westways* (June 1974), 22–26, 64.

———. "The Ceramics of Beatrice Wood." *Craft Horizons* (March 1970), 28–33.

Clark, Garth. "Beatrice Wood: Luster, The Art of Ceramic Light." In *Beatrice Wood Retrospective.* Fullerton: California State University, 1983, 31–38.

DeAngelus, Michael. "Beatrice Wood." In *Avant-Garde Painting & Sculpture in America, 1910-1925.* Ed. William I. Homer. Wilmington: Delaware Art Museum, 1975.

Hare, Denise. "The Lustrous Life of Beatrice Wood." *Craft Horizons* (June 1978), 26–31.

Hapgood, E. R. "All the Cataclysms: A Brief Survey of the Life of Beatrice Wood." *Arts Magazine* (March 1978), 107–09.

Naumann, Francis M. "Beatrice Wood and the Dada State of Mind." In *Beatrice Wood and Friends: From Dada to Deco.* New York: Rosa Esman Gallery, 1978.

———. "The Drawings of Beatrice Wood." In *Beatrice Wood Retrospective.* Fullerton: California State University, 1983, 9–20.

———. "Introduction and Notes to 'I Shock Myself: Excerpts from the Autobiography of Beatrice Wood.'" *Arts Magazine,* May, 1977, 134–39.

———. "Preface." In *The Angel Who Wore Black Tights,* by Beatrice Wood. Ojai: Rogue Press, 1982.

MARIUS DE ZAYAS

A. Zayas, Marius de. *African Negro Art: Its Influence on Modern Art.* New York, 1916.

———, and Paul B. Haviland. *A Study of the Modern Evolution of Plastic Expression.* New York: 291 Gallery, 1913.

———, illustrator. *Vaudeville.* By Caroline Caffin. New York: M. Kennerley, 1914.

B. Zayas, Marius de. "Caricare." *391,* no. 5 (June 1917), 3.

——. "Caricature: Absolute and Relative." *Camera Work,* no. 46 (April 1914), 19–21.

——. "Cubism?" *Arts and Decoration,* 4 (April 1916), 284–86, 308.

——. "The Evolution of Form: Introduction." *Camera Work,* no. 41 (January 1913), 44–48.

——. "How, When, and Why Modern Art Came to New York." Intro. and notes by Francis Naumann. *Arts Magazine,* 54, no. 8 (April 1980), 96–126.

——. "Modern Art: Theories and Representations." *Forum,* 54 (August 1915), 221–30.

——. "Modern Art in Connection with Negro Art." *Camera Work,* no. 48 (October 1916), 7.

——. "Negro Art." *The Arts,* 3 (1923), 199–205.

——. "The New Art in Paris." *Camera Work,* no. 34/35 (April–July 1911), 29–34.

——. "New York n'a pas vu d'abord." *291,* no. 5-6 (July–August 1915).

——. "Pablo Picasso." *Camera Work,* no. 34-35 (April–July 1911), 65-67.

——. "Photography." *Camera Work,* no. 41 (January 1913), 17–21.

——. "Photography and Artistic Photography." *Camera Work,* no. 42/43 (April–July 1913), 13–14.

——. "Preface to His Show." *Camera Work,* no. 42/43 (April–July 1913), 20–22.

——. "The Sun Has Set." *Camera Work,* no. 39 (July 1912), 17–21.

——. "291." *Camera Work,* no. 47 (July 1914), 73.

C. Runk, Eva Epp. "Marius de Zayas: The New York Years." M.A. Thesis, University of Delaware, 1973.

D. *The Collection of Marius de Zayas of New York City.* New York: Anderson Galleries, 1923.

Galerie 291. *Marius de Zayas.* New York: Galerie 291, 1909.

——. *Marius de Zayas.* New York: Galerie 291, 1910.

——. *Marius de Zayas. Caricature: Absolute and Relative.* New York: Galerie 291, 1913.

E. Bohn, Willard. "The Abstract Vision of Marius de Zayas." *Art Bulletin,* 62 (1980), 434–52.

Haviland, Paul B. "Marius de Zayas – Material, Relative, and Absolute Caricatures." *Camera Work,* 46 (April 1914), 33–34.

"Marius de Zayas, a Kindly Caricaturist of the Emotions." *Craftsman,* 13 (January–March, 1908).

III. Periodicals Associated with New York Dada.

Aesthete 1925. Ed. Walter S. Hankel. New York, 1925. 1 number.

The Blind Man. Ed. Henri-Pierre Roché, Marcel Duchamp, and Beatrice Wood. New York, 1917. 2 numbers (no. 1 entitled *The Blindman*), Reprints: (1) in *Dada americano.* Ed. Arturo Schwarz. Milan: Mazzotta, 1970. (2) New York: Johnson Reprint.

Broom. Ed. Harold A. Loeb, Matthew Josephson, and Alfred Kreymborg. Rome, Berlin, New York, 1921–1924. 6 volumes. Rpt. New York: Kraus Reprint, 1967.

Camera Work. Ed. Alfred Stieglitz. New York, 1903–1917. 50 numbers. Rpt. New York: Kraus Reprint.

Contact. Ed. William Carlos Williams and Robert M. McAlmon. New York, 1920–1923. 5 numbers. Rpt. New York: Kraus Reprint, 1967.

The Little Review. Ed. Margaret Anderson. New York, 1914–1929. 12 volumes. Rpt. New York: Kraus Reprint, 1967.

Manuscripts. Ed. Paul Rosenfeld. New York, 1922–1923. 6 numbers. Microform reprints: (1) New York: New York Public Library. (2) White Plains: Kraus Microform.

New York Dada. Ed. Marcel Duchamp and Man Ray. New York, 1921. 1 number. Reprints: (1) in *Dada americano.* Ed. Arturo Schwarz. Milan: Mazzotta, 1970. (2) New York: Johnson Reprint.

Others. Ed. Alfred Kreymborg. Grantwood, N.J., New York, Chicago, 1916–1919. 5 volumes. Rpt. New York: Kraus Reprint, 1967.

The Ridgefield Gazook. Ed. Man Ray. Ridgefield, N.J., 1915. 1 number. [Entire contents written by Man Ray]. Reprints: (1) in *Dada americano.* Ed. Arturo Schwarz. Milan: Mazzotta, 1970. (2) New York: Johnson Reprint.

The Rogue. Ed. Allen Norton. New York, 1915–1916? 2 volumes? Microfilm reprint: Ann Arbor: University Microfilms International.

Rongwrong. Ed. Marcel Duchamp, Henri-Pierre Roché, and Beatrice Wood. New York, 1917. 1 number, Reprints: (1) in *Dada americano.* Ed. Arturo Schwarz. Milan: Mazzotti, 1970. (2) New York: Johnson Reprint.

Secession. Ed. Gorham Munson and Matthew Josephson. Vienna, New York, 1922–1924. 8 numbers. Rpt. New York: Kraus Reprint, 1967.

The Soil. Ed. Robert Coady. New York, 1916–1917. 5 numbers. Microform reprints: (1) New York: New York Public Library. (2) Ann Arbor: University Microfilms International.

TNT. Ed. Henri S. Reynolds, Adolf Wolff, and Man Ray. New York, 1919. 1 number.

391. Ed. Francis Picabia. Barcelona, New York, Zurich, Paris, 1917–1924. 19 numbers. Rpt. ed., with critical apparatus by Michel Sanouillet. Paris: Le Terrain Vague, 1960–1966.

291. Ed. Alfred Stieglitz. New York, 1915–1916. 12 numbers. Rpt. New York: Arno Press, 1972.

Notes on Contributors

CRAIG ADCOCK teaches Art History at Florida State University in Tallahassee. He is the author of *Marcel Duchamp's Notes from the "Large Glass": An N-Dimensional Analysis* (1983).

WILLIAM AGEE, independent art historian, is the author of a number of important exhibition catalogs, among them *Synchronism and Color Principles in American Painting, 1910–1930* (1965), *Patrick Henry Bruce, American Modernist* (1979), and *Morton L. Schamberg* (1982). He is currently preparing a catalogue raisonné of Stuart Davis.

WILLARD BOHN teaches French at Illinois State University in Normal. He is the author of *Apollinaire et l'homme sans visage: création et évolution d'un motif moderne* (1984), and *The Aesthetics of Visual Poetry, 1914–1928* (1986). He is currently preparing an anthology entitled *The Dada Market*.

KENNETH BURKE is the author of *The Philosophy of Literary Form* (1941), *A Grammar of Motives* (1945), *Language as Symbolic Action* (1966), and many other studies. His essay "Dada, Dead or Alive" was originally published in *Aesthete 1925* (February 1925), pp. 23–26, and is reprinted here for the first time.

ROGER CONOVER is the editor of *The Last Lunar Baedeker*, containing the collected poems and selective biography of Mina Loy. For some years he has been at work on a "speculative" biography of Arthur Cravan.

RUDOLF KUENZLI teaches English and Comparative Literature, and directs the International Dada Archive at The University of Iowa. He is the coauthor of *Dada Artifacts* (1978), coeditor of *Dada Spectrum: The Dialectics of Revolt* (1979), and coeditor of the journal *Dada/Surrealism*.

FRANCIS NAUMANN teaches Art History at Parsons School of Design. He is the author of *The Mary and William Sisler Collection* (1984), and numerous essays on New York Dada. He is currently finishing a book on Man Ray.

ROBERT REISS has curated a number of art exhibitions in the United States. He has been a contributor to *The Journal of Magic History*, among other publications. He was an organizer of and performer in "Magic-Environmental Surrealism" at Lincoln Center.

TIMOTHY SHIPE, librarian, is the archivist of the International Dada Archive at The University of Iowa.

DICKRAN TASHJIAN teaches Comparative Culture at the University of California at Irvine. He is the author of *Skyscraper Primitives: Dada and the American Avant-Garde, 1910–1925* (1975), *William Carlos Williams and the American Scene, 1920–1940* (1978), and many essays on New York Dada.

JUDITH ZILCZER, historian at the Hirshhorn Museum and Sculpture Garden in Washington, D.C., is the author of *"The Noble Buyer": John Quinn, Patron of the Avant-Garde* (1978), and numerous essays on the early American avant-garde.